W9-BYA-480

EMMAUS PUBLIC LIBRARY
11 EAST MAIN STREET
EMMAUS, PA 18049

The Southwest Center Series

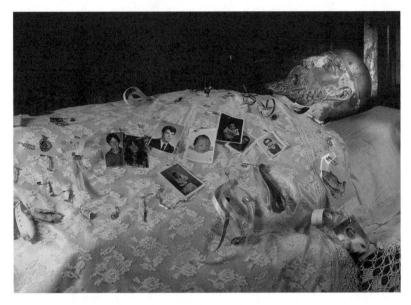

Reclining statue of St. Francis Xavier at Mission San Xavier, with offerings of milagros, photographs, and hospital identification bracelets, 1982. (Photograph by Helga Teiwes)

Eileen Oktavec

ANSWERED PRAYERS

MIRACLES AND MILAGROS
ALONG THE BORDER

THE UNIVERSITY OF

ARIZONA PRESS

TUCSON

The University of Arizona Press

© 1995

The Arizona Board of Regents

All Rights Reserved

♾ This book is printed on acid-free, archival-quality paper.

Manufactured in the United States of America

00 99 98 97 96 95 6 5 4 3 2 1

Library of Congress Cataloging-in-Publication Data

Oktavec, Eileen.

Answered prayers : miracles and milagros along the border / Eileen Oktavec.

p. cm. — (The Southwest Center series)

Includes bibliographical references and index.

ISBN 0-8165-1557-3. — ISBN 0-8165-1581-6 (pbk.)

1. Tucson Region (Ariz.)—Religious life and customs. 2. Sonora (Mexico : State)—Religious life and customs. 3. Votive offerings—Arizona—Tucson Region. 4. Votive offerings—Mexico—Sonora (State) 5. Mission San Xavier del Bac (Tucson, Ariz.) 6. Santa María Magdalena (Church : Magdalena de Kino, Mexico) 7. Francis Xavier, Saint, 1506–1552—Cult—Arizona—Tucson Region. 8. Francis Xavier, Saint, 1506–1552—Cult—Mexico—Sonora (State) 9. Tucson Region (Ariz.)—Social life and customs. 10. Sonora (Mexico : State)—Social life and customs. I. Title. II. Series.

BX1418.T83O38 1995 95-4403

246'.55'097217—dc20 CIP

British Cataloguing-in-Publication Data

A catalogue record for this book is available from the British Library.

To my parents,

Albert William Oktavec III,

who always had faith in me, and

Margaret Beatrice Oktavec,

who, through her example, taught me as a child the wonderful things that can happen

when you approach people of another culture or ethnic group with a sincere desire to

learn about their lives and beliefs.

EMMAUS PUBLIC LIBRARY
11 EAST MAIN STREET
EMMAUS, PA 18049

CONTENTS

ILLUSTRATIONS

FOREWORD

Artifacts—all artifacts—are by definition ideas, emotions, or beliefs fashioned into tangible form. They are the physical emblems of thought processes—most generally conceived to be those of *Homo sapiens*—that can be seen, touched, or otherwise experienced through human senses. Further, artifacts tend less to be the products of idiosyncratic individual behavior and more the concrete manifestation of traditional group behavior. It is this property that gives artifacts the collective label "material culture."

Artifacts provide an objective record of people's highest aspirations and deepest fears, as well as our most mundane daily activities. Interpreting this record has become the purview of archaeologists and other material-culture specialists who study the part of our world shaped by human beings.

The tiny objects and the statues of religious figures described in this study by Eileen Oktavec epitomize the very essence of the concept of artifact. For persons raised outside the cultural traditions that give rise

to these objects, they may seem strange, exotic, and, perhaps, signs of "superstition." But for the thousands of men, women, and children who continue to leave votive offerings attached to the image of a favorite saint, they are the logical and sensible tokens of an important transaction between a supplicant and God. Among believers in prayer, they are simply a way of giving that prayer—whether of petition or of thanksgiving—a tangible form. They are, in short, artifacts of faith.

That the votive offerings left with images of saints are called *milagros,* or "miracles," is altogether fitting. In its Indo-European origins, "milagro" comes from a word meaning "causing one to smile," or "wonderful." Miracles are positive events believed to result from acts of God, and when they occur, they are indeed wonderful and do, in fact, cause us to smile. Those who read this book will come to understand the perfect fit among idea, label, and object.

For me personally, it is extremely gratifying at long last to see Eileen Oktavec's years of study and hard work in printed form. She began this project in 1973 and continued, to some extent under my tutelage and encouragement, through her analysis of more than 3,000 milagros from Tucson's Mission San Xavier del Bac. From then until now, her interest in the subject has continued unabated, and she has become one of the world's leading authorities on the subject. Hers is also the first published report on milagros to take the reader well beyond their mere classification and catalog presentation into a far more important realm: how they function in the lives of people who use them in their dealings with God. She further examines their more recent use as decorative objects detached from their original religious context. *Answered Prayers* will remain as the foundation for our understanding of milagros for decades to come.

BERNARD L. FONTANA

PREFACE

Beneath the blue sky and glaring sun of the Sonoran Desert southwest of Tucson, Arizona, the Mexican baroque mission church of San Xavier del Bac[1] rises gleaming white above the terra-cotta-colored sands of the San Xavier Reservation of the Tohono O'odham Indians. The mission stands as a silent witness to an ancient folk rite that still takes place inside its adobe walls. Visitors find evidence of this ritual on a side altar, where there is a large reclining statue of St. Francis Xavier. The clothes and blanket on the statue, as well as the pillow under its head, are dotted with small metal representations of men, women, and children, human arms, legs, eyes, and hearts, as well as cows, cars, and other objects. Almost daily, devout Indians and Mexican Americans reverently approach the statue and leave these images on it as part of a personal religious rite.

These representations, popularly known as *milagros* (Spanish for "miracles"), are presented either in thanksgiving or in supplication for divine intercession to cure a disease or to bring about some other favor. The many milagros hanging on the statue of St. Francis are testimony to

people's belief that prayers can be answered and that miracles do occur.

A milagro is an *ex-voto*, a Latin word meaning "from a vow." In the Roman Catholic Church, an ex-voto is a votive offering left at a church or shrine to fulfill a vow to God or a saint. Joan Prat divides ex-votos into three categories: (1) objects directly related to a disease or disability, such as crutches, canes, eyeglasses, hospital identification bracelets, and even clothes worn while the person was afflicted; (2) paintings and photographs illustrating an illness, injury, or other misfortune; and (3) milagros, which are small sculptures or reliefs created especially to symbolize people or body parts.[2]

Unlike many other Catholic shrines, San Xavier and Magdalena (in Sonora, Mexico) do not have clothing or prosthetic devices piled by the altar or by statues of Xavier. Photographs are common only at San Xavier, and ex-voto paintings are virtually unknown in this region. In the San Xavier–Magdalena corridor, it is milagros that have traditionally fulfilled the faithful's desire to express their petitions or gratitude to a saint or God.

More milagros are offered at Mission San Xavier than at any other place in Arizona. Only 120 miles away is another shrine to St. Francis Xavier where even more milagros are offered on another reclining statue of Xavier—the church of Santa María Magdalena in Magdalena de Kino, Sonora, Mexico.

The custom of offering milagros not only thrives at these two major shrines but also pervades the surrounding region, which was once part of Mexico and is heavily populated by Catholics: Mexicans, Mexican Americans, and Indians whose ancestors were converted by Spanish missionaries. Milagros are offered at hundreds of private and public sites, including churches and shrines in Tucson, the twin border cities of Nogales, Arizona, and Nogales, Mexico; and the towns of Sonora, Mexico. The custom is also carried out in similar form at many other Catholic and Greek Orthodox sites around the world.

My interest in milagros began in August 1973. I had just moved from New York to Tucson to attend graduate school at the University of Arizona, and people recommended that I go to Mission San Xavier—not

for religious reasons, but simply because it was one of the must-see sights of Tucson. No one told me San Xavier is a pilgrimage site.

When I walked inside the beautiful old church, I saw a line of Papago (now Tohono O'odham) Indians, Mexican Americans, and a few others who were waiting to approach something in the left transept. Curious, I joined the line. As it moved along, I saw those ahead of me kissing and caressing a reclining statue adorned with dozens of photographs, hospital identification bracelets, flowers, and little gold- and silver-colored metal offerings in the shapes of people, body parts, cars, and houses.

That was the first time I saw milagros, but although I was surprised, they did not seem strange to me. As a Roman Catholic, I had seen hundreds of crutches and other prosthetic devices at shrines in the eastern United States and Canada, and milagros seemed to be manifestations of the same custom—offering something that graphically symbolized a cure or favor granted through a saint's intercession with God. What I did not realize then was that some of the milagros may have been offered to St. Francis in petition.

I first went to Magdalena two months later, at the height of the Fiesta de San Francisco, and I was amazed and delighted by the crowds and the sights, sounds, and smells of the fiesta. What struck me most, however, was the intense piety of the Indian, Mexican, and Mexican American pilgrims who prayed beside and left their offerings on another reclining statue of the saint, here called by his Spanish name San Francisco. For most of the next three days, I interviewed those who had made the pilgrimage and left offerings of candles, flowers, jewelry, milagros, ribbons, pillows, clothing, and miniature statues for the saint.

When I later thought of the various offerings, I realized the milagros intrigued me most because only they symbolize so graphically why the donor would be so grateful to San Francisco.

Two years later, in 1975, Bernard Fontana, then an anthropologist at the University of Arizona, offered me the opportunity to classify a collection of 3,045 milagros from Mission San Xavier, which had recently been donated to the Arizona State Museum. I jumped at the chance and have been studying milagros and the customs associated with them ever since.

During the Fiesta de San Francisco in October 1981, Padre José Santos Saenz, then pastor of Santa María Magdalena, told me several times in

his excellent English that he had hundreds of thousands of milagros at the rectory. Padre Santos knew I had been studying milagros for years, but he was also a great jokester, so at first I thought he was teasing. But the next day, when I accepted his invitation to see the milagros, he proudly showed me three large trunksful of the offerings, which he had stored in his bedroom closet. With great delight, he opened the top trunk and exclaimed, "I've been saving these milagros for forty years!" Two days later, I had sifted through two of the trunks and had set aside the most unusual ones.

A few weeks later, I returned with Helga Teiwes, the Arizona State Museum photographer. While she photographed those I had already set aside, I sifted through the rest, but I did not have time to count or thoroughly catalog the approximately half a million milagros in Padre Santos's trunks.[3]

In April 1992, Padre Francisco Jaime Salcido Lizárraga, the present pastor of Santa María Magdalena, told me that one of the priests started cataloging the milagros left over the years, "but we've had so many other things to do here that take priority that he had to abandon the task." Padre Salcido welcomed me to study the collection, and I returned the following March to sort and count a representative sample of the types of milagros offered there.

Due to renovations at the rectory, offerings from the preceding four and a half years had been stored in the church office on the Plaza Monumental. With the help of a colleague and five diligent church employees, I spent four days sorting and counting 43,891 offerings in that collection.

I tried to do a similar count of milagros offered in recent years at San Xavier, but Father Michael Dallmeier told me the milagros are no longer saved there for more than a few months. Therefore, to compare the milagros offered at San Xavier with those offered at Magdalena between 1988 and 1993, I used the five-year collection from San Xavier that I cataloged in 1975.

In addition to studying the types of milagros offered in the region, I sought to answer several other questions: Where and when did the use of milagros begin? What beliefs and customs are associated with offering them? What circumstances lead people to promise milagros? At what other sites in the region besides San Xavier and Magdalena do people offer milagros? (Every time I thought I had this question answered,

someone would tell me about yet another site. There are undoubtedly some I *still* have not discovered.) Why do the faithful promise to bring milagros to one shrine instead of another? Where do people buy milagros? How are they made? What happens to offerings left at each site? What is the attitude of local priests toward the custom of offering milagros? Is the custom dying out? Last and perhaps most important, what are the benefits of the custom to the people who practice it?

To answer these questions, I researched the history of votive offerings worldwide. I returned to San Xavier and Magdalena again and again, during the feasts of St. Francis and at other times. Beginning in 1973 and ending in 1995, I made fifteen trips to both shrines. I also went to other churches, hospitals, and public shrines in the Tucson-Magdalena corridor where people were said to leave milagros. Wherever I found milagros, I tried to interview the people who left them there, as well as the priests and other people associated with the sites. I also interviewed shopkeepers who sell milagros in Tucson and in Magdalena, Nogales, and Agua Prieta, Mexico, and some of their wholesale suppliers. Three silversmiths explained and demonstrated their different methods of making milagros, and I gathered other supporting information at churches and monasteries in Spain in 1989, and at Cuban churches and shrines in Miami and Tampa, Florida, in 1985.

This book records what I have learned in twenty-two years of studying milagros. It also attempts to explain the customs associated with milagros so that people unfamiliar with this tradition might understand its value to the people who are part of the milagro-offering culture.

Many of my conversations were in Spanish or mixed Spanish and English. The most notable exception was Padre Santos, who said he preferred to speak English because he had few other chances to do so. In Arizona, a few conversations were in Spanish, but the majority were in English. All translations from Spanish to English are my own. Virtually all foreign words in the text are Spanish, with translations in parentheses.

I did not use a tape recorder. At San Xavier and Magdalena, I was an outsider approaching total strangers, in churches where they had just engaged in a very personal religious act. In that setting, I did not think it would be appropriate or productive to hold out a tape recorder and ask permission to record their responses. A tape recorder would have inhibited or completely precluded many informative conversations with

people who were unused to being recorded, some of whom were questioning my motives for asking about their offerings and beliefs. However, no one appeared to mind my taking notes. Also, because I was usually trying to interview as many people as possible before they left the site, and because I knew I could take excellent notes using a personal shorthand, I felt that the time it would take to convince people to let me record their words would be better spent talking to more pilgrims.

I also think that other informants, including local priests, shopkeepers, and the owners of household shrines, probably would not have responded as candidly if I had been recording their words. I wanted their comments to be as uninhibited as possible because although I honored their requests not to publish certain information, I knew that some things they told me in confidence would help me to understand more fully the custom of offering milagros.

Some milagros are solid sterling silver or solid 14-karat gold or better, but the vast majority are not. Some are silver- or gold-plated, but most are nickel, brass, or other metal. Thus, when I refer to a "gold" or "silver" milagro, I am referring to its color, not its content.

I use St. Francis's English name to refer to the saint or to his statues in the United States. I use his Spanish name, San Francisco, whenever I refer to him or to his statues in Mexico. When I quote people, however, I use whichever of his names they used.

I use the titles "Señor" and "Señora" before the names of people living in Mexico because it is customary in their culture.

Some people quoted in the text used the word "Anglo," which is commonly understood in the Southwest to mean all people who are non-Indian and non-Hispanic.

Regarding references to "Papagos" and "Tohono O'odham," although these native people of the Sonoran Desert had long called themselves "O'odham" (or "the people"), the Spanish, and later the U.S. government, called them "Papagos." In 1982 the tribe officially changed its named to "Tohono O'odham," or the Desert People. Because this is a long name, some call themselves simply "O'odham" or even "T.O.'s." Some O'odham, however, still refer to themselves as Papagos, and many other people continue to use that name as well. If informants used

"Papago," I used the same name in the text. I also use "Papago" when I describe events that occurred before the 1982 name change.

The majority of the O'odham live on the United States side of the U.S.-Mexico border on the 2.5-million-acre Papago Indian Reservation of the Tohono O'odham Nation. The largest parcel, known as the Sells Papago Indian Reservation, is about fifty miles west of Tucson. The San Xavier Reservation, a small, detached district of the main reservation, is just southwest of Tucson, along Interstate 19.

I often refer to Mission San Xavier as "San Xavier" or "the mission" because that is how local people refer to it. In this book, "San Xavier" does not refer to the San Xavier Reservation, on which the mission is located, and which I always denote by its full name.

I use the name "Magdalena" to refer not only to the town of Magdalena de Kino but also to the Church of Santa María Magdalena, *in* Magdalena, because that is how almost everyone who lives outside the town and who is part of the milagro-offering culture refers to the church. When people say "I'm going to Magdalena" or "I'm going to bring a milagro to Magdalena," everyone who is part of the tradition immediately understands that they mean not just the town, or even the church, but the chapel where Xavier's statue lies.

ACKNOWLEDGMENTS

During the twenty-two years in which I have studied milagros, so many people have helped me in so many ways that it would be impossible to mention them all. Some, however, stand out.

Most of all, I wish to thank my mentor, Bernard Fontana, formerly of the University of Arizona. He is a kindred spirit who always shared my excitement about milagros and this book. His never-ending support and editorial advice were invaluable.

The late Edward Spicer, also of the University of Arizona, gave me many hours of sage advice as he guided my early fieldwork among the Tohono O'odham and Yaqui Indians.

Helga Teiwes is appreciated not only for her skills as a photographer but also for her unfailing good humor and fine company on two unforgettable trips to Magdalena, Mexico. All her photographs in this book are provided courtesy of the Arizona State Museum, University of Arizona.

Ruben Nubes Duarte of Magdalena; Agustin Calleros, Carlos Diaz,

and Rose Navarro of Tucson; and Sylvia Contreras of McAllen, Texas, each spent many hours explaining how milagros are made.

Four women in Tucson were also very helpful. Adelina Aros has been an inestimable source of information about Mexican Americans' use of milagros. Josefina Lizárraga was always happy to talk about milagros and the reasons people bought them at her shop. She was also a generous and lively companion on research trips to Mexico. Marcia McClincy shared three memorable trips to Magdalena with me and long provided me a home away from home whenever I was in Tucson. My niece, Yana Frascella, was always willing to accompany me to Nogales, Mexico.

Several Tohono O'odham, especially Edith Lopez and the late Herbie Martinez, taught me much about O'odham traditional religion and their people's devotion to St. Francis. Mary Narcho and Matilda Garcia broadened my knowledge of the veneration of St. Francis at Mission San Xavier.

Several Yaqui Indians, including Anselmo Valencia, the Yaqui Indian spiritual leader, gave me valuable information about their religious beliefs and their use of milagros.

Edith Clark Espino and Jimmy Campbell of Tucson; Manuel Costenera of Bisbee; Ed Madrid, formerly of Bisbee; Raul Castillo Murrieta and Lucía López of Nogales, Mexico; Josefina Gallego of San Ignacio, Mexico; and Delfina Suarez Viuda de López and Eduardo Corrales Meza of Magdalena all provided detailed accounts of milagro-offering sites.

Many Roman Catholic priests, friars, and church employees helped me with my research and shared their thoughts about the custom of offering milagros. I especially remember Padre José Santos Saenz, the late pastor of Magdalena, who gave me access to the vast collection of milagros offered there and extended warm hospitality. Padre Francisco Jaime Salcido Lizárraga, Magdalena's present pastor, took a scholarly interest in my research and organized a count of part of the milagro collection. With great diligence and good humor, Cristina Peralta Estrada, José Santos Frasquillo, Griselda Seym Hernándes, Lourdes Margarita Preciado de Romero, and Basilia Ortiz Yañez helped me sort milagros offered at the church. María de la Luz del Cid de Avechuco, Isabel Parra Ibarra, and Margarita Lariche provided other assistance. Consuelo Ochoa Cantua shared her years of experience guarding San Francisco's

statue. Manuel Moreno, bishop of Tucson, and Carlos Quintero Arce, archbishop of Hermosillo, Mexico, discussed church views on milagros and the veneration of San Francisco. Monsignor John Oliver of Sacred Heart Church in Nogales, Arizona, shared his knowledge of church history in the region. Padre José Luis Alegría of Iglesia de San José in Ímuris, was also helpful, as were many people from churches in Tucson, including Father Cyprian Killackey and Yolanda Grijalva, of St. Margaret's; Father Gilbert Padilla and Victoria Orosco, of Holy Family; Father Gerald M. Cote and Alice Gallardo, formerly of Holy Family; Father Stephen Watson, Betty Galaz, and Roberto Ortiz, of Santa Cruz; and Monsignor Arsenio Carillo, V. G., Barbara Valenzuela, Geraldine Bartlett, and Tom Peterson of St. Augustine's Cathedral. Fred Allison, of the Diocese of Tucson, also helped. Michael Dallmeier, O.F.M., of Mission San Xavier, provided valuable insights on the custom of offering milagros.

Over the years several nurses and Catholic nuns helped me keep track of milagros left at their respective hospitals: Sister Margaret Walsh and Sister Alberta Cammack of St. Mary's Hospital in Tucson; Polly Phillips, Karen Van Wie, Sister Mary George Long, and Sister Patrick Bernard Lyon of St. Joseph's Hospital in Tucson; and Sister Augustina Hernandez of Holy Cross Hospital in Nogales, Arizona.

Several scholars, now or formerly associated with the University of Arizona, made my task easier. Kieran McCarty, O.F.M., and Charles Polzer, S. J., shared their extensive knowledge of Padre Kino and the history of the Pimería Alta. James Officer helped me with historical details about the black statue of Christ in Ímuris. James S. Griffith provided valuable information about regional shrines and offering sites.

Ron MacBain and Gus Carrasco of Tucson introduced me to the world of milagro art. Martha Mendivil, Arturo Mercado, Berta Wright, Amy Lau, Dino Alfaro, and Diedre and Allan Mardon of Tucson; Kim Yubeta of Tumacacori, Arizona; and Elena Serna of Nogales, Mexico, added to my knowledge of this new phenomenon.

Dr. Felipe de Jesús Valenzuela led me to the shrine of Juan Soldado and, with his wife, María del Carmen, provided hospitality at their home.

Comparative information was provided by Father Miguel Mateo of El Santuario de Chimayo in Chimayo, New Mexico, and Ruben Yza-

guirre of Virgen de San Juan del Valle Shrine in San Juan, Texas. Marion Oettinger of the San Antonio Museum of Art and Martha Egan of Santa Fe shared their knowledge of milagro-offering sites worldwide.

Four specialists reviewed photographs of milagros: Jennifer Loveman of the Metropolitan Museum of Art in New York City, Barbara Mauldlin of the Museum of New Mexico, Patricia Rieff Anawalt of the Fowler Museum of Cultural History in Los Angeles, and Janine Seyhun of the Los Angeles County Museum of Art.

Several others also deserve mention: Jan Bell, Diane Dittemore, and Kathy Hubenschmidt of the Arizona State Museum; the late Mama Chatman, Lourdes Matus, José Matus, Sister Mary Gregory Cushing, and Sister Delores Dowling of Tucson; Charles Pulido of Phoenix; Marilu Lopez of Rio Rico, Arizona; and Clarissa Ramirez and Adelina Albaraba of Nogales, Arizona.

Richard E. Ahlborn provided extensive and very useful comments on the manuscript.

Joanne O'Hare and Alexis Noebels of the University of Arizona Press were patient and sensitive editors.

Edward C. Lee provided generous financial assistance for field research, and the Southwest Center of the University of Arizona provided funds to help publish this book.

My fiancé, Robert Gillmore, spent most of his first trip to Mexico counting milagros offered at Magdalena and San Ignacio. He also spent countless hours editing the manuscript and provided constant encouragement.

To all these people and everyone else who helped me, I am extremely grateful.

Answered Prayers

Milagros and the Cult of St. Francis

Most of the faithful who offer milagros to the saints do not know how or where the custom originated. Even most Catholic priests know little about its origin. None of the priests in the Tucson area, including the former historian of the diocese, Father Francis Fox, were able to offer me any insights. Most priests say they have seen milagros but never thought much about them. They usually say only that the tradition must have come from Europe.

In fact, it did. People have used symbolic offerings to thank or propitiate gods or spirits since prehistoric times, possibly dating back to the Paleolithic period.[1] The early Persians, Sumerians, Minoans, and Egyptians used votive offerings depicting animals and people, some dating as early as ca. 3000 B.C.[2] The ancient Greeks also left countless votive offerings—more than any other culture—in the shrines and temples dedicated to their many gods.[3] These clay, stone, and metal representations of animals, people, and body parts include the small, stylized bronze horses and deer of the geometric period as well as later realistic

sculptures such as the famous larger-than-life-size bronze "Charioteer of Polyzalos." Roman votive offerings called *donaria* were mainly reproductions of the human body and its parts, including trunks of bodies with large openings that exposed the internal organs.[4]

Votive figurines of animals, people, and body parts were also offered in ancient times in present-day Spain. Beginning between the seventh and third centuries B.C., bell-shaped, nude terra-cotta figures of men and women were offered in sacred wells on Ibiza's La Isla Plana (the Flat Island).[5] In the third century B.C., bronze models of bears, birds, horses with carts, and a horse-drawn sled were offered at the southern Iberian sanctuary of Cerro de los Jardines (Hill of the Gardens).[6] Bronze figures of soldiers, people on horseback, and men and women kneeling and praying were offered in other ancient Iberian sanctuaries. Later, bronze arms, legs, feet, hands, eyes, and even sets of teeth were left as offerings.[7]

Royal offerings include a gold and jeweled votive crown dedicated by Recaredo, the Visigoth king of Spain from 586 to 601,[8] and a silver model of genitals presented in 1522 by the Infante Don Enrique de Aragón.[9] According to legend, Hernán Cortés, the conqueror of Mexico, offered a hollow gold scorpion decorated with emeralds, rubies, and pearls to Nuestra Señora de Guadalupe (Our Lady of Guadalupe) at her shrine in Extremadura, Spain, because he believed she had saved him from the fatal effects of a scorpion bite in Mexico.[10]

As the legend of Cortés's offering suggests, the custom of presenting milagros was brought to the New World by the Spanish conquistadors, but they found that some pre-Columbian cultures already had a long history of dedicating offerings to their gods.[11] After many of those native peoples had been converted to Catholicism, it was a small leap for them to begin offering milagros to Christ and the Christian saints.

Today milagros are offered throughout the Roman Catholic and Greek Orthodox world. Although they may have different names, they are seen in Spain, Portugal, Italy, Greece, the Philippines, and Latin America (where they are especially popular in Mexico). Milagros are also offered in parts of the United States where large numbers of immigrants from those countries have settled, including Arizona, California, New Mexico, Texas, Florida, Rhode Island, Massachusetts, and New York.

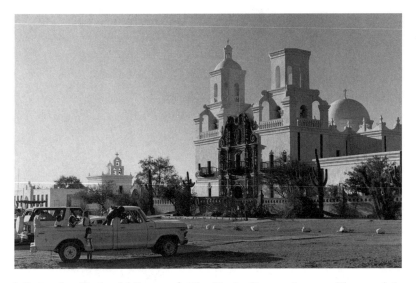

Mission San Xavier del Bac, on the San Xavier Reservation near Tucson, Arizona, 1985. (Photograph by the author)

In the Tucson-Magdalena corridor, which extends from southern Arizona into northern Sonora, Mexico, most of the faithful offer their milagros on St. Francis's image, although they also offer them to other saints and to Christ. Even at San Xavier itself, a few milagros are occasionally seen pinned to the dress on the statue of the Virgin as the Sorrowing Mother, or tied to the ankles of the figure of the crucified Christ on the back wall of the church. Occasionally someone leaves a milagro on an image in the mortuary chapel. At Magdalena, a few milagros are offered on images of San Martín de Porres, San Antonio de Padua, and La Virgen de Guadalupe. The vast majority of milagros, however, are promised to Xavier, both because of the life he led and because he was popularized by an extraordinary Jesuit missionary, Padre Eusebio Francisco Kino.

St. Francis was born a nobleman in 1506 at the Castle of Xavier in Navarre, Spain, but at age twenty-six, he became one of the first seven Jesuits to be led by Ignatius Loyola. Considered by many to be the greatest Catholic missionary since Paul,[12] St. Francis journeyed to India, Malacca, Ceylon, and Japan, and his record of conversions inspired later Jesuits who faced the challenge of spreading Catholicism among the Indians of New Spain.[13]

Besides teaching the faith, St. Francis spent much of his time administering to the sick. When he sailed to Goa, India, he used his cabin as an infirmary to care for ill passengers. In a Goa hospital, after working all day, he slept on the floor beside the bed of the most gravely ill patient so that he could help him at a moment's notice.[14]

While working among the Tamil-speaking Paravas in 1542, Xavier wrote, "During my stay there ... I was besieged by crowds of people who wanted me to come to their huts and pray for their sick. ... owing to their faith and the faith of their families and friends, God has shown great mercy to the sick, healing them in both body and soul."[15] Some church scholars have interpreted this last sentence to mean that St. Francis had performed miracles.[16] Xavier's work with the sick may partly explain his popularity with the people of the Sonoran region, who pray to him for everything, but most of all for health.

While en route to China in December 1552, St. Francis died on the island of Sancian, near Canton. The next night he was buried in a coffin filled with quicklime. When his body was exhumed four months later to be taken back to Goa, it did not appear decayed and was still flesh-colored—a sign that he was a saint. Seventy years later, in 1622, Francis Xavier was canonized. At expositions in the cathedral in Goa, India, the ornate glass and silver casket containing Xavier's now-desiccated body is kissed by thousands of devout pilgrims who believe his remains have supernatural powers.[17]

Almost 150 years after his death, Mission San Xavier was dedicated to the saint by Padre Kino, who believed St. Francis had once responded to his prayers and saved his life when he was mortally ill. Padre Kino's gratitude to the saint led him to spread devotion to Xavier throughout most of the Pimería Alta (the Upper Pima [Indian] country), which extended from the Río Concepción in Sonora, Mexico, to the Gila River in present-day Arizona, and from the San Pedro River, east of Tucson, to the Colorado River and the Gulf of California.[18] Padre Kino traveled extensively through this desert region, baptizing the Indians and establishing more than twenty new missions, including San Xavier and Santa María Magdalena.

Most of the Indians welcomed him because they knew that other villages where missions had been established had prospered.[19] Padre Kino loved these Indians and enjoyed their friendship.[20] He helped protect

them from harsh treatment and compulsory labor in Spanish colonial mines, he increased the agricultural production of their settlements, he fiercely defended them against false rumors of hostility, and he helped unite them against the ravaging Apache and Jocome tribes on their borders.[21]

Padre Kino named Xavier the patron saint of Mission San Xavier after construction of the original chapel (the first of two churches)[22] began in 1700. Sixty-seven years later, Spain's King Charles III expelled the Jesuits from New Spain,[23] and they were replaced the next year by Franciscan friars, whose founder and patron saint was St. Francis of Assisi. Although the Franciscans built the church that stands at San Xavier today, they retained Xavier as the mission's patron saint, probably to preserve a feeling of continuity among the local Indians.[24]

In Magdalena, Padre Kino created what is now the region's most important shrine to St. Francis. He encouraged his companion, Padre Agustín de Campos, to complete the original small chapel dedicated to his favorite saint, Xavier. The chapel was later incorporated into a larger church complex dedicated to Santa María Magdalena.[25] During the dedication mass for the chapel in 1711, Padre Kino suddenly became ill. He died the same night and was buried beneath the chapel.[26] Soon afterward, many of the Indians who loved him began pilgrimages to the San Francisco chapel where he was buried.[27]

The present domed, pink-stucco church was built between 1830 and 1832 near the site of the previous one, which had deteriorated.[28] As in Arizona, the Franciscans who built the church had replaced the Jesuits in 1768, and they kept Santa María Magdalena as the patron saint of the principal church, but the cult of Padre Kino's beloved saint—Xavier—continues to thrive there, even more strongly than at Mission San Xavier.

Even at many other churches and shrines in the region where he is not the focus of devotion, St. Francis Xavier's presence is felt. In countless homes and public sites, including about half of the other churches and shrines where milagros are offered, either a small copy or a photograph of the Magdalena statue of St. Francis is displayed.

The custom of praying to saints developed centuries ago in the Old World because miraculous cures and other assistance were attributed to them. The saints were believed to have interceded with God to obtain

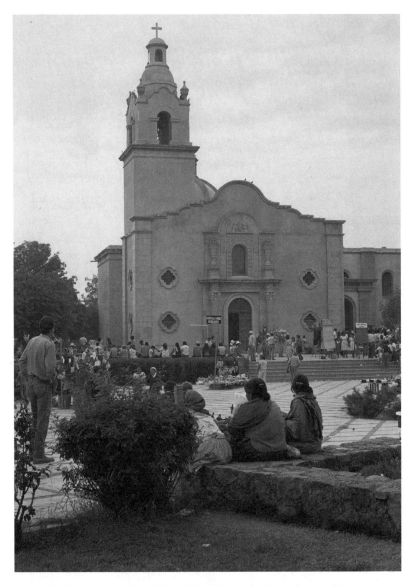

Iglesia de Santa María Magdalena. Magdalena de Kino, Sonora, Mexico, 1981.
(Photograph by the author)

special help for the faithful. Many miracles were believed to have taken place at shrines dedicated to the saints, or at the sites of their relics.[29]

Certain religious orders encouraged the veneration of individual saints, and such beliefs were spread by devoted travelers and by monks and nuns who established new communities and churches. As previously

mentioned, devotion to St. Francis Xavier was spread in the Pimería Alta by Padre Kino.

Some saints are known as patrons of people suffering from a particular disease or problem, or of people in a particular occupation, and some hold more than one patronage. Saints become official patrons by a decree of the church, but many saints enjoy popular patronages not formally ratified by the church. Patronage is usually granted by the church when a saint has a long record of helping people with a particular concern—often something the saint dealt with during his or her life. Some patronages are assigned after a group requests that a saint be declared their patron. In 1978, for instance, Pope Paul VI granted the request of the Argentine pelota players to make St. Francis Xavier their patron saint.[30]

Often, the most revered patron saints are those thought to intercede with God in particular circumstances. For example, many people pray to St. Lucy for relief from eye problems, to St. Anthony of Padua for help in recovering lost articles, and to St. Jude for help in hopeless situations. People may also seek help from a saint because he or she is the patron saint of their church, city, or country. Such saints are believed to be especially responsive to the requests of local people.

St. Francis Xavier is the church-designated patron saint of both Mission San Xavier and the San Xavier Reservation, but he is also the popular patron saint of almost the entire Pimería Alta. Several O'odham have told me that St. Francis is really the patron saint of the whole Tohono O'odham Nation. Consequently, even though the church has never decreed him a patron of the sick or of any other conditions for which people generally seek his help, the faithful believe that because he is their patron, St. Francis is efficacious for them in all of these situations.

People generally feel close to the patron saint of their church, town, or region. Many O'odham regard St. Francis with deep affection, and some refer to him tenderly as "the Old Man." Some even report seeing him alive. Herbie Martinez of Crowhang, on the Sells Reservation, said sometimes people say that they have seen the Old Man standing by their well or some place in the desert, and that he would say, "I'm just stretching. Then I'll go back and lay down [on my bier in the church]."

Even images of the saint evoke strong feelings. At the San Francisco fiesta in 1985, an O'odham man told me that several years earlier, a few other O'odham went to Magdalena and saw some Mexicans riding

around in a truck with a stone statue of St. Francis in the bed. After the truck passed several times, the O'odham said, "We have to save the Old Man from riding around in this heat." So they bought the statue from the Mexicans and brought it back to Schuchulik on the Sells Reservation, where he said it still remained.

Monsignor John Oliver of Sacred Heart Church in Nogales, Arizona, says Catholic churches have images such as the statues of St. Francis "because the dynamics of nonverbal communication is very powerful." The images of Xavier, which represent the historical Francis Xavier who once lived on earth, as well as the heavenly being who can intercede with God, help people picture the saint to whom they direct their prayers.[31] St. John Damascene, an eighth-century theologian and scholar, believed that "images open the heart and awake the intellect, and, in a marvelous and indescribable manner, engage us to imitate the persons they represent."[32] According to the *New Catholic Encyclopedia*, "the veneration of images is natural to man" and "is related to the natural inclination of man to express his thoughts and feelings in various forms of art." Therefore, "it is normal that man's religious beliefs and sentiments should be channeled through every form of artistic expression."[33] "Since the worship given to an image reaches and terminates in the person represented, the same type of worship due the person can be rendered to the image as representing the person."[34] However, although the church holds that images of saints should be venerated, it also states that the images are symbolic only, have no inherent spiritual power, and should not be worshipped.

Despite such teachings, certain saint's images seem to induce adoration because some people do believe they have power in and of themselves. Part of this belief probably arises from the respect and veneration given to consecrated images,[35] which help create the feeling that some life or force is present inside them. Also, lifelike details such as glass eyes and clothing, as well as the realistic manner in which the images are displayed, further evoke the feeling that the statue is in some way the actual saint.

Although such responses may seem strange, emotional experiences in response to certain images are common. For example, a man looking at a photograph of his beloved wife who has died might say to himself, "There she is." By gazing at the picture, "she" exists again, at least momentarily, because there is a fusion of the image and the person loved.[36]

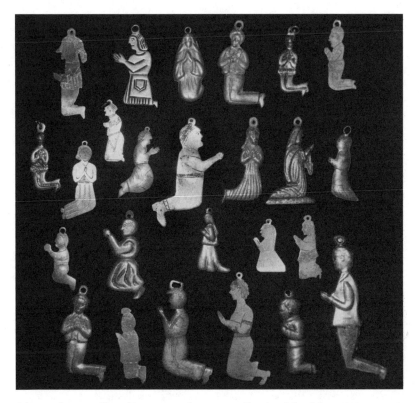

Silver milagros of kneeling men and women offered at Magdalena. (Photograph by Helga Teiwes)

Other pictures and sculptures can cause people to become sexually aroused, as if the nude depicted were alive. Yet even if the response to an image is merely emotional and not sexual, many people repress their feelings out of embarrassment and, perhaps, fear. Others prefer to believe that only ancient or more primitive people have been affected by these feelings.[37] But when people who believe in a saint's powers concentrate on the image, then "what is represented becomes fully present," and the statue becomes "the living embodiment of what it signifies."[38] "Perhaps . . . it is not that the bodies [of saints] are present; it is *as though* they were present."[39] But "to respond to a picture or a sculpture 'as if' it were real is little different from responding to reality as real."[40]

All images of the same saint are not equal, however. It is not unusual for one image to be considered more powerful than another if reports of cures and favors obtained at one shrine outweigh those granted else-

where. Then the image, rather than the saint, may be believed to produce the miracle.

Therefore, although the reclining statue of St. Francis at San Xavier is part of many mandas and receives many votive offerings, some people insist that his statue at Magdalena has greater power. This is partly because of the much longer history of favors granted at Magdalena, and partly because most people believe more prayers are answered there. Consequently, some people who make mandas and offer milagros to St. Francis at San Xavier also go to Magdalena if they can. They say they go there, too, "just to make sure." Others skip San Xavier entirely and go directly to Magdalena.

The perceived power of the statue of San Francisco Xavier at Magdalena, like that of many cult images, is based partly on stories of how it got there and why a church was built at that site. One popular story, told to me in 1973 by a Mexican American family in South Tucson, is that Padre Kino ordered the statue brought from Spain, intending to place it in the chapel at Mission San Xavier. The statue was shipped from Spain to Veracruz, Mexico, where it was loaded on a wagon for shipment to San Xavier. When the wagon broke down in Magdalena, people took this as a sign that the saint wanted a shrine there. Thus the statue stayed in Magdalena, where the original San Francisco chapel was built.

The most vivid evidence of popular belief in both St. Francis's and his statue's power is the sight of pilgrims rubbing their holy pictures, statues, and other belongings against San Francisco's image to transfer its potency to their own images. Most pilgrims carry just one or two images, usually wrapped in paper or a colorful cloth, but some people bring shopping bags full of statues and pictures. Several O'odham have told me that their household images are "like the batteries in our cars. They have power for awhile, and then they grow weak." People bring them to the shrine of San Francisco to "recharge" them for another year.

Many Mexicans and Mexican Americans feel the same way. Any day, but especially during the fiesta, people can be seen leaving their homes in Magdalena and carrying their household images to the church to rub them against the statue of San Francisco. At the 1981 fiesta in Magdalena, one Mexican American woman from Goodyear, Arizona, showed me a *cuerpecito* (or "little body"), a small, mass-produced, painted plaster replica of the reclining statue of San Francisco in a glass and metal casket.

Herbie Martinez, a Tohono O'odham, leaving the chapel with a newly purchased *cuerpecito* that he had just rubbed against the statue of San Francisco. Magdalena, 1981. (Photograph by the author)

"I bought this cuerpecito here in Magdalena when I was twenty," she said. "I'm forty-three now and I've brought it back every year to touch San Francisco."

Some people vow to wear brown dresses or shirts known as *hábitos*[41] in honor of the saint, and it is customary to rub their newly purchased garments on the statue before putting them on. People also rub the clothing of sick people against the statue in hopes of a cure. Further evidence of belief in the statue's supernatural power is the practice of breaking off its toes, fingers, and other parts to carry away as relics. Padre Santos recalled that years before, in about 1966, "someone took both of the hands and we had to get new ones."

The power and emotional appeal of San Francisco's image is demonstrated even outside the church at Magdalena. Especially during the fiesta, which is also the most popular time for people to offer milagros to the saint, even the sidewalks outside some of the merchants' shops are stacked high with dozens of cuerpecitos and larger replicas of the statue

to sell to eager pilgrims. The larger images evoke so much emotion in some pilgrims that they will suddenly stop on the sidewalk and bend over to kiss one.

The celebration of San Francisco's feast day in Magdalena is October 4, even though, according to the church, his feast day is December 3 (the date of his death and immediate ascension into Heaven). October 4 is actually the feast of St. Francis of Assisi, who founded the Franciscan order, but in Magdalena, sometime between 1814 and 1828, St. Francis Xavier was given the feast day of St. Francis of Assisi. One explanation offered by Archbishop of Hermosillo Carlos Quintero Arce and many other priests is that the cold weather of December would have caused great hardship and could have been unhealthy and even dangerous for the pilgrims walking to Magdalena, and for all those who camped near the church plaza.

Other considerations also may have influenced the decision. Father Charles Polzer says the Franciscans were busy preparing for Christmas in December and did not want to accommodate pilgrims then. It is also possible that they wanted the celebration to be closer to harvest time, when food would be more plentiful.[42] Polzer and other scholars also suggest that the Franciscans made the change simply so Xavier's feast day would be celebrated on the feast day of *their* patron saint in the hope that the populace would switch its allegiance to St. Francis of Assisi.[43] One result of the date change was confusion between the two saints that continues today, both in Magdalena and at Mission San Xavier. Some people think the reclining statues represent St. Francis Xavier, while others think they depict St. Francis of Assisi. Many others fuse the two saints and say the statues represent simply "St. Francis" or "San Francisco."[44]

Further confusing the issue are the brown hábitos worn by some pilgrims. In 1897 the Franciscans administering to the Pima and Papago (O'odham) Indians changed the color of their habits from dull blue-gray to brown.[45] Father Polzer says that later, the Indians going to Magdalena on pilgrimages in honor of St. Francis Xavier, a Jesuit who wore a black robe, began wearing brown garments, possibly in imitation of the Franciscan friars.[46]

Even the plaster replicas of Xavier's statue reflect the confusion of the two saints. The smaller, five- to twenty-inch-long cuerpecitos are dressed in brown cloth robes instead of Xavier's black robe. However, the cuer-

pecitos are sold in glass and metal caskets that represent Xavier's real silver and glass casket in Goa. Thus these little statues wear the brown habit of St. Francis of Assisi but lie in a glass casket like St. Francis Xavier's. The large, two- to four-foot-long replicas have no caskets but do have black-painted robes like Xavier's statue in the chapel at Magdalena. The pastors in Magdalena have insisted that the large replicas have black robes because these more expensive images are often bought for public shrines and churches, and the pastors want St. Francis Xavier portrayed accurately.

Regardless of the confusion between the two saints, the statues of Xavier at San Xavier and Magdalena are the physical foci of the cult of St. Francis in the region. His statue at Magdalena lies in the elaborate San Francisco *capilla* (or chapel), which was built onto the northwest corner of the church in 1977 and has Corinthian columns, a huge crystal chandelier, gold trim, and red velvet drapes on the wall. The statue is a reclining, life-size, gessoed wooden[47] image portraying the saint in his black Jesuit robe. The barefoot figure is also usually dressed in a black cloth robe with a white sash, and it lies in the saint's classic death pose on a white marble bier. The faithful have caressed the face and hair so much that in places the paint has been worn away.

In October 1981, Padre Santos told me the statue was carved in Guadalajara almost forty years before[48] and that it replaced the previous statue, destroyed in 1934 near the end of an eight-year conflict between the church and the Mexican government. Government officials had closed the church, and in an unsuccessful attempt to end the cult of San Francisco, Governor Rodolfo Elías Calles and other state officials "burned the sacred image in the ovens of the 'Cervecería de Sonora,' or Sonora Brewery."[49] Padre Santos lamented the loss of that more elaborate statue, which he said Padre Kino had ordered from Spain, and he shook his head in dismay, saying, "The other carvers who made the first statue were much better than this one." His concern, however, does not seem to be shared by the many pilgrims who visit the statue and leave their offerings on it.

During the San Francisco fiesta, all the streets near the church are transformed by the influx of thousands of pilgrims and by the smells of cooking fires, freshly brewed coffee, hot tortillas, and grilled meat drifting from dozens of makeshift outdoor restaurants. Mariachi bands stroll

Pilgrims posing for a Polaroid picture. Magdalena, 1985. (Photograph by the author)

by, eager to play a few songs. Vendors tempt people with everything from balloons, sneakers, and plastic dishpans to parrots, jewelry, and fine leather jackets. Herbalists hawk dozens of varieties of dried plants and sea life said to cure everything from sore throats to cancer. Tiny Mixteca Indian women silently hold out their wares—chewing gum, candy, and trinkets—and small, colorfully dressed Huichol Indian women beggars tug gently on pilgrims' clothes. A couple of sleight-of-hand artists and fortune tellers operate at the far ends of the plaza, and photographers with Polaroid cameras stay close to the church, offering to take people's pictures as mementos of their pilgrimage.

The thousands of people who take part in the early October pilgrimage to Magdalena become part of a collective religious experience in which they relate to one another on common ground, and social status temporarily becomes irrelevant. The well-to-do must take their turn with the poor, standing four abreast for more than an hour in the hot sun as the long line of pilgrims inches toward the chapel door. Once

inside, they all carry out similar acts of veneration to San Francisco.

United by their belief in and devotion to the saint, the pilgrims experience a sense of camaraderie, sometimes even sharing food with total strangers—including me. Late one afternoon at the 1985 fiesta, I sought relief from the heat in the shade of a low stone wall. Two Mexican women in their thirties sat down next to me, but I was too hot and tired to start a conversation and barely looked at them. A few minutes later, their husbands arrived with a large bottle of cold beer sticking out of a paper bag. Shyly, one of the women took the bottle and drank from it. Then, without a word, she passed it to me.

The celebrations at San Xavier lack the bustling markets and entertainment of Magdalena's fiesta but have more religious pageantry. The mission actually has two St. Francis celebrations, and a different statue of Xavier is honored and given milagros at each one. Unlike Xavier's statue in Magdalena, which always lies on its marble bier in the capilla, the two statues at San Xavier are moved by the local O'odham parishioners from their usual positions in the church to places where more people can easily touch them. They are also taken on processions outside the church.

At the mission, the Feast of St. Francis Xavier is celebrated on the official church date, December 3. The statue used is the mission's original Xavier statue, ordered from Mexico in 1759 by the resident Jesuit priest, Alonso Espinosa.[50] The beautiful five-foot-high, gessoed wooden representation usually stands in a niche above the center of the main altar. Its face and hands are painted flesh color, and its hair, moustache, and beard are black. The illusion of reality is enhanced by teeth made of bone or shell, eyes with brown glass irises, and a rich wardrobe of real underwear, a black biretta, a black Jesuit cassock, a white satin stole, and a surplice.[51]

Although the O'odham, Yaquis, and Mexican Americans revere this statue, they leave few milagros or other offerings on it, even when it is moved down to just inside the altar rail where they can easily reach it. During the celebration in 1992, people left fewer than twenty-five milagros by this image. Moreover, most of the offerings were left on a cloth at the statue's feet or in an O'odham basket beside the image; only a few were placed on the statue. Local people say that the inaccessibility of the statue the rest of the year may have long discouraged people from leaving milagros on it. People also say that perhaps because the statue's clothes

are so elaborate, the faithful hesitate to pin anything to them even when the image *is* accessible.

In contrast, the reclining statue that usually lies on the side altar in the west transept receives countless caresses all year long and nearly all the milagros and other offerings brought to St. Francis. Interestingly, this is also the statue used for the October 4 Feast of St. Francis, during which the friars celebrate the mass of St. Francis of Assisi, whose feast day it really is, but the laity honor the reclining statue of Xavier, just as in Magdalena.

As one priest in the area said, "The custom of using the statue of Xavier is part of the popular tradition because some people don't distinguish between the two Saints Francis. For them, this is just St. Francis, and however *we* [the church] distinguish it is irrelevant to them." He did not seem to mind at all that some people fuse the two saints, and instead said it fascinated him.

This statue was not even created as an image of St. Francis Xavier. The life-size wood statue probably was originally a figure of Christ on the Cross. No one even knows where it came from. But at some point, the bent legs of the crucified Christ were sawed off at the upper thighs, and the statue was converted to the reclining image of Xavier.[52]

Several things distinguish this statue. Instead of a black Jesuit robe, it is usually dressed in only underwear and a white surplice, with decorative blankets covering the image up to its shoulders to hide its missing limbs. Bare wood and cloth strips on the head show where the faithful have worn away most of the painted gesso surface by their constant touching and caressing.[53] Enclosing the statue on all but one side is a glass and wood casket. This casket is part of the classic representation of Xavier in this region, portraying the saint lying in his glass and silver casket in Goa, India.[54]

About a week before the celebration, members of one of the rotating Tohono O'odham Feast Committees[55] move the statue from its bier in the west transept, bathe it, and dress it in clean underwear and fresh clothes.[56] Then they lay it on a sheet-covered mattress on a cloth-draped table. They place the table in the crossing, in front of the altar,[57] an open area where more people can easily approach the statue.

The 1993 Feast Committee dressed the statue in a new white dress shirt, open at the collar. "They usually make a robe for him, but we

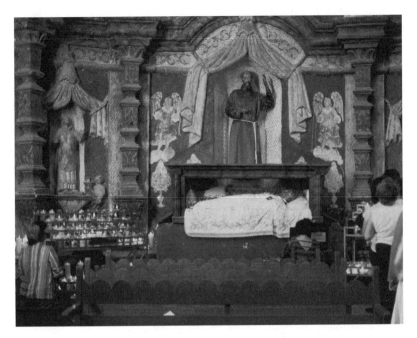

A woman kneels by the reclining statue of St. Francis Xavier while others wait patiently in line for their turn. Another woman kneels by a votive-candle stand after visiting the statue at Mission San Xavier, 1982. (Photograph by the author)

wanted to do something different," Mary Narcho, a member of the committee, told me. "We said, 'He's a man—why not put a man's shirt on him, and pants?' We thought *he* would like that. Because he's missing his legs and is always mostly covered by a blanket, they usually don't put pants on him—just shorts or long johns, depending on the weather. The pants we put on him are soft, like sweat pants, but lightweight, because it's so hot."

On October 4, the statue was covered up to its chest with a woman's fringed purple satin-polyester dance shawl. "For the last week he had a white blanket trimmed with gold that someone made," Narcho said. "But so many people came last night and touched it that it got dirty, so we changed it. I brought over a Pendleton blanket that's very special to me, but a lot of the elders didn't like it because it was too heavy for him in this heat. So I went and got my powwow dance shawl and put it on him. We treat the saint just like he was one of us. We treat the statues as though they were alive, although we know they're not."

During the day on October 3 and 4, several groups of O'odham sell hot food under ramadas in front of the mission. Recorded music plays softly at a few shops in the small arts and crafts plaza nearby, and O'odham fiddlers and bands play polka-like "chicken-scratch" music in the reservation's dance ramada, about 200 yards away. The bands entertain people, mostly O'odham, eating in the tribe's Feast House. In one room of the house, in front of an altar, O'odham pray and sing to honor St. Francis most of the day. That evening, everyone returns to the church to join a procession.

Many O'odham, Mexican Americans, and Yaqui Indians who cannot get to Magdalena for the October 4 feast day celebration go instead to San Xavier to pay their respects to St. Francis, pray to him, and leave milagros and other offerings on his statue. Even some people who *are* going to Magdalena turn off Interstate 19 and stop at the mission to visit this reclining image of the saint as well as the one in Magdalena.

A couple of days after the festival, members of the feast committee undress the statue, wash it, redress it, and place it back in its bier in the west transept for another year. Still pinned to the statue's clothes, pillows, and blanket are milagros—signs of prayers made to, and answered by, their favorite saint.

1

Offerings and Answered Prayers

At both Magdalena and San Xavier, more milagros are offered to St. Francis during the October celebration than at any other time of the year. In Magdalena, more than two thousand milagros are placed on his statue in that one week.

MAGDALENA

I first joined the multitudes honoring San Francisco in Magdalena on October 4, 1973, when Xavier's statue was still kept in the church.[1] The scene as I watched people bring their offerings to the saint was typical of what anyone might see there during the annual fiesta. Behind and in front of me, the endless line of Mexicans, Mexican Americans, Tohono O'odham, and Yaqui Indians pressed forward in the hot, stagnant air toward the life-size statue of San Francisco reclining on his white marble bier. From outside the church came the muffled sounds of carnival rides, mariachi bands, loud recorded religious music, and ringing church bells. Competing for attention were the loud voices of three blanket vendors

squawking through bullhorns to attract customers to the backs of their trucks. At times I could hear the gentler sounds of Yaqui Indian flutes, cocoon rattles, and water drums.[2]

Except for an occasional whisper, the faithful inside the church were silent. One heavyset Indian man, sweating from the heat and the strain, struggled to hold a little boy above the crowd so he could have a clear view of the statue they had traveled so far to see. The frail boy seemed to look at everything but the statue. Occasionally his eyes widened as Polaroid cameras flashed and photographers jostled for the attention of pilgrims who might want their pictures taken as they made their offerings to the saint.

When it was finally their turn, the Indian man lowered his son so the child could kiss the statue's lips. When the man stooped to kiss the statue himself, he began crying, and his tears fell on the statue's face. After caressing San Francisco's painted hair, he placed a gold milagro in the shape of a boy on the white satin pillow beneath the statue's head. As he turned to leave with his son in his arms, I saw a tumor bulging from the base of the boy's skull.

Pilgrims followed each other so closely that as the Indian man was kissing the statue's lips, a teen-aged Mexican boy was already caressing its legs. When the man stepped away, the youth lifted its head, but he lifted so hard, he hoisted the statue almost upright, pulling it sideways off the bier. Immediately, dozens of hands reached out to cradle the statue and gently lower it back to the bier. No one scolded the boy. A Mexican American woman standing next to me whispered, "People say being able to lift San Francisco's head is proof of your faith and lack of sin. Some people lift hard to make sure they move it." The pilgrims who next approached the statue stroked the image as if to calm and reassure it. Then they continued with their own devotions, kissing and caressing the statue and gently lifting its head.

Two Mexican women approached the statue and blessed themselves. The younger woman watched while the other took a milagro out of her handbag and carefully pinned it to the statue's black robe. Then both women kissed the statue and together lifted its head. The next three people dropped money into the donation box at the foot of the statue before they, too, kissed and caressed the image.

A middle-aged Mexican man, his wife, his mother, and his teenage

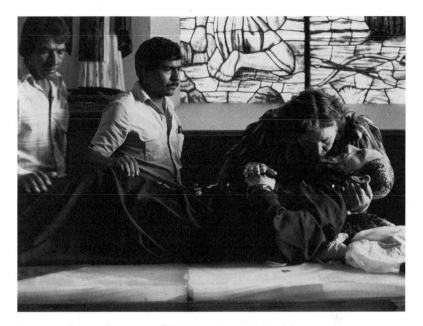

A woman kisses the statue of San Francisco at Magdalena as two men caress the statue's legs, 1985. (Photograph by the author)

daughter with Down's Syndrome approached the church doorway leading to the statue of San Francisco. Eight members of a mariachi band followed them. The family stood at the open doorway hugging each other while the mariachis played four religious songs to San Francisco. When the musicians finished, the man paid them, and the family approached the statue. The man took a silver milagro of a girl from his shirt pocket and pinned it to the statue's robe. Then his wife untied a brown paper parcel, pulled out a hábito, and rubbed it on the image. Next, one by one, they kissed the statue and lifted its head. Then they walked to the door of the church, where the three adults put the hábito on the girl. Finally, arm in arm, they disappeared into the crowd outside.

Then a Tohono O'odham family neared the statue. The woman cradled a new, two-foot-long statue of San Francisco, and her husband held a small, old, faded cuerpecito. As his wife rubbed their new statue against the church statue, the man placed their old cuerpecito on San Francisco's bier. A woman whispered to me, "That's what people do. When they buy a new statue of San Francisco they leave the old one here." The couple and their daughter kissed San Francisco, and the little

girl shyly placed four pieces of broken blue pottery and a silver milagro of a girl on his robe.

An elderly Mexican woman standing a few feet from the statue began silently weeping. I asked if she was crying because she was ill. She put her hand on my arm and sobbed, "It is my mother. She has been unable to walk for two years. The doctors can do nothing more so I have come to ask San Francisco to bring my mother relief. I am going to promise him two leg milagros if he will heal her legs. There have been many cures at Magdalena. I have come here every year of my life."

A group of four Yaqui men nearing the statue suddenly left the line and placed four large brown paper bags full of tall white votive candles next to a wrought-iron candle stand already filled with burning candles. Then the men hurried back to their place in line, kissed the statue, and lifted its head.

Behind them, two old Mexican women shuffled along, carrying statues wrapped in brown paper. When they reached San Francisco, they took so long to unwrap the statues that a church attendant reached over to tear the paper off. Unperturbed, the women carefully rubbed their statues against San Francisco and kissed the statue's face. They then took the brown paper back from the attendant, painstakingly rewrapped their statues, and slowly moved away.

Next, a young Mexican couple kissed the statue and placed two elaborately embroidered silk pillows by its head. As soon as they left, a thin, old church attendant in a gray workman's outfit snatched up the pillows. All day he had been removing the larger offerings—statues, pillows, candles, and bouquets—and dropping them into large galvanized metal pails. Periodically, other attendants took the full pails away and returned with empty ones.[3]

The old attendant continued watching the statue, his dark eyes intent. Whenever large amounts of money or expensive-looking milagros or jewelry were placed on the statue, he would wait until the people left, and then he would reach out, grab the offering, and drop it in the large, locked donation box beside him.

Just as a plainclothes policeman was telling me that these precautions are necessary, he suddenly grabbed a short man and pushed him against the chapel wall. As he handcuffed the older man, the policeman explained to onlookers that the man had just stolen a ten-dollar bill from

the hatband of the pilgrim in front of him, who had removed his hat in homage while waiting to offer his money to the saint.

The man who was robbed implored the policeman to let the thief go because it was San Francisco's feast day, but the policeman replied that he must arrest the man, and he wished a courteous *"Buenas noches"* as he forced the thief out the chapel door. Within seconds, the mood of the pilgrims returned to silent piety. No one even whispered about the event. All that seemed to matter was their visit to San Francisco. At least once an hour, *all* milagros were removed from the statue and placed in the donation box.

By 10 P.M., after the flood of thousands of pilgrims had dwindled to a trickle, the three attendants prepared to close the church for the night. A few minutes after the church was locked, a husky but exhausted-looking young Mexican American man crawled to the chapel door, his white cloth knee pads dark with dust and grime. He wore a baseball cap, and a white dress shirt hung partway out of his black slacks. An older man and woman—his *padrino* and *madrina* (godfather and godmother)— walked on either side of him.

When the young man reached the church door, he blessed himself and, with his padrino's help, stood up. He did not knock at the door or make any attempt to have it opened; he was resigned to wait until morning. As other pilgrims shook their heads in sympathy, he slowly walked away and his godparents followed.

The padrino told me that his godson had suffered many injuries in an automobile accident in Douglas, Arizona. When he regained consciousness, he promised San Francisco that if he recovered, he would walk the fourteen miles from Ímuris to Magdalena, then crawl to the church to offer a gold milagro of a car. By the time he had reached Magdalena, he was too tired to shop for the offering, so he planned to buy it the next day.

As I walked away from the church with the young man and his godparents, I saw an old, white-haired Mexican man hugging his gray-haired wife as they slept sitting up, propped against the church wall and lit by floodlights above. Colorful blankets, probably bought from one of the vendors, covered their legs and part of a shopping bag that held their possessions. Scores of other people, many wrapped in similar blankets and apparently unaffected by the noise of the fiesta, slept on the grass

around the church and plaza, and on the floor of the arcade. Like many pilgrims, they either could not find a room in Magdalena's few motels, or they simply could not afford one. Many Yaqui Indians were camping by the riverbank west of the church, and a number of O'odham were camped a few blocks east.

Most pilgrims, however, were not sleeping but instead were enjoying the carnival rides, music, fireworks, dancing, restaurants, and bars until early morning.

MISSION SAN XAVIER

That same night, a very different scene was unfolding at Mission San Xavier. There, the friars were observing the Feast of St. Francis of Assisi, while—in the very same celebration—the laity were honoring the reclining statue of St. Francis Xavier. As at Magdalena, the October St. Francis celebration at San Xavier is essentially the same year after year.

I last attended this celebration in 1993. For a week, many people traveled by car or on foot to visit the statue of Xavier, which the local Tohono O'odham Feast Committee had temporarily moved to a cloth-draped table in front of the altar rail. The pilgrims honor this statue just as the faithful honor his statue in Magdalena—by caressing it, kissing it, and lifting its head. They had also brought offerings of money, milagros, jewelry, hospital identification bracelets, driver's licenses, photographs, decorative pillows, clothes, hair, and hair ornaments. Most people visited the statue on October 3 and 4, the saint's vigil and feast days.

On the morning of October 4, one of the friars celebrated a special Mass for the Feast of St. Francis of Assisi. Afterward, the O'odham choir sang several songs, some in English, some in Spanish, all directed to a generalized St. Francis or San Francisco. Several O'odham bands also played to honor St. Francis. All day, people waited in long lines for their turn to venerate Xavier's statue and leave their offerings.

That evening, a couple thousand people gathered at the mission to take part in what many consider the celebration's main event: the seven o'clock procession that takes the statue outside the church. (A similar procession always takes place the night before, the vigil of the feast day.) A half-hour before the procession, even the aisles of the church were filled with people, and those who came later had to stand outside the open doors.

At the appointed hour, one of the friars emerged from the sacristy followed by five O'odham altar boys carrying a gold processional crucifix,[4] burning candles, holy water, incense, and a gold censer. The friar, Father Michael Dallmeier, read a benediction[5] before blessing St. Francis's statue with holy water. Adorning the statue were twenty-six milagros pinned to its white dress shirt and shawl.[6] Father Dallmeier then filled the censer with incense, lit it, and swung the smoking censer over the statue several times.

The men of the feast committee then lifted the statue onto a mattress on a wooden litter. The mattress was covered with white cloth; the litter was decorated with strips of white cloth, lace, and artificial roses. The men slid the statue from the table to the mattress as gently as nurses moving a patient from a hospital bed to a stretcher. Four of the men then hoisted the horizontal poles of the litter to their shoulders, and the procession was under way.

In the lead were Yaqui Indian *matachini* dancers[7] wearing crownlike headdresses with colorful paper streamers, and carrying wands and gourd rattles. Next came the statue, followed by the altar boys, the friar, and the other members of the feast committee. Falling into line behind them were a dozen members of the San Xavier choir, then all the people in the church, and finally, the crowd waiting outside.

As soon as the statue passed through the church doorway, the mission bells began ringing nonstop and fireworks filled the sky. For about twenty minutes, almost everyone followed the statue in a slow-moving, arc-shaped procession around the edge of the parking lot in front of the mission and then back inside. As the statue reentered the church, the bells were silenced. After the men returned the statue to the table, more pilgrims lined up to pay their respects while, outside, the matachinis danced.

By 10 P.M. the church was deserted, but a couple hundred people—mainly O'odham—had gathered by the dance ramada near the Feast House. Until early morning, couples of all ages would be dancing to the polka-like music of a chicken-scratch band.

After the procession, Father Dallmeier told me, "At shrines like San Xavier, you tend to see more popular expressions of people's faith than that which comes out of the institutional church. It's a very meaningful kind of practice for the people because it flows from their own life expe-

rience and expression of belief. So you let it happen and even encourage it. The popular faith and the official church faith go hand in hand, and one enriches the other."

THE MILAGRO TRADITION

The pilgrim who brings a milagro or other gift to St. Francis is ordinarily completing the last act of a widely practiced personal religious rite that begins when one seeks supernatural help to cure sickness or injury or to solve a major problem.

Some who seek help for health problems have already been to physicians, medicine men, herbalists, or possibly *curanderos*, or healers.[8] Some people promise milagros only after customary efforts have failed and a miracle is needed. Other people do not wait for traditional medicine to cure them but seek heavenly assistance at the same time. As one Mexican American woman told me, "We want to cover all the possibilities."

The church's belief in miracles is ingrained in almost every Catholic since childhood. As the Vatican Council of 1870 declared: "If anyone should say that no miracles can be performed . . . or that they can never be known with certainty, or that by them the divine origin of the Christian religion cannot be rightly proved, let him be anathema."[9]

When Catholics need divine assistance, they can make informal personal appeals directly to God, Jesus Christ, the Holy Spirit, or all three—together known as the Holy Trinity. Catholics can also make an indirect appeal to God through the Virgin Mary or other saints.[10] Because the saints are with God in Heaven, they can intercede with Him on the supplicant's behalf.[11] In Catholic Europe, Latin America, and some parts of the United States, this church-sanctioned plea is often combined with a folk custom in which the supplicant vows to carry out certain acts of devotion to God or a saint—such as offering a milagro—if his or her request is granted.

In southern Arizona and Mexico, this vow is popularly known as a *manda*, a Spanish word meaning "offer" or "proposal." A manda is an agreement, or contract, between a person and a celestial being. No priest need serve as an intermediary, and no witnesses are required. The manda can be made anytime and anywhere—at home, at work, in a hospital, on a battlefield, at a private shrine, or in a church.

Mandas are often made in the presence of a statue or other image of

the heavenly being whose help is being sought. Because this custom is not a part of orthodox Catholic ritual, the church has no rules for it. The act of making the manda, however, is frequently accompanied by conventional Catholic prayers, gifts of votive candles, or some other church-recognized act of devotion. The degree of ceremony accompanying the making of a manda depends on individual inclination and circumstances. A manda made at a moment of crisis is, understandably, apt to be done with much less ritual than one made for a cure for chronic illness or solution of a long-standing problem.

The very informality of this custom permits people to promise a wide variety of devotional acts. A person may promise to make a pilgrimage to a particular shrine; to crawl to the shrine from a certain place; to wear a hábito for weeks, months, or even a year or more; to complete a formal novena;[12] or to offer money, candles, flowers, jewelry, fancy pillows—or a milagro. Usually the manda includes two or more of these acts. When milagros or other gifts are promised, all of the effort, travel, time, and money necessary to obtain and bring them to the saint are considered part of the offering.

People commonly offer milagros, money, flowers, jewelry, and pillows at both Magdalena and San Xavier. However, wearing hábitos and leaving candles are more common at Magdalena. In fact, in Magdalena, candles are sometimes brought to the saint by the bagful, especially by Yaqui Indians from both sides of the border.[13]

Unless the devotional acts are to be carried out at a shrine at home, mandas almost always include a pilgrimage, sometimes on foot. Even if people can drive to the shrine, they consider the journey to be an offering. Although many people have reliable cars and can make the trip easily, poor people with undependable or dilapidated vehicles often make sacrifices to pay for car repairs so that they can make the trip. Others who are unable to fix their cars may take the risk of driving their vehicles anyway, which one Tohono O'odham referred to as "praying their cars to Magdalena." Somehow, though, these cars almost always make it. I have ridden to Magdalena in two vehicles that mechanics insisted would never make it there and back. A Mexican American mechanic who later worked on one of the cars said, "The only reason it made it was because it went to Magdalena. If it had gone anywhere else, it would have broken down."

In October 1982, I was standing in Nogales, Mexico, watching the annual procession of pilgrims on their way to Magdalena, when I noticed an old, faded Chevrolet with a serious oil leak preparing to head south. The car, one of hundreds of vehicles traveling to Magdalena that day, was loaded with an O'odham man, two women, and a young girl—and enough clothing, blankets, food, and firewood for their three-day excursion.[14]

One woman held a two-foot-tall statue of the Virgin Mary on her lap. She and the driver, who was wearing a black "Slave" T-shirt and black pants, were quick to smile when I saw their statue and asked if they were heading to Magdalena. The main reason for their trip was the young girl. She had become irritable about two months earlier and had been sleepwalking into the desert. They were hoping St. Francis would cure her.

The girl's father had survived a triple-bypass operation two years before and planned to buy a heart milagro. They were also bringing the statue to be "recharged" by St. Francis. An old cuerpecito in the back seat would be offered to St. Francis after they bought a larger one in Magdalena.

Like many other O'odham women making the pilgrimage to Magdalena, these two had spent months making and selling extra baskets to help pay for the trip to Magdalena. Whatever money was left at the end of their stay would be given to St. Francis.

The family had already traveled more than a hundred slow miles in ninety-degree heat from a tiny village on the Sells Reservation. As they headed down the old two-lane highway out of Nogales, other cars, including the one I was riding in, followed in a steady stream, waiting for a chance to pass. When we finally passed them, they recognized us and smiled and waved. Although I wondered if their car would break down, they later told me they were confident because they had prayed the car would make it to Magdalena. It did.

All along the sixty-mile stretch of highway between the border and Magdalena, other pilgrims were walking. (A few people had walked all the way from Tucson, another sixty-three miles north of the border.) There were women in slacks and blouses and others in dresses, some carrying brightly colored umbrellas to protect themselves from the sun. Men were dressed in everything from business suits to dungarees and

cowboy hats. Adults carried bulging shoulder bags and huge packs, water jugs, canteens, and coolers, and pieces of cardboard to shield babies from the sun. Most of the children carried plastic water bottles, too.

Those who found the journey difficult stopped at Red Cross tents set up to aid pilgrims. There they had their blisters cared for and their legs bandaged to stop the pain of cramps before continuing on their way. A woman from Nogales, Mexico, told me she once walked to Magdalena, and she said, "It's hard. Some twenty-four hours. The heat of the day between ten and four is the worst. Then sometimes the cold nights. You get terrible cramps. When I walked, I came with a group. Now I come alone, so I drive to Magdalena. I come every month."

Although a colleague counted 267 pilgrims walking as he drove south from Nogales that weekend, I was told that many more were walking the back roads, especially between Ímuris and Magdalena.[15] Some pilgrims trudge through the mountains on old wagon roads and dirt paths. One of them was Louisa, an O'odham woman from the Sells Reservation. Louisa told me she had wanted to make the pilgrimage to Magdalena by foot for years. In 1982, when she was forty-five, she finally did it. Her husband jokingly told her she was out of shape and that even if she got there, she would arrive too late for the festival.

Louisa was accompanied by her daughter, her eleven-year-old son, and five other O'odham. They had only sleeping bags, some tortillas, and a little water. When they ran out of water, they had to drink from ponds, and at first Louisa's daughter refused to drink pond water. "But I told her 'that's all there is,'" Louisa said. "When she got thirsty enough she drank it."

After passing Kitt Peak and the Baboquivari Mountains, they cut across the desert into Mexico on an old wagon route. Sometimes they walked at night, when the air was cooler. They had expected to reach Magdalena in three days, but the journey took four because one of the women was very heavy, and they had to stop often so she could rest. Louisa told me later that even though they were thirsty, sore, and exhausted, the first thing they did when they finally reached Magdalena was visit St. Francis, which is what most pilgrims do.

People also walk to Mission San Xavier, and they can be seen on Ajo Way, Valencia, and Mission Road almost any day of the year, but especially on weekends and holidays. But even those who extol the virtues of

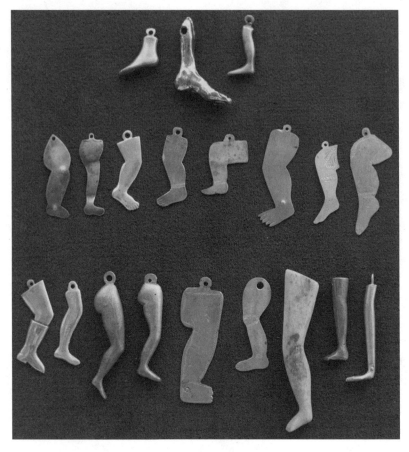

Foot and leg milagros offered at Magdalena. Note the hand-cast, half-face leg with a high gold boot *(bottom left)*. One milagro is bone *(bottom row, third from right)*. (Photograph by Helga Teiwes)

devotional acts such as walking to Magdalena or San Xavier are quick to say that the devotions of other pilgrims are just as likely to persuade a saint to help them. As a gray-haired woman from Hermosillo told me, "It does not matter which act of devotion you choose to fulfill as long as it is the same one promised in your manda."

A manda is normally very explicit, and when a milagro is promised, the supplicant specifies its exact qualities, including its material, design, workmanship, size, and possibly cost. If the request is granted, every effort is made to secure the exact milagro specified in the manda.

With very few exceptions, the milagros offered in this region are

metal, but milagros made of other materials such as wood, shell, or bone are acceptable offerings.[16] Many people say that "in the old days," people only offered "real gold" milagros. Although some of the faithful still believe that one should promise only milagros that are 14-karat gold, or at least sterling silver, most people are content to pledge less expensive mass-produced pieces. Some of these are moderately priced gold- or silver-plated offerings, described by vendors as "those that had a bath in gold or silver." Much more common are milagros that may look like solid gold or silver but are actually brass, nickel, or gold or silver alloys containing very little precious metal. Only a few people offer the cheap, flimsy offerings stamped in aluminum or copper foil, as thin as the cheapest aluminum foil used in the kitchen.

Any milagro, though, no matter how inexpensive or poorly made, is considered a worthy offering. The petitioner must present the exact type of milagro promised in his manda, but most people believe the quality or cost of the offering will not determine whether one's prayers are answered, and in fact some people fear that expensive milagros may be stolen from the statue. Consequently, they may promise a cheaper milagro as well as money that they can leave in a nearby locked donation box.

Most people promise to complete their mandas on the feast day of their chosen saint. If for some reason they cannot do it on that day, they try to complete the manda as close to the feast day as possible. People are more relaxed about this at San Xavier than at Magdalena. October 4 fell on a Monday in 1993, and more milagros were left at the mission on Sunday, the day before. The local O'odham said it was because more people were able to travel then. Some people believe it is acceptable to complete a manda any time during the week preceding or following the feast day.

With the help of Señora Consuelo Ochoa Cantua, an older Mexican woman who proudly told me she has been "watching over San Francisco's statue for forty years," I was able to count the 1,300 milagros that were offered at Magdalena during the seven-day fiesta in 1992. More than half were left on October 4, 150 were left on the eve of the feast, and 101 the day after. Fewer than 100 milagros were offered on each of the other days.[17] Although the feast fell on a Sunday that year, Señora Ochoa said that far more milagros are *always* left on October 4, no matter what day of the week it falls on.

Some people promise to carry out their mandas not on the saint's

feast day but as soon as their request is granted. That is why, on any day of the year, a pilgrim can be seen quietly entering a church or shrine and bringing the saint candles, coins, a bouquet of flowers, a milagro, or other gift.

On one cool April morning in 1974, I watched a young Mexican woman and her husband enter the deserted church at Magdalena. The woman's hair was as short as his. As they approached San Francisco's statue, the woman unfolded a bright green scarf from which she lifted a long black braid of hair. Attached to the braid with a white ribbon was a silver milagro of a baby, and the woman placed the offering on the statue's abdomen. The couple lingered for a moment, then reverently kissed the figure's forehead and left in silence. Outside the church, they told me that San Francisco had answered her prayer for a pregnancy. Instead of waiting until the saint's feast day, they had rushed to Magdalena the day after a doctor confirmed that she was pregnant.

Petitions and mandas can be made not only for oneself but also on behalf of other people. Mandas are also made for pets, farm animals, and even inanimate objects such as cars, trucks, and houses. Although a manda is usually made by an individual, a group of people may make and fulfill one together. When they believe their prayers have been answered, they may pool their money to buy a large milagro and travel together to present it to the saint.

There is no limit to the number of mandas a person may make, nor is it necessary to complete one manda before making another. A person can also make several mandas at one time, either to one or more saints. Since different saints are known to help in different situations, a person may feel the need to beseech several of them. Because St. Francis is the popular patron saint of the Sonoran region, many people ask him to help them with *all* their problems. This explains why some pilgrims bring him several milagros at once, usually attached to each other by a safety pin, string, or ribbon. At San Xavier, I once found seven gold offerings on one safety pin: a left leg, a right leg, a kneeling woman, a right leg, another kneeling woman, a left leg, and yet another kneeling woman. A pilgrim next to me speculated that the offering represented three women with leg problems and that the donor wanted St. Francis to know which leg or legs belonged to which woman.

Petitioners almost always complete their mandas if their pleas have been answered. Not to do so would be to risk divine retribution or, at the very least, the loss of the saint's support in the future. In March 1993, Josefina Lizárraga, who sells milagros at her store in Tucson, told me, "Today an Anglo lady came in with the cutest little blond boy, three years old. She said she was in her late forties when she got pregnant and had a lot of problems with the pregnancy, so she promised St. Francis, if the baby came up okay, she'd bring him $200, a milagro, and a candle. But she never brought them. Now the little boy is sick, and she thinks St. Francis is collecting the debt. She bought a gold boy milagro from me and said, 'I just got my income tax refund, so I'm going to take St. Francis the $200 and the milagro I owe him.' She was on her way down to the mission after she stopped here."

However, if a person is truly unable to complete his manda alone, it is permissible for relatives and friends to help. They can provide money to buy the milagro or to pay for the pilgrimage. They can also help shop for the offering or even buy it and, if necessary, deliver it to the saint on the petitioner's behalf.

In 1981, on the night of the feast day, I met a Mexican woman in the Magdalena depot waiting for the bus to Hermosillo, 117 miles south. She had three young children in tow, and an old woman, wobbling on her feet, clung to her arm. The younger woman told me, "My mother made a promise to come to Magdalena on this day, and she could not make the trip alone, so I had to take off from work to bring her here.... After my mother brought her milagro to San Francisco, we had something to eat and then tried to find a place to stay. We've been walking around since five and can't find a room, so now we're going back home." There was no resentment in her voice, and her facial expression and matter-of-fact manner indicated she was content just to have been able to help her mother complete her manda.

Many of the faithful are eager to help someone obtain a milagro. Whenever I expressed interest, people who used milagros would assume I needed one for a manda, and they would enthusiastically offer to help find it. One woman, a Mexican American executive at a Tucson health clinic, surprised me by offering to have her husband drive me sixty-five miles to Nogales, Mexico, the following Saturday to buy a "nice" mila-

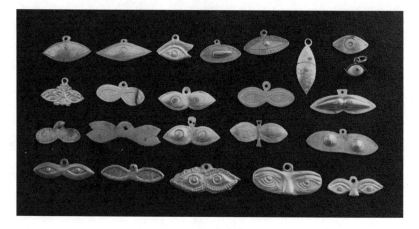

Silver eye milagros offered at Magdalena. One has a glass cornea and blue iris (*far right, second from top*). (Photograph by Helga Teiwes)

gro. "He won't mind at all," she said. "And my husband knows where to get a decent-looking milagro at the best price. He'll take you to the shops farthest from the border."

On another occasion, an Acapulco taxi driver, when I had asked where I might find the best milagros for sale, said there was no need for me to go back to the city, which was fifteen miles from my hotel. He said that if I told him what kind of milagro I wanted, he would buy it himself and deliver it to me on his next trip to the hotel. Having discovered I was childless, the driver was positive that what I really wanted was a milagro of a baby, and he insisted that he would bring me a baby milagro the next day, but I finally convinced him I just studied milagros.

Even if a request is only partly granted, a petitioner will usually complete a manda. Toward the end of one feast day, I noticed a slightly cross-eyed young Mexican girl clinging tightly to her mother's side in the crowded Magdalena bus depot, frightened by the horde of people shoving each other as they tried to buy tickets. The girl's mother told me that her daughter had been born cross-eyed. She had promised San Francisco that if the girl's third eye operation were successful, she would travel to Magdalena and bring him an eye milagro. Although her daughter's eyes were still slightly crossed, the woman had nevertheless decided that San Francisco had earned the milagro, and she had traveled ninety miles by bus to bring it to him.

One night in 1975, a small group of O'odham women were talking

during a cake-baking class at St. Catherine's Catholic school in Topawa on the Sells Reservation. They were discussing the upcoming Feast of St. Francis. One woman said, "You give St. Francis a silver leg and say, 'This is my leg—heal it!'" The nun who was teaching the class said Mexicans do it differently: they offer milagros not in supplication but only in thanksgiving. A gray-haired old O'odham woman replied good-naturedly, "Mexicans want action first. The Papagos have faith!"

When I first started studying milagros, most people told me it was "only the Papagos" who offered milagros in supplication. Since then, however, I have met many Mexicans and Mexican Americans, and some Yaqui Indians, who offered milagros when they first asked for help.

People also ask for help when giving a milagro in petition. In 1974, an O'odham woman born and raised on the San Xavier Reservation solemnly told me, "My mother's mother once asked me to go to Tucson to buy a foot milagro and bring it to St. Francis over at the mission for her. She suffered from diabetes and was on her way up to the Indian Health Service Hospital in Phoenix for treatment of an infected toe. She was afraid because the infection was spreading. But I was having a lot of problems in my life, so I kept putting it off." With great sadness in her voice, she continued, "I didn't think much of it until she came home with her leg amputated. I don't know if that is why it happened, but I never told my grandmother that I didn't bring the milagro for her."

A number of pilgrims have been traveling to San Xavier and Magdalena for years hoping for a cure. An elderly Mexican American man from Riverside, California, who continued to pray for a cure for a bad foot, told me in 1981 that he had gone to Magdalena every year since 1942. Others who went year after year include an ancient blind Yaqui man guided by his son; a crippled, hunchbacked Mexican man; a teenage Mexican boy with Down's syndrome; a slender, diabetic Mexican girl missing her right eye; and an old Yaqui man with only one leg. Some pray for a remission or cure of the disease. Others pray just for the fortitude to cope with their misfortune.

Although many pilgrims go away uncured, faith in miracles and in San Francisco is not easily lost. People know that the saint is only an intermediary, so they usually do not blame him if their prayers go unanswered. In 1982, Señora Josefina Gallegos, the *sacristana*[18] of the church of San Ignacio de Loyola, just north of Magdalena, recited a couplet that

her mother had taught her as a child: *"Si Dios no quiere, / El santo no puede"* (If God does not want it, / The saint cannot do it).

Most people do not blame God for not answering their prayers because they trust his judgment. A Mexican American woman from South Tucson told me, "When God or the saints do not answer your prayers, it is because they know what is best for you. If God had answered your prayers, you might have gone from bad to worse."

A few people do become annoyed or angry, and some may withhold their usual devotions or even attack a statue. Padre Santos of Magdalena said, "Some of the people treat [the statue of] San Francisco like another person. If he doesn't give them what they want, they break his fingers. . . . Parts of the statue have had to be replaced many times."[19] Actually, in this region, such behavior is rare. The vast majority of the faithful would never even think of harming the statue or any other religious image.

Even if a request is not granted, some people complete their vows anyway, perhaps hoping that the saint will reconsider their pleas or future prayers will be answered. In 1992, Señora María de Jesús Mares de Pérez, the owner of La Providencia, a gift shop in Nogales, Mexico, told me she was going to bring four milagros to El Santo Niño de Atocha[20] in Zacatecas, including one for her husband who had died a year and a half before. "I promised the milagro while he still lived," she said, "but even though he died, I'll bring it."

Buying and presenting a milagro are serious matters. Once purchased, a milagro is never treated lightheartedly or carelessly, and is rarely carried around openly. As soon as a milagro is bought, it is carefully wrapped in paper or cloth and tucked safely away in a pocket or handbag, or in the folds of a shawl. Some vendors provide a tiny envelope or bag for each milagro. Unless the offerer wants to show it to someone, the milagro is usually concealed until it is offered to the saint.

Sometimes a manda includes a promise to have the milagro blessed by a priest before it is placed on a statue or other sacred image. In Magdalena, whenever Padre Santos prepared for Mass during the Feast of St. Francis, he was surrounded by people who wanted him to bless their offerings of candles, jewelry, and milagros. Even as the padre and Archbishop Carlos Quintero Arce dressed for the mass of San Francisco Xavier in 1981, people lined up outside the open doorway of the sacristy,

waiting for a signal from the padre to enter and have things blessed. Both the padre and the archbishop showed great patience with these requests.[21] In fact, Padre Santos always seemed to allow extra time before Masses for blessing offerings. (Some priests in Tucson, including Father Cyprian Killackey, pastor of St. Margaret's Church, are known to bless milagros, but a few priests consider milagros part of a superstitious folk ritual and refuse to bless them.)

Some people bless their milagros themselves. When a customer asks Josefina Lizárraga (who sells milagros in Tucson) how to do it, she tells them to "go to the holy water fountain [font][22] in the church, put the water on it, and say, 'I bless you in the name of the Father, the Son, and the Holy Ghost.'" A vendor in Magdalena said, "Just say an Our Father over it and the milagro's blessed." Many other people believe that a milagro somehow becomes holy as soon as it is purchased with the intent of offering it to a saint or to God. Lizárraga said, "As soon as it's placed on the shrine or rubbed on the statue, it gets blessed by itself."

When a pilgrim is ready to offer a milagro, it is usually placed as close as possible to a statue or other representation of the saint. That is why almost all milagros have a tang, or projecting metal loop, through which a ribbon or string can be tied to hang the offering on or near the image. If the milagro is to be placed on a clothed statue, a safety pin is used. Vendors in Magdalena and Tucson, near shrines with clothed statues, often provide a small safety pin with each offering. At shrines where the statue or painting is inaccessible or protected by a glass case, milagros may be pinned on a special paper or cloth hanging nearby.

Knowing that offerings are removed periodically, some people try to conceal their milagros from the attendants' eyes by hiding them in the sleeves or folds of the statues' robes or blankets. A few people make special efforts to make removal difficult. At the 1993 October 4 celebration at San Xavier, one donor brought a needle and thread to sew a clear plastic bag containing a gold milagro to the purple shawl on Xavier's statue.

Most people know their offerings will be taken away eventually; they merely hope to keep their milagros near St. Francis's image as long as possible so they and their offerings will be uppermost in the saint's thoughts. (Many people believe the saints retain some of their earthly characteristics such as forgetfulness.) One woman told me, "The milagro is supposed to stay on the statue until you get your miracle." A

pilgrim at Magdalena told me, "Out of sight, out of mind. When your milagro is gone, St. Francis might forget you."

People who want to ensure that the saint will know and remember who brought the milagro and what it represents may have their names, initials, or other identification engraved or painted directly on the milagro. They might also attach their milagros to notes, to photographs of themselves, or to personal documents such as drivers' licenses. Milagros marked with the donors' names, initials, or other identification are more common at Magdalena than at San Xavier.

One of the more elaborate milagros of this type is a 13-by-16-inch wooden model of a fishing boat.[23] This milagro, by far the largest I have seen in the region, is painted white with blue doors and red and black trim, and a purple fishing net hangs from the rigging. The name of the boat, "BANFOCO-6," and the designation "G-6" are painted in blue on the bow. A date, "29 Junio 1971," and the home port, "Guaymas, Son. [Sonora]," are printed with blue paint on the model's unpainted wooden base. When Padre Santos showed me this colorful offering, he said, "Probably it was offered by a fisherman whose boat was saved in a storm.

Large painted wooden fishing boat and stand offered at Magdalena. (Photograph by Helga Teiwes)

Herbie Martinez wearing a heart milagro. Sells Papago Indian Reservation, 1985. (Photograph by the author)

Or maybe he wanted to thank San Francisco for a year of good fishing or for finally getting the money to buy a real boat."

Other milagros at Magdalena inscribed with names, dates, or symbols include a gold anatomy book, a gold automobile license plate, and a silver horse with a brand on its left flank. Donors' names and initials are also engraved on several whole-body and body-part milagros at Magdalena. A two-dimensional silver man in a uniform has the word "con- ductor" inscribed on his cap, and the initials "t.m.g." beneath his feet.

Virtually no milagros at San Xavier are marked with identification. In fact, only two of the 3,045 milagros offered there between 1969 and 1974 are inscribed. On the other hand, milagros attached to notes, photographs, or other means of identification are much more common at San Xavier than at Magdalena. Most notes contain a prayer or a message to the saint.

One note that I have always remembered was attached to a silver kneeling-woman milagro on St. Francis's statue in 1974. It read simply, "Please give me the strength and courage just to keep on going." Attaching such notes to milagros is eminently rational for Catholic donors, who believe that the saints represented by the statues are able to read

their letters.[24] The faithful believe the notes will clarify exactly why they left the milagro and will continue to remind the saint of their request or their gratitude.

All of the photographs I have seen attached to milagros portray people. Many are in color. Although most portray the whole person, few show any signs of illness, injury, or deformity. A photograph pinned to a silver kneeling woman at San Xavier on March 23, 1993, is typical. The 4-by-6-inch color print depicted a robust, smiling, dark-complected gray-haired woman in high heels and a bright pink pantsuit. She was posing by a stairway outside an expensive-looking red brick condominium.

In some cases, the photographs portray healthy people because the offerings were made in thanksgiving and the photographs were taken after the people recovered. In other cases, the pictures were probably taken before the disease or calamity struck. Photographs portraying happy, healthy people may also reflect the state of being to which they hope to return.

On rare occasions, someone might promise to carry a milagro for a certain period, perhaps in a pocket or wallet, on a neck chain, or pinned or sewn to clothing.[25] In these cases, he or she will rub the milagro against the statue of the saint before wearing it. When I was discussing this custom with Edith and Herbie Martinez at their home on the Sells Reservation, Herbie suddenly excused himself and went into their bedroom. When he reappeared, he wore a big smile and a leather flight jacket with a heart milagro pinned to it. He said that when he had a heart operation in 1980, doctors told him he would live five to seven years at most. To lengthen his life, he bought the heart milagro during the feast at Magdalena in 1982 and rubbed it on the statue of San Francisco before he began wearing it. In 1987, seven years after his operation, he brought it back to Magdalena and left it on the statue.

2

Offering Sites throughout the Sonoran Region

Milagros are offered not just at San Xavier and Magdalena, the two major shrines in the region. So popular is the custom that they are left at literally hundreds of private household shrines and at least thirty-two other public sites, including nineteen churches, three Catholic hospitals, four residential shrines, four roadside shrines, and even a tomb—all of which I visited in March 1993.[1]

Although it is unlikely people will stop bringing milagros to San Xavier and Magdalena, the number and frequency of offerings at the lesser sites do change. Over the years, offerings at some sites declined or even ceased temporarily, perhaps because of outside influences such as crime or vandalism, or due to people's individual decisions that the custom was old-fashioned or unnecessary because modern medicine and technology were available. Those who continued to make mandas may have decided to promise the saints money, an equally worthy offering, but one that requires less time and effort than offering a milagro. Occasionally, offer-

ings increased at some sites, often in response to a far-reaching phenomenon such as war.

Not only have offering patterns changed, but the shrines themselves change over time. Some have been vandalized, but at other shrines, people have tried to beautify the statues and the settings where people bring their offerings.

CHURCHES IN TUCSON

People bring milagros to four Roman Catholic churches in Tucson: St. Margaret's, Holy Family Church, Santa Cruz, and St. Anthony's Chapel. All of them have many Mexican Americans in their congregations.

St. Margaret's Church

Except for Mission San Xavier, more milagros are brought to St. Margaret's Church on North Grande Avenue than any other site in Tucson. The relatively new, white-painted brick church, built in 1956, is on the northern end of a predominantly Mexican American part of the city.

Since the church opened almost forty years ago, people have brought their offerings to a 26-by-11-foot alcove on the right side of the church. Inside this immaculate room are ten life-size or half-life-size painted statues looking out from atop wooden pedestals that are almost 3 feet high. Dominating the scene is a nearly life-size statue of the Sacred Heart of Jesus, whose most striking feature is an exposed red heart on the figure's cream-colored robe.

Facing the statue is a kneeling statue of the church's patron saint, St. Margaret Mary Alacoque, the seventeenth-century French nun who popularized devotion to the Sacred Heart of Jesus after experiencing a vision.[2] Flanking the image of Jesus, on three of the walls, are statues of St. Jude, St. Joseph, St. Anthony, St. Thérèse, the Infant of Prague, and three representations of the Virgin: the Immaculate Conception, the Sorrowing Mother, and Our Lady of Mount Carmel.[3]

For Adelina Aros, a middle-aged Mexican American woman who is the former treasurer of the St. Margaret's Sacred Heart Society, the alcove is "a solitary place, away from everything else in the world, where you just feel totally surrounded by the statues." Aros says people used to leave milagros on all ten statues, as well as on a painting of Our Lady

of Guadalupe.[4] Now, she says, most people promise their milagros only to the Sacred Heart of Jesus, St. Jude, or the Infant of Prague.

Aros and others say that the faithful hardly ever put milagros directly on the statues because in recent years, many offerings were stolen. Instead, most people leave their milagros with a member of the Sacred Heart Society, or with a priest or the secretary in the rectory. The offerings are then added to a large display of milagros protected by an 8½-foot-high wrought-iron grill with a locked gate. The grill was originally built to protect the statue of the Infant of Prague, which was twice stolen from the church and is still missing its solid-gold crown. The unusual, dark-complected 2-foot-high statue was brought from Spain by Father Francisco Xavier in the mid-1940s. Also behind the grill are statues of the Immaculate Conception and St. Thérèse.

The milagros hang from plain pins on two white foamboard panels behind the Infant of Prague, one on each side. Each of the 2-foot-wide, 6-foot-high panels is trimmed with gold foil and decorated with five gold-foil crosses along the top. If the offerer states which statue the milagro is intended for, the offering is pinned on the panel closest to it.

"If someone says 'It's for the Sacred Heart of Jesus,' we put it on the panel on that side. I say to them, 'It's right there, and He can see it,'" said Aros, who made the original display in 1990 using 150 milagros that people had left on the statues over the years. She recalled that when she joined the Sacred Heart Society thirty years before, "There were a lot of milagros in boxes and just loose in drawers in a back room of the church. . . . We would have had the panels full with all the milagros we had here over the years, but half of what was here was lost. Now what's left is saved. I hope to see the panels full some day."

In March 1993, more than two hundred offerings decorated only half of the panels, but such a large display is uncommon. Although similar wall displays are common in churches in some parts of Mexico and Europe, this is the only one I am aware of in the Pimería Alta.

Almost half the milagros in the display at St. Margaret's represented whole people.[5] Three-quarters of those (74) were kneeling men and women; only one figure, a man, was portrayed standing. The rest were milagros of children, including three infants. Except for two houses, all of the others were body parts, mostly legs and heads but also thirteen

left feet.[6] There were only seven copper milagros. The rest were gold and silver offerings, numbering 105 and 104, respectively.

Holy Family Church

Another collection of milagros that keeps growing is at Holy Family Church, less than a mile east of St. Margaret's on University Boulevard. The display, a collection of milagros offered over the past several decades, used to hang inside the eighty-year-old adobe and white plaster church. Once again, though, fears that the offerings might be stolen led to a decision to place the collection in the church office next door.

When I saw the collection in March 1993, the red velvet lining of the wood display case was almost completely covered with 160 milagros, including slightly more body parts than whole figures. Victoria Orosco, the church secretary, says that people occasionally bring their milagros to the church office and ask her to put them in the case. A few other people still leave them on the statues in the church, but Orosco moves them to the display case for safekeeping. The only milagro in the church that day was a silver head of a woman—hanging eight feet above the floor on a statue of the Virgin holding the infant Jesus, meaning someone had to climb on the altar, or be lifted up, or use a ladder to place the milagro there.

Santa Cruz Church

A handsome white plaster structure with a 90-foot bell tower, Santa Cruz Church on South Sixth Avenue is in another predominantly Mexican American area. In the church's walled front courtyard stands a life-size white plaster crucifix. On March 6, 1993, there were at least a dozen milagros jammed between the Christ figure's loincloth and the almost 8-foot-high plaster cross. Four vases of fresh flowers and nine votive candles burning in colorful glass holders in front of the crucifix heightened the feeling that this is a frequently used offering site.

Inside the church, five of the eight milagros were safety-pinned to the pink satin robe and cloak of a finely detailed statue of the Infant of Prague. Brother Angel Brinque told me the statue was brought from Barcelona, Spain, fifty or sixty years earlier. Another milagro, a gold heart, was glued to the glass protecting a 41-inch-high blue-and-gold litho-

graph of Our Lady of Guadalupe. Two double-eye milagros, one gold and one silver, hung from a nail driven beneath a windowsill on the right wall of the church, and they looked like the same milagros I had seen the year before on a gold-framed picture of St. Lucy, which Father Stephen Watson said was stolen from the church about 1991 or early 1992.[7]

St. Anthony's Chapel

Ironically, the statue with the most milagros on it is not in a parish church but in St. Anthony's Chapel, a small beige cement-block building on Thirty-Fourth Street in South Tucson, a separate municipality with a majority of Mexican American residents.

On March 20, 1993, there were two girl milagros and exactly 100 eye milagros on the painted, 42-inch statue of St. Lucy. Not only did this statue have more milagros on it than I have ever seen at one time in the Tucson-Magdalena corridor, it was also the only statue in Tucson with virtually only one type of milagro on it. Most of the offerings hung on colorful ribbons and strings, but one was stuck between two startlingly realistic raised glass eyeballs on a white plate in the statue's left hand. The eyeballs, complete with red-painted plaster blood vessels, provided a sharp contrast to the serenely beautiful statue with its long black hair, brown glass eyes, gold-trimmed green robe, peach cloak, and gold shoes.

According to legend, Lucy tore her eyes out to discourage a suitor, because she had already vowed to God to remain chaste. Miraculously, her eyes grew back more beautiful than before.[8] The eyeballs on the plate represent her old eyes. In the Magdalena–San Xavier corridor, St. Lucy is second only to St. Francis in the number of milagros she is offered. Many people pray to St. Francis for health, but St. Lucy has such a strong reputation for curing eye problems that some of the faithful turn to her when faced with this difficulty.

Betty Galaz, the secretary at Santa Cruz Church, told me that her mother, who believed in "Santa Lucía," was given a pair of silver eyes before going for a cataract operation in 1978. "She wanted to put it on a Santa Lucía statue, so we were looking for a church that had one. She was too old to go to San Ignacio [in Sonora], so Father Cyprian [Killackey], who was here at the time, told us about the statue at St. Anthony's. So we brought it there."

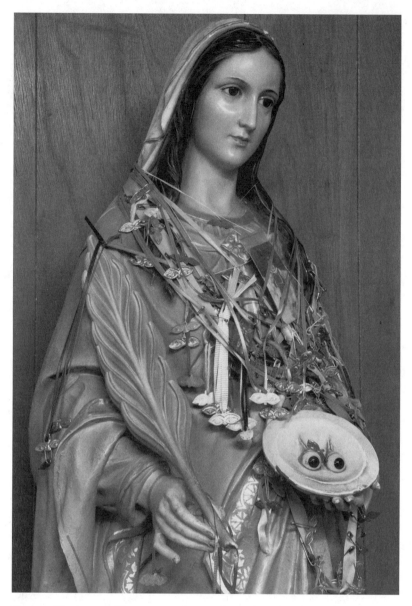

Statue of St. Lucy with 100 eye milagros. St. Anthony's Chapel, Tucson, 1993.
(Photograph by the author)

People in the barrio near St. Anthony's Chapel also have great devotion to St. Lucy. As one Mexican American woman there told me, "We know God is our boss but we *love* St. Lucy."

Thirteen other milagros were hanging on three other statues, with eleven of them on a statue of St. Anthony, the patron saint of the chapel who is holding the infant Jesus. Two milagros were on the Sacred Heart of Jesus, and one was on the Infant of Prague.

YAQUI INDIAN CHAPELS

Milagros are offered at two chapels in Yaqui Indian villages in Tucson. In Old Pascua, on the west side of the city, the white stucco San Ignacio Chapel and its twin bell towers stand out vividly against the nearby Tucson Mountains. The open front of the chapel allows people to see the statues inside, but a pale blue folding metal gate protects them from vandalism. When people want to make offerings, the gate is opened by an employee of the nearby Pascua Neighborhood Center. Although there were no milagros on the day of my visit, several Yaquis told me that they are still offered occasionally on several of the statues of saints, the Virgin, and Christ on several altars placed along the length of the chapel's back wall.

The other Yaqui chapel, San Martín de Porres,[9] is located on West Thirty-Ninth Street in Barrio Libre, in South Tucson. Somehow the chapel has always seemed peaceful even though an elevated section of Interstate 10 and two huge billboards loom behind it.

On April 1, 1993, the completely open front side of the white adobe chapel revealed many statues along the rear wall. Dominating the scene in the center was the life-size statue of the chapel's patron saint, San Martín de Porres. The day I was there, only a single gold milagro in the shape of a left hand hung from San Martín's neck. A Yaqui nurse praying by a 4½-foot-long reclining statue of St. Francis Xavier told me, "Sometimes there are more milagros here. Usually they're on San Martín, San Francisco, and San Judas [St. Jude]."

The statue of San Martín was stolen that fall. The following April, vandals destroyed all of the remaining statues. Anselmo Valencia, the Yaqui spiritual leader, told me that the Yaquis had asked for donations of new statues and had erected a 7-foot-high black wrought-iron gate across the chapel entrance. José Matus, who leads Yaqui ceremonies at

the chapel, said, "I didn't want to put the gate up, because it's not very pretty. But now we don't trust anyone. We open it during the day so people can go in. But as soon as the sun goes down, we lock it up."

HOSPITALS IN TUCSON

Milagros are also brought to Tucson's two Catholic hospitals. On the southwest side is St. Mary's. The significantly higher percentage of Mexican American and Indian patients at St. Mary's probably explains why people leave more offerings there than at St. Joseph's on the east side.

At St. Mary's, most people bring their offerings to the 2-foot-high statue of the Infant of Prague in the pediatrics unit. The blond-haired, brown-eyed statue used to stand on a low, white wooden cabinet in front of a large window with a view of the Santa Catalina Mountains. In early 1993, however, a child knocked the statue over. Someone caught it before it hit the floor, and the nurses put it on top of a filing cabinet in their conference room until they could find a way to display it more safely.

On March 3, 1993, thirty-five milagros hung on the statue. It had been dressed in a red satin robe and cloak by a woman who had made a manda to change its garments every three months. All but two offerings dangled from a strand of thin blue plastic-coated wire looped around the statue's neck. Sister Alberta Cammack, the hospital archivist, told me that this milagro "necklace" was her idea.

In July 1990, I had seen thirty-six milagros, twenty-eight photographs, and nineteen notes of thanksgiving written in Spanish to the Infant of Prague or God, all attached to the statue's cape with safety pins. Sister Alberta told me that just a few weeks later, she went to look at the Infant of Prague, "and it didn't look very good. So I strung the milagros on a wire and hung it around the statue's neck." She did not know what had happened to the photographs and handwritten notes, which someone else had removed.

Milagros also appear occasionally on a colorful statue of the Virgin of Guadalupe and other statues and religious pictures in the hospital. "It always surprises you," Sister Alberta said. "You can find them anywhere. We are always discovering evidence of old devotions and traditions."

The milagros left at St. Joseph's Hospital are usually pinned to the clothes on another 2-foot-high statue of the Infant of Prague. The statue stands on a green-and-gold pedestal mounted on the wall of a small

alcove near the birthing rooms. On March 6, two milagros and three Miraculous Medals[10] were pinned to its new white satin brocade robe and emerald-green satin cloak. Both milagros were infants—one gold, one gold foil.

Sometimes milagros are also offered by the statue of St. Catherine on the fifth floor and on the statue of St. Martin de Porres in the new east lobby.

PRIVATE SHRINES

Milagros are also offered in private homes, including the houses of faith healers and Indian curanderos, who usually have at least one statue or holy picture on which to hang milagros. But many Mexicans, Mexican Americans, and Indians place milagros on statues in their own household shrines.

Adelina Aros, who sells milagros at St. Margaret's Church, said, "Lots of people buy milagros from me to put on their statues at home. I have a statue of Jesus and I have put three gold milagros on it—a kneeling woman, a pair of eyes, and a pierced heart. I offered all of them in petition, and Jesus granted all three requests."

Most household shrines are intended for family use, but if prayers are answered, and word of the "miracles" gets out, friends and neighbors may ask if they, too, may pray and leave offerings at the shrine. "A few other people bring milagros to my statue," Aros said. "And some have sent milagros in the mail to put on it. They either heard about it or saw it when I put it in the front window during the Christmas *posadas*."[11]

Aros's statue is a 35-inch-high image of Jesus Scourged, representing Christ after he was flogged on the day he was crucified. The painted plaster statue is very realistic, with detailed facial features, brown glass eyes, and blood dripping from gaping wounds all over its body. Usually the body is draped with a piece of red velvet. When Aros removed the velvet, she looked at me and said, "The sight of the statue shocks you and it stays with you."

The statue stands in an illuminated niche built into Aros's bedroom wall. In March 1993, twenty-eight milagros hung on the left wall of the niche, and Aros told me she always keeps fresh flowers in front of it.

Aros remembers that she first saw the statue in the Benedictine convent that used to be on Main Street. "When I was a child, I used to go

there and pray and ask Him to grant my wishes—that my father, who had been in the hospital sixteen months, would have his health restored, and for other things, like a new pair of shoes, because I was barefoot. He granted all my wishes, and I promised Him that someday when I grew up and worked, He would be mine because I was going to buy Him—which I did in 1953. Sisters at the convent gave me the address of a statue company in Chicago, and I sent for Him. Since then, so many wishes have been granted because of Him."

Yard Shrines

Some families leave milagros in shrines in their front or side yards. Like household shrines, these are usually intended primarily for the use of the family. However, at least three families in Tucson have opened their side-yard shrines to the public, and they permit anyone to pray or leave offerings there. Like Adelina Aros, the owners of these shrines say that if money is left as an offering, they either give it to charities or use it for maintenance or improvement of the site. The three shrines are so popular that Father Killackey of St. Margaret's Church says a Mass at each of them on the annual feast days of the particular saints they honor.

People have been bringing milagros to Edith Clark Espino's shrine of St. Jude since 1962, a year after her husband Antonio and a friend built it to help fulfill her manda.[12] Espino, a petite and lively older Mexican American woman who has dressed in black since her husband's death in May 1992, said she made the manda to get the loan to buy her present home.

Espino recalled that "one day my father came over and said, 'I'm going to sell my house and I'm going to give you the first chance to buy it. I'll give you five days to get the money.' I always wished I could live there because there was plenty of room, an acre or more, and it was a nice house. But my husband said, 'No one will give us a loan.' I told my husband to have faith because St. Jude is king of the impossible. I began praying to St. Jude, and I prayed with my whole heart. The third day, we got the loan, and we were able to pay my father cash."

At first, they built just a small shrine. "We couldn't build the big shrine right away, so I told my husband to build the small one you see on the corner of the house," she said, pointing to a 15-inch-high statue of St. Jude in a niche lit by a string of Christmas lights. "I was sick at the

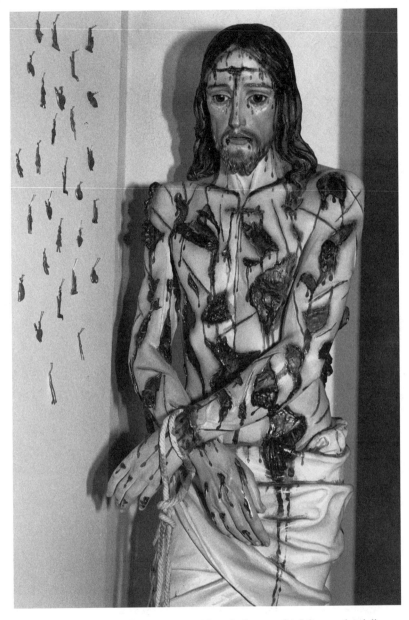

Milagros and a statue of Jesus Scourged in the home of Adelina and Adalberto Aros. Tucson, 1993. (Photograph by the author)

time and I told him that if I went away [died], then at least I'd have half the manda completed."

The larger shrine, on a residential street on the south side, used to have a green sign saying, "St. Jude / St. Judas / Winter Hours 9 A.M. to 6 P.M. / Summer Hours 8:30 A.M. to 8 P.M." After Espino's husband died, however, she was bothered by loiterers, so she took down the sign and locked her gate. "Now people just have to know where the shrine is," she said, after apologizing several times for keeping the gate locked.

Behind a 5-foot cyclone fence, amid trees and plants and the sound of wind chimes, is a carport-sized ramada with black wrought-iron posts, wooden joists, and a corrugated tin roof. Strings of small, colored Chinese electric lanterns hang in rows between the joists. Sheltered beneath the ramada is a handmade stone and concrete grotto dedicated to St. Jude. In front of the grotto are five wooden kneelers—benches with knee and arm rests for prayer—on a green-and-gold shag carpet.

The 5-foot-high grotto has a small stone-and-concrete cross on top, and a ceiling vent to draw the smoke from votive candles. The outside of the grotto is covered with bouquets of plastic flowers. Inside the grotto are busts of St. Jude, Christ, and the Sorrowing Virgin. In the center stands a 41-inch painted plaster statue of St. Jude with a light green robe, brown cloak, and brown glass eyes, which Espino had put in to make the statue more realistic.

The statue is protected by a locked wrought-iron gate across the front of the grotto. "Twenty years ago," Espino said, "I came home one day and someone who was trying to steal St. Jude already had him moved part way out of the grotto, so I had to put the gate up." Espino pointed to a fluorescent light and strings of colored Christmas lights illuminating the statue and said, "See, there's perpetual light for him. Twenty-four hours. He's never in the dark. That was part of my promise."

On March 5, 1993, there were four offerings in the grotto: a lock of brown hair, a brown hábito, and two gold milagros—a kneeling man and a pair of women's breasts—both hanging from strings around the statue's neck.

Another yard shrine where people leave milagros is beside a one-story yellow stucco house in a mostly Mexican American neighborhood just west of the Santa Cruz River. In the shade of a partly enclosed ramada is Pauline Romo's El Señor de los Milagros (the Lord of the Miracles).

The one-foot-high wood crucifix with a painted Christ figure is inside a white concrete niche protected by a bullet-proof glass window and an elaborate, locked wrought-iron fence.[13]

Romo said the crucifix is about four hundred years old and has been passed down through fifteen generations of her family. "It has worked many miracles for us. My mother had the crucifix with her when she was coming from Mexico to the United States in 1918. In Guaymas [Mexico] there was an Indian attack. My relatives were the only ones who survived."

Romo said "only some people leave milagros," but on March 3, more than a hundred[14] were hanging from two boards wrapped in white cloth, one on each side of the crucifix. The board to the left held more gold than silver offerings, the other more silver than gold.

The largest side-yard shrine where people leave milagros is owned by Jimmy Campbell, a tough-looking but friendly man affectionately called *"Chapo"* (a Mexican Spanish nickname for a short, stout person). Located on District Street on Tucson's south side, the shrine is marked by a white wood sign with red letters saying "Santa / TERESITA / CHAPEL / OPEN TO THE PUBLIC." For the convenience of people who arrive at night—some as late as midnight—there is also an illuminated sign, framed in metal and protected behind glass, identifying the shrine as the "CHAPEL OF SAINT THERESA." A gate to the left of Campbell's house opens onto a worn, grassy area. The chapel, a garage-size white building made of concrete block, has a 3-foot-high cross on its peaked roof. At night, the white cross is illuminated by a string of colored Christmas lights.

Campbell has done his best to make the chapel comfortable and attractive. It has both a solid wooden door and a screen door, aluminum windows with screens, ceiling vents, a brass and milk-glass chandelier, and a wall-to-wall carpet with a multicolored floral design. Five wooden pews, painted brown, face altars filled with plastic flowers and statues. A finely executed statue of the chapel's patron saint, St. Thérèse of Lisieux, dominates the center altar.

"I ordered her statue from Italy about 1969 from a woman who had a shop in Tucson," Campbell told me proudly. "Except for three statues, I bought all the rest myself. I bought the three cuerpecitos of St. Francis on three separate trips to Magdalena many years ago."

The chapel also has a guest book—the ninth to be used in the last twenty-five years—signed by visitors from throughout the Southwest, as well as Mexico and Spain.

Unlike the other two side-yard shrines, Campbell's is never locked. "I don't worry about people stealing things because the ground is blessed," Campbell said. "Besides, I used to be a deputy sheriff and a lot of people know that, so they'd think twice before taking anything here."

With help from a neighbor, Campbell built the chapel to fulfill a manda he made to St. Thérèse after a motorcycle accident in 1963.[15] He was told he would never walk again. At the age of 76, Campbell does need a cane to walk—but only because of arthritis, not the accident.

In May 1992, the large statue of St. Thérèse holding an armful of roses was laden with artificial flowers, photographs, hospital identification bracelets, scapulars,[16] rosary beads—and forty milagros. The paint on the statue was slightly worn but the image had a lifelike complexion and pale blue eyes, and a subdued but rich brown robe, a pale yellow cloak, and a black nun's veil.

When I returned less than a year later, the statue looked completely different. It had been colorfully painted with a bright pink face and hands, vivid green eyes, rose lips, and white fingernails. The robe was still brown, and the nun's veil black, but the cloak and the one visible shoe were now metallic gold. All the offerings were gone.

"Before the mass held here for her feast day last October first," Campbell said, "I cleaned everything off the statue. There were fifty milagros on her. For years people kept putting milagros, hospital IDs, and photos on the statue. I liked the statue looking that way, but some people didn't. Last summer a lot of ladies and neighbors said to me, 'Why don't you take everything off her? She looks like she's weighted down and bent over. Take everything off her and have her repainted.' So I did it and my friend repainted the statue."

Eleven milagros were hanging on four other statues in the shrine: seven on St. Martin de Porres, two on St. Elizabeth of Hungary, one on St. Francis of Assisi, and one on St. Joseph holding the Infant Jesus.

A few weeks later, Campbell told me five milagros had been left on St. Theresa. "Twice a day I go in the chapel and say prayers," he said. "I can tell if there are any new milagros."

Campbell estimates that about 80 percent of the people who leave

Shrine of the Virgin Mary near Bisbee, Arizona, 1992. (Photograph by the author)

milagros are Mexicans, and the rest, "Americans." "If I'm outside and people want someone to talk to, maybe they'll tell me about their mandas," Campbell said. "They may tell me if they left something here. Some people say they had a bad arm or leg and they went out to San Xavier too to bring a milagro."

Roadside Shrines

People in the Sonoran region also leave milagros at roadside shrines, which are usually privately owned but open to the public.

One of the more popular roadside shrines is the shrine of the Virgin Mary near Bisbee, a town about ninety-six miles southeast of Tucson and only eight miles north of the border. Surrounded by high grassy hills

dotted with small trees, the shrine is on the east side of Route 80, almost seven miles north of the center of town. A cyclone fence keeps out the cattle grazing on the hillside directly behind it.

A local man, Edward Madrid, built the original shrine just before his induction into the army in 1951. He said he had promised to build it alone, "as a manda in return for my brother Arnold and me to come out of the Korean conflict alive and well. But when my padrino, Don Francisco de la Cruz, got wind of my project, he insisted he'd help me. But it was crudely done, so later I rebuilt it to make it more aesthetic."[17]

Madrid later told me that he built the shrine where he did because he always thought the spot was so beautiful. "But the land belonged to someone else," Madrid said. "So I asked the owner, Mr. Hannon, for permission to build the shrine, and he said okay."

Madrid recalled often seeing a little hand milagro there—a metal one—as well as other body parts and money. "On occasion," he said, "people vandalized the shrine to get the money if I didn't collect it, so before I left the area, I turned the shrine over to the church."

Madrid said that years later, the highway department moved the road and asked his permission to move the shrine. "At their own expense, they built a new cinder-block shrine about one-third larger than the old one," he said.

The new white, stepped-gable shrine[18] is about 4 feet square and 6 feet high. It has a 2-foot metal cross on the roof, and an arched doorway and wrought-iron gate, which is left unlocked. On the floor of the shrine, cemented atop a blue half globe, is a 32-inch-high statue of the Virgin Mary. The St. Vincent de Paul Society provided money for the statue, a replacement for an earlier one that was vandalized. Bisbee resident Alice Martinez painted Mary's robe white and her cloak blue. Also in the shrine were smaller statues of St. Jude, St. Joseph, and St. Martin de Porres, and also a small wooden crucifix.

To the right of the shrine is a bronze plaque: "DEDICATED TO / OUR BLESSED MOTHER / BY THE MADRID FAMILY / MAY 13, 1951 / MARY, MOTHER OF GOD, Pray For Us ... / For those in the Armed Forces / For the weary traveler / And for all who ask for your help. AMEN."

People continue to leave money, photographs, and milagros at the shrine, according to Manuel Costenera, president of the St. Vincent de

Paul Society in Bisbee and now the shrine's principal caretaker. Every Monday he goes to the site to sweep, clean up, make repairs, and collect any money left there. He hangs the milagros on a cork bulletin board he made himself, and he turns the money over to the St. Vincent de Paul Society for its charitable work.

In March 1993, there were ninety-eight votive candles burning, five vases with plastic flowers, a pot of live chrysanthemums on the floor, and fifty-four photographs of people on the bulletin board. A silver leg milagro was thumbtacked to the crucifix, and another milagro, a gold kneeling woman, was hidden behind a candle in the rear corner.

The clean and neatly kept shrine continues to be robbed of both statues and milagros, and it has been damaged by vandals three times in the last six years. In late July 1993, Costenera told me that a week before, "someone threw combustible material into the shrine and set fire to it. The only thing we got left is the burned statue of the Virgin Mary. The rest of the things in there were completely destroyed."

"A few men helped me repaint the shrine today," Costenera continued. "Alice Martinez already cleaned the statue at her house and is ready to paint it again so we can put it back in the shrine. Even now we don't want to lock the shrine because a lot of people want to go in and pray and leave offerings and that's what it's there for."

Some of the faithful who appreciate the shrine decide, on their own, to enhance it. "Somebody just went and glued glitter on the gold paint around [the Virgin's] neck and waist," Martinez said in early 1995. "People just go and do little things to make it pretty."

Milagros are still left occasionally at roadside shrines along the remnants of Route 89, the old two-lane highway from Tucson to the Mexican border. The one with the most milagros in March 1993 was the shrine of Nuestra Señora de Guadalupe, perched on a hillside behind the house of Carmen Vega, in the town of Carmen. Vega's son Richard said that his father, Ramon, built the 7-foot-high domed shrine, with a tile picture of the Virgin, to complete a manda after she granted his request to bring some of his brothers and brothers-in-law back safely from World War II, and to save the others from going at all.

The shrine was decorated by tiny flashing Christmas lights and offerings of thirteen sets of rosary beads, twenty-six large votive candles in glass holders, and a braid of blond hair. A long strip of yellow macramé

had twelve milagros pinned to it, including a 1½-inch toy pistol. Neither Vega nor her son knew who left the pistol, nor why anyone would offer it to the Virgin.

CHURCHES ON INDIAN RESERVATIONS

Milagros are also offered in churches on two other Indian reservations in the region besides the San Xavier Reservation.

On the New Pascua Yaqui Indian Reservation, about three miles west of San Xavier, people leave offerings on several statues at the cross-shaped Church of Cristo Rey (Christ the King). Inside the church, a 2-foot statue of a dark-complected Cristo Rey sits on a silver-painted wooden throne, both carved and painted by a Yaqui man named Juan Morillo. In early April 1993, ten silver milagros hung from colored ribbons and strings tied around the statue's left wrist. A gold milagro of a kneeling man hung on the small statue of San Martín de Porres.

The previous May, I had seen milagros on other statues as well, including a life-size standing figure of Cristo Rey made of painted plaster of paris by Lourdes Matus, a woman from Barrio Libre; a small Mexican figure of Nuestra Señora de San Juan de Los Lagos (Our Lady of St. John of the Lakes) with satin clothes and real human hair; and another statue of the Virgin. The lack of milagros on the statues in 1993 was explained by a Yaqui woman at the church, who told me the milagros had just been removed because the images were being covered with purple cloth for Holy Week.

On the huge Sells Reservation, west of Mission San Xavier, the Tohono O'odham offer milagros in at least two of the churches.

Most people leave their milagros on a reclining statue of St. Francis, in the Church of Our Lady of the Sacred Heart in the town of Sells, the headquarters of the Tohono O'odham Nation. The stone church, with two white-painted plaster bell towers, stands out against the nearby hills and the dramatic Baboquivari Mountains sixteen miles to the east— where the O'odham have long brought other types of offerings to their god, I'itoi.[19]

The 53-inch statue of St. Francis, with movable arms and legs, and white long johns painted on its body, lies on a long wooden table in the left transept of the church. On April 1, 1993, it was dressed in a white

Fruit of the Loom tank-top undershirt, white boxer shorts, and a brown robe with a white sash.

Father Lawrence Dolan, then the pastor, calls the image a "combination statue" because it has features characteristic of both St. Francis of Assisi and St. Francis Xavier. It is dressed in the habit of the Franciscan order, and on its hands and feet are the red-painted stigmata commonly found on statues of Assisi. However, the reclining position and the lace coverlet and pillow under his head are part of the customary treatment of statues of St. Francis Xavier. This confusion of styles does not concern the O'odham, who "just call the statue St. Francis," Father Dolan said. As another priest said, "The Indians don't waste time analyzing and theorizing about these things."

Beside the statue's head was a 10-inch-long heart-shaped pillow covered with white eyelet cloth and adorned with fifty-three milagros—sixteen whole people, thirty-six body parts, and a feather—as well as one hospital bracelet and two insignia from military uniforms. Two other milagros were pinned to St. Francis's robe.

The O'odham also bring milagros to St. Mary's Church in the remote village of Hickiwan, in the northern part of the reservation. I am always struck by the simple beauty and utter serenity of this offering site. The stepped-gable white plaster church, its facade outlined in bright mission blue, stands in a vast expanse of Sonoran Desert with only a few scattered adobe houses nearby.

Inside the church is the most colorfully dressed statue of St. Francis Xavier I have ever seen. Resting on a table in front of the church's stepped altar, the 49-inch-long plaster statue with brown glass eyes and shiny painted black robe is typical of large depictions of the saint. When I was there on April 1, 1993, it was dressed in a pale but vibrant purple cotton robe that matched the pillow under its head, the cloth on the main altar, and even the curtains on the windows. Its robe and pillow were covered with a pale lavender lace. Its hands held a small, dark-purple satin pillow with five milagros pinned to it: two kneeling men, a boy, a right arm, and a pierced heart.

In a niche above the reclining St. Francis statue stands a large statue of the Immaculate Conception of Mary, the patron saint of the church. Lining the three ledges of the stepped altar were eighty-four colorful

framed pictures of Christ, the Virgin, and various saints, as well as seven bouquets of plastic flowers and fourteen small statues, mostly of the Virgin.

A trim, older O'odham man who had bicycled from one of the houses told me, "My daughter changes the clothes on the statue [of St. Francis] several times a year—gold, brown, black. At Christmas maybe gray clothes." I asked him why she used different colored clothes, and his automatic response reflected the popular belief that the statue should be treated like the actual saint. "Because everybody changes their clothes. I just took a shower and I changed my clothes," he said, pulling on the sleeve of his clean plaid shirt.

A CHURCH IN AGUA PRIETA, SONORA

About twenty-five miles southeast of Bisbee and just across the border from Douglas, Arizona, lies the quiet Sonoran town of Agua Prieta (Dark Water), where the faithful bring milagros to a life-size statue of San Francisco completely enclosed in a museumlike showcase just inside Parroquia de Nuestra Señora de Guadalupe (Parish of Our Lady of Guadalupe). The image lies in a red velvet-lined rectangular niche set into a white marble wall and sealed off by a locked glass window.

In March 1993, three milagros were on the statue, which was dressed in a black cotton robe and resting on a lace-covered mattress and pillow. A Mexican American woman from Elfrida, Arizona, who had been praying before the statue, said she has sometimes seen "lots of milagros on him, especially in past years." She also had seen milagros on other statues in the church, although there were none on them that day.

FOUR SITES IN NOGALES, ARIZONA

In the border town of Nogales, Arizona, sixty-three miles south of Tucson, people bring milagros to two of the city's three Catholic churches and its only Catholic hospital, Holy Cross.

In sharp contrast to the offering patterns in Tucson, many more milagros are left at the hospital than at the two churches combined. On March 25, 1993, six milagros hung on a 42-inch-high statue of the Sacred Heart of Jesus next to the hospital's reception desk. Another half-dozen were on a statue of a barefoot Immaculate Conception of Mary, which has stood across from the nursery since the hospital opened in 1963. "It's

plaster and very old and touched a lot," one nurse said, "so some of the fingers are broken off." As I counted the milagros on the image, a Mexican American family walked by and fell to their knees for a moment in front the statue. "That's pretty common here," a hospital technician said.

By far, the most milagros had been offered in the hospital chapel on an almost life-size statue of St. Martin de Porres with a gold-colored metal halo. One unusually large 5-inch-high silver engraved heart pierced by a sword had been placed in the statue's left hand. Twenty-two other milagros dangled on ribbons and threads of various colors from both the large heart and the statue's left hand.

The year before I had seen a large reclining statue of St. Francis Xavier in the vestibule, but the statue and the milagros attached to it were no longer there. The statue had been donated to the hospital by the family of Jose Ramirez in 1990, on the first anniversary of his death, because according to his daughter, "he had great faith in St. Francis." Nuns in the chapel said that the statue and its offerings had been moved to Nogales's new Catholic church, San Felipe de Jesus. A member of the hospital staff said that the large new church had been having trouble with poor attendance, "so they went looking for something. They thought maybe it would help if they had a St. Francis statue, that maybe it would increase devotion. So the St. Francis statue from the hospital was sent over there about a year ago with the permission of the Ramirez family."

The modern and airy San Felipe de Jesus Church, built in 1991 on a hilltop in the northern outskirts of Nogales, is the loftiest offering site in the region. It has a 360-degree vista of the surrounding mountains as well as views of Ambos Nogales, meaning "both" Nogaleses: the U.S. and the Mexican. The 43-inch statue of St. Francis, with lifelike brown glass eyes and realistic eyelashes, lies on a lace-covered folding table in the back of the church.

In March 1993, none of the milagros were pinned on the statue's black satin robe, as they often are elsewhere. Instead, all eight milagros were hanging from a blue ribbon tied to its right hand. Two were identical: nude, inch-high sitting infants made of flesh-colored plastic and tied to the blue ribbon with red rubber bands. Apparently someone was using little dolls as milagros, a rare example in this region of nonmetallic milagros.

People also leave milagros in Sacred Heart Church on North Rodriguez Street. Like San Felipe de Jesus, its congregation is about 95 percent Mexican American. Monsignor John Oliver believes the atmosphere of the large brown stucco Romanesque church "gives people a feeling of peace. The simplicity of the design brings people immediately into contact with God. Many people have told me that, and I have experienced it myself."

Most offerings are left on a 3-foot statue of the Infant of Prague to the left of the pulpit. "The Infant of Prague is popular with the Mexican American people," the monsignor said, "because they feel at home with the belief that God took on human form and became a little child." On March 25, 1993, eight milagros—seven whole bodies and one silver heart pierced by a sword—hung from the blond-haired, blue-eyed image. At its base lay one white patent leather infant's shoe.[20]

A total of five milagros hung on four other statues. The only statue of St. Patrick that I have ever seen with a milagro on it stands by a pillar in the right front side of the church. The offering was a silver kneeling man hanging from the statue's right thumb, next to a green satin shamrock that someone had placed in its hand. In the rear of the church, a 4-foot-long reclining statue of St. Francis Xavier had a gold milagro of a boy pinned to its black satin robe. To the right stood a 50-inch-high statue of San Martín de Porres with a real broom stuck behind his right arm.[21] Hanging from his left hand was a gold pierced-heart milagro.

The most impressive sight, however, was in the vestibule: two gold leg milagros hung from the bottom of a 5-foot-high black-and-ivory wooden crucifix with elaborate gold trim and a beautiful painted statue of Christ. The crucifix is mounted on the wall, 8½ feet above the floor. One can only conjecture how someone put the offerings on it.

CHURCHES IN NOGALES, SONORA

Just across the border in Nogales, Sonora, milagros are offered at three of the city's Catholic churches.

The busiest and oldest church in the city, built in 1891, is la Parroquia de la Purísima Concepción (the Parish of the Immaculate Conception). The twin-towered, buff-colored stone edifice is on Avenida A. L. Mateos, in the bustling tourist shopping area only one block from the U.S.-Mexico border crossing.

Just inside the main entrance, through a doorway on the left, is a small alcove, only 7½ feet wide and 9 feet long. On three sides of the room, staring out from white wood shelves set 4½ feet above the floor, are six painted plaster statues, all 4 to 4½ feet high. The alcove has a worn, heavily used aspect. Its floor is stained with dirt and wax from dripping candles. The room appears to have been stripped of everything but its essentials—the statues—and on March 13, 1993, even some of those were missing. The empty arms of the San Cayetano statue, which used to hold an image of El Infante Jesús, and the empty space on the shelf next to him were blatant reminders that two statues had been stolen.

Any votive gift has a good chance of being stolen, too. Yet all day long, people enter the church just to come to this room, say a prayer, touch the statues, and perhaps leave a votive candle or, occasionally, a milagro. That day, a silver right leg hung from the hand of San Judas, and one silver kneeling man hung from a string around the neck of San Martín de Porres. In the main part of the church, four other milagros were hanging on the elaborate wood frame of a 4½-foot-high oil painting of Nuestra Señora de Guadalupe.

Milagros are also offered at Santuario de Nuestra Señora de Guadalupe on Calle Padre Nacho. The pretty white stucco church with four star windows on its single bell tower is about a mile south of the border, one block uphill from Nogales's main street, Avenida Obregón.

On March 25, 1993, I found seven milagros in the church. Two hung more than 8½ feet above the floor—one on a life-size statue of San Martín de Porres, the other on a life-size statue of Jesús Cristo on a 10-foot-high cross on the front altar. Someone less athletic had laid a silver girl milagro at waist level by the bare right foot of a statue of San Judas. Someone else had stuck a plain pin holding three milagros right into the lower part of a huge old 10-by-6-foot oil painting of the crucifixion.

Milagros are occasionally left at la Iglesia de la Sagrada Familia (the Church of the Holy Family), built on a dirt road in a poor residential area uphill from International Highway 15, about two miles south of the border. On March 25, 1993, the tan-and-brown stucco church, with its extremely large and elaborate multicolored marble altar and altarpiece, contained only two milagros: a pierced heart and a man's head. The milagros hung from strings that had been taped to the extended right hand

of a 37-inch-high statue of la Sagrada Corazón de Jesús (the Sacred Heart of Jesus).

ROADSIDE SHRINES AND CHURCHES BETWEEN
NOGALES AND MAGDALENA

Occasionally milagros are left at roadside shrines along Highway 15 between Nogales and Magdalena.

The best known is the handsome white cement-block shrine of San Ramón Nonatus,[22] located five miles south of the border, in southern Nogales. Set in front of two large assembly plants known as *maquiladores*, the chapel is the third San Ramón shrine to be erected there. As with many old offering sites, there are several quite different accounts of why this shrine was built.

Raul Castillo Murrieta, who lives nearby, said that his uncle, Ubaldo Murrieta Inclan, built the original white plastered adobe shrine about 1938 to fulfill a manda after his daughter-in-law gave birth to his grandchild despite a difficult pregnancy. During World War II, so many people visited the shrine that the family decided to construct a better one. According to one Mexican businesswoman, the site used to be so popular that "no one would come south of the border without stopping to get San Ramón's blessing." However, when the industrial park was developed in the 1970s, the shrine was razed by a bulldozer. Castillo said so many people complained about this that the factory owners built the present, larger shrine. (Some people say that such bad luck befell the people who had it bulldozed that they rebuilt the shrine to end their misfortunes.)

Until twenty or thirty years ago, many milagros were left at the shrine. Since then, however, "It's always being vandalized and the statues stolen," Castillo said. "But it doesn't matter—it's still San Ramón's shrine, so people keep going there to fix it up again and bring new statues and pictures of him. People walk past here all the time on their way to fulfill their mandas to San Ramón, and some still leave milagros."

When I asked why I had never seen any milagros there, Castillo and his wife, Cruz, laughed and replied, almost in unison, "People say it takes longer to hang a milagro at San Ramón's shrine than it takes for someone else to steal it."

On the east side of the highway, a couple miles north of the tiny town

of Cibuta, is a 4-by-5-foot white painted shrine of San Judas. When I stopped there in March 1993, I saw a gold pierced heart hanging on a string around San Judas's neck. The 16-inch-high statue, which was glued to the center of the altar, was surrounded by thirteen burning votive candles and two San Francisco cuerpecitos.

Milagros are also seen in the churches of small towns on or near Highway 15. About twenty miles south of the border is la Capilla de Nuestra Señora de Guadalupe, which I visited on March 9, 1993. The dusty, little-used, and usually locked classroom-size church sits next to two adobe houses on the east side of the highway in Cibuta. Behind the altar, a beautiful gold-framed 6½-foot-high lithograph of Nuestra Señora de Guadalupe rests against the wall on an elaborately carved wood table. Stuck between the frame and the glass protecting the print were two gold milagros, a right eye and a right leg, glued to a piece of clear plastic.

More milagros are brought to an imposing life-size black statue of El Cristo de Esquípulas in la Iglesia de San José in the small town of Ímuris, forty-four miles south of the border. The image is named after a similar black statue in Esquípulas, Guatemala.[23] The impressive figure, which had a metallic silver cloth draped around its waist, hangs on a large brown-stained wood cross standing on the left side altar. On March 12, 1993, four milagros hung from the fancy finial-like nail head on Christ's right foot. Two had been pinned to a red velvet band on the statue's left ankle. Two others were safety-pinned to the silver cloth behind the statue's back. (Ironically, in this region where San Francisco is so popular, I saw no milagros on an armless 39-inch-long reclining statue of the saint at the foot of the giant crucifix.)

About fifteen miles south of Ímuris is the shrine of Santa Lucía in the tiny town of San Ignacio. The shrine is in the impressive Iglesia de San Ignacio de Cabúrica (the Spanish for "Church of St. Ignatius" combined with the O'odham word for "small hill"). The late-baroque structure incorporates parts of the walls of the earlier church built after Padre Kino established the mission in 1687.

Although there are several old statues in the church, many people visit only the beautiful painted-gesso statue of Santa Lucía. The barefoot figure stands on an altar on the right side of the church, its long, dark curly hair cascading over the shoulders of its black and gold dress. Father

Charles Polzer has concluded that the 34-inch-high statue was originally used at Magdalena to represent Santa María Magdalena, but none of the faithful seem to know or care about the statue's history. Father Polzer says the statue was converted because so many people in the area were suffering from a genetic disorder of crossed eyes that they wanted a statue of Santa Lucía to which they could pray and bring milagros.[24]

On March 13, 1993, 159 milagros—all of them in the shape of eyes—were lying next to the 34-inch statue on a light, pecan-colored wood tray with a dark blue velvet lining. One pair of gold eyes had green, emerald-like irises and was attached to its own tiny gold tray, like the tray and two eyes that Santa Lucía is often depicted holding.

The sacristana, Josefina Gallego, told me that people occasionally leave milagros on other statues in the church, and I found two silver ones, a kneeling man and a kneeling woman. They were hanging by threads from the left hand of the very old statue of San José Oriol,[25] dressed in a brown cloth robe and hat and an ancient-looking white surplice. Pointing to the statue, Señora Gallego said, "He's the one for stomach problems." Then she pointed to the black-robed, 2-foot-high statue of the patron saint of the church, San Ignacio de Loyola, on the front altar. "He's the patron of cattle ranchers," she said. "Once in a while, people leave cattle milagros."

ANOTHER CHURCH AND TWO UNIQUE SITES
IN MAGDALENA

In Magdalena, people offer milagros not only at the pilgrimage church but also at a smaller church and at two sites that are unique in this region.

Besides the pilgrimage church, Magdalena has two smaller churches and another large one under construction, but milagros are offered at only one of them: San Martín de Porres, located in a residential neighborhood seven blocks east of Highway 15. Only three milagros were in the church: a gold right arm on the statue of San Judas, a silver kneeling man on the statue of San Martín above the altar, and a silver left foot on top of the tabernacle.

The most unusual offering site is the tomb of Padre Eusebio Francisco Kino, erected on the Plaza Monumental over the place where his bones were uncovered in 1966.[26] The white stucco monument is an arcaded dome that covers and encircles a much smaller domed vault with

windows on all sides. Through the glass, people can see the padre's exposed skeleton[27] and part of the stone foundation of the original San Francisco Chapel. Although Padre Kino is not a canonized saint, his fame in the region is such that some people believe his remains have supernatural powers.

On March 13, 1993, I found five milagros inside the tomb. Four lay on a windowsill, and one was lying on the rocks of the chapel's foundation. Eduardo Corrales Meza, a municipal employee and the principal caretaker of the tomb, told me that whenever anyone wants to leave a milagro, he opens the padlock on a 3-foot-high wooden door on the west side of the tomb. Before allowing offerers to go inside, Señor Corrales tells them they can place milagros on the rocks or windowsills, but not on or near Kino's remains. "About five to eight people a month leave milagros in the tomb," he said. "Most of them come back after awhile to get their milagros and bring them to the church or to their homes."

People also leave milagros outside the tomb, in a miniature glass casket containing a San Francisco cuerpecito. The casket is displayed on a shelf inside the arcade from 7 A.M. until 9 P.M., when Señor Corrales locks the casket in a booth beside the tomb. That day, there were thirteen milagros, including two houses, in the casket.

Magdalena's other unique offering site is la Capilla de Juan Soldado (Chapel of John Soldier), on the east side of Highway 15, about two miles south of the city's business district.[28] Unlike virtually every other church and chapel in the region, the capilla is dedicated not to a canonized saint but to the *anima,* or spirit, of a Mexican soldier popularly known as Juan Soldado.

Delfina Suarez López, an older woman who lives a short distance down the narrow dirt road beside the chapel, told me that Juan was an army private in Tijuana. In February 1938, his captain raped and murdered a girl who came to the garrison and then accused Juan of the crime. A few days later, he had Juan shot without a trial. Afterward, Juan's spirit appeared to the captain, who finally confessed and then died. Soon people began to report that Juan's soul had performed miracles. Folklorist James Griffith visited the chapel at Juan's grave in Tijuana, Mexico, and was told several variations of Señora López's account. Juan's real name reportedly was Juan Castillo Morales.[29]

The capilla, with a handsome triple-arched arcade on its front and

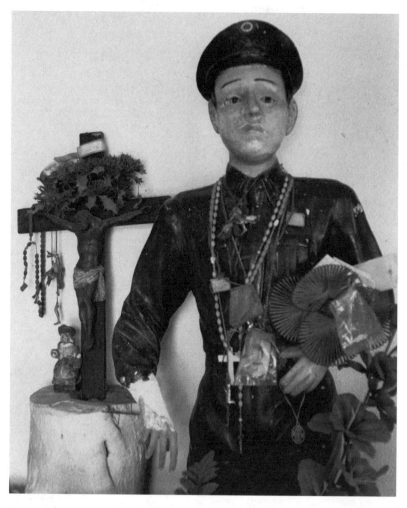

Statue of Juan Soldado with milagros and other offerings. Magdalena, 1993. (Photograph by the author)

sides, is the most impressive roadside chapel I have seen in the San Xavier–Magdalena area. The 9-by-11-foot white plaster and brick chapel has two windows, electric lights, and a padlocked wrought-iron door. Atop a stepped altar on the back wall are a 33-inch statue of the Sacred Heart of Jesus and a 41-inch statue of the young Juan Soldado in the olive-drab uniform of a Mexican soldier.[30] On March 13, 1993, the statue was decorated with seventy-two milagros—forty whole people, thirty body parts, and two houses—as well as rosary beads, artificial flowers, and other offerings.

I was able to get the keys to the chapel from Señora López, who kept trying to impress upon me that Juan Soldado is an *alma,* or soul, who was executed unjustly and can therefore grant miracles. In other parts of Latin America, Juan might be called a "folk saint," one who was "canonized" by the people after miracles were attributed to his intercession.

This is the second Capilla de Juan Soldado at the site. Twenty-three years ago, Señora López's husband, José, built the first one, which was smaller, to repay Juan Soldado for "miraculously" freeing their son Gerardo from prison. She told me her son had been hired to drive a truck loaded with salt into the United States and did not know that illegal drugs were hidden inside. After he was arrested in Arizona and sentenced to twenty-five years in prison, someone in Magdalena told her to pray to Juan Soldado for a miracle. Thirty days later, her son was released, and the charges against him were dropped.

The present chapel was built in 1975 by Carlos Martínez after he, too, had been arrested on drug charges and was released from prison after praying to Juan Soldado. Señora López and Ignacio Duarte commissioned Arturo Pino, in Magdalena, to make the statue of Juan Soldado that is in the shrine today.

"Several people a day ask for the key to the chapel, and some of them leave milagros," Señora López said. "A lady left one just five days ago."

Excluding the uncounted hundred or so offerings at Romo's shrine, there were 968 milagros at the thirty-two sites,[31] but the relevance of these minor offering sites lies not so much in the number of milagros offered or even the particular images on which they hang. The sites are important because they reflect the fact that milagros are offered not only at the two major shrines in the region, but in the very neighborhoods where people of milagro-offering cultures live—in private homes and yards, in local churches, in hospitals, and along the roads they travel.

3

Buying a Milagro

Years ago, anyone who wanted to buy a milagro went to a local silversmith who made one of silver or, occasionally, gold. Today only a few milagros are custom-made by silversmiths. Instead, the vast majority of people go to religious goods and jewelry stores for milagros that are "mass-produced" by casting or stamping inexpensive gold or silver alloys, brass, copper, nickel, or occasionally, aluminum.

BUYING A MILAGRO IN TUCSON

Although the custom of offering milagros is still very much alive in the Tucson area, only a few places sell them. They are so little known that a number of Mexican Americans and Indians have asked *me* where they could buy milagros in Tucson. In August 1993, I could find only eight shops in the entire city that carried the offerings. Three—the West Boutique Florist shop, Trinity Bookstore, and Madonna—were Catholic religious goods stores.

The West Boutique Florist shop, on West St. Mary's Road, had the

largest selection. Only a block from St. Mary's Hospital, the business is in a largely Mexican American neighborhood. The owner, Josefina Lizárraga, has sold milagros since 1976, when she decided to turn half of her florist shop "into a department of Catholic religious goods." To passersby, her store still looks as if it sells only flowers, so every day she puts out on her sidewalk the only outdoor advertisement for milagros I have ever seen in Tucson: a folding white wooden "A"-board sign saying "Religious Gifts/Statues/MILAGROS." Lizárraga also advertises milagros in the Yellow Pages under the heading "Religious Goods."

The milagros are not immediately visible to potential customers. Lizárraga, a lively and outgoing woman originally from Guadalajara, Mexico, keeps her milagros on a shelf in a blue metal box with clear plastic drawers—"The type you use to store screws in," she said. "I bought it at K-Mart." In May 1992, most of the offerings were gold or silver alloy pieces selling for $1.50 each. Each drawer of the box was labeled with the type of milagro it contained: kneeling men and women; standing boys and girls; babies, both sitting and lying down; men's and women's heads; double eyes; ears; lips; right and left hands, arms, feet, and legs; pairs of women's breasts; stomachs; kidneys; pairs of lungs; and pierced hearts.

"Knees are the most popular milagros that old ladies want," Lizárraga told me, "but there are no knees, so they buy legs." There were also horses, cows, and cars, but the drawer labeled "Houses" was empty. "I cannot find houses for at least a year," Lizárraga said.

The drawer marked "Elephants" also was empty. "I used to have elephants for people in the circus," Lizárraga explained. "They don't want to lose an elephant! But they didn't sell, so I ended up giving the last five or six to relatives as charms."

Other drawers held 14-karat gold milagros, selling for much higher prices, determined by size and weight and ranging from about $30 to $45. There were engraved sheet-gold boys and heads, half-face hearts, praying hands, crutches, horses, and the Infant of Prague. A milagro of St. Peregrine,[1] who Lizárraga said is the patron saint of people with cancer, was $39.

"We don't advise people to buy expensive milagros like the 14-karat gold ones," Lizárraga said, "because they might be stolen from the churches. Where there is gold, there is temptation. But it's okay if they're buying gold ones to put in their shrines at home."

Lizárraga gets her milagros from Mexico. "For six years I got my milagros from a nun who lived near Mexico City," she said. "The nun was the sister of a friend of mine from my hometown in Mexico. She never told me where she got the milagros. She died in April 1991, and it took me a long time to find someone else to get them for me. You always need someone to bring milagros up from any of the little shops that produce them all over Mexico. Then I found a wholesaler, Sylvia Contreras, who comes from Texas and brings milagros made by her in-laws in Mexico City."

Usually the people who buy the milagros as offerings bring them to Mission San Xavier, but she said some people buy them before going to Magdalena, "because they don't want to take chances that they won't find the type they need there."

Lizárraga said she sold fewer than a hundred milagros in 1990, and most of those were bought by craftspeople who incorporated them in their work (see chapter 7). "I used to sell more milagros, but the custom of offering them is dying," she said. "All traditions die with time." Even though she sold about two thousand milagros in 1993, most were still bought for nonreligious purposes.

Lizárraga is concerned that some people who buy milagros may use them sacrilegiously and possibly even in devil worship. "When people who are on drugs or wearing crucifixes in their ears and rosaries around their necks want to buy milagros, I worry what they will do with them, and I may refuse to sell them to them," she said.

Trinity Bookstore, in a pink stucco building on East Fort Lowell Road, has carried milagros since it opened in 1986. In April 1993, all the milagros were in a glass jewelry display case, each type in a little white envelope labeled in Spanish. When I asked the store's buyer, Penny Pick, why they were not openly displayed, she replied, "We never have made a display, but now that you mention it, I'm going to make one if I can find a little display box."

Among the eighteen different types of offerings were kneeling men and women, standing girls and boys, babies (lying down and sitting up), eyes, ears, lips, legs, arms, hands, breasts, navels, pierced hearts, lungs, kidneys, and houses. Most were gold-colored, and all cost $1. "They're all just some inexpensive metal," Pick said. "Most people who come in here want 'gold' ones, and they usually order a couple, or three or four."

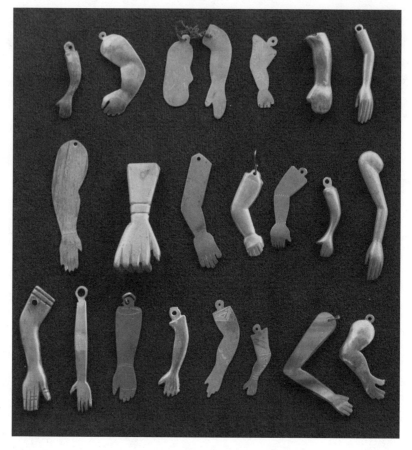

Arm milagros offered at Magdalena. Note the arm and liver milagros connected by thread and offered together *(top row, center)*, and the arm milagro cut from abalone shell *(bottom row, second from right)*. (Photograph by Helga Teiwes)

The owner of the shop, Donna Scott Lopez, buys her milagros from Sylvia Contreras, the same supplier Lizárraga uses.

Madonna, a religious goods store on South Twelfth Avenue that went out of business in early 1993, was bought that summer by Nicolas Acevedo and moved to a corner of the J. J. Newberry store on West St. Mary's Road. Acevedo's wife, Manuela, who runs the shop, said that most people who buy milagros there bring them to Pauline Romo's shrine of El Señor de los Milagros.

A large selection of gold and silver milagros, obtained from vendors from California and Texas, were all priced at $1.50. There were sixteen

types of whole people and common body parts as well as cars, trucks, locks, houses, pigs, cows, and the only scissors milagros I have ever seen. A Mexican American man working at J. J. Newberry said scissors are offered by hairdressers and barbers.

Two other religious goods shops that *used* to carry milagros closed permanently between 1991 and 1993. Librería Méjico (formerly in the rear of Los Grandes Indoor Swap Meet on South Twelfth Avenue) went out of business in 1993. Milagros were only a small part of their business, and they had been selling them for only a year.

The Ave María Shop, however, had been selling milagros since 1946, and several older Mexican Americans told me it had been one of the most popular places in Tucson to buy milagros. In 1991, it was closed due to the illness and death of the owner, Viola Zepeda. The shop used to be across the street from St. Augustine's Cathedral on South Stone Avenue, but it was moved to Ochoa Street a few years before her death.

Zepeda always carried a large selection of the most common mass-produced offerings. In March 1974, when I first met her, she said she obtained her milagros directly from Mexico since Tucson's wholesale religious goods dealers did not handle them. Like most other sellers of milagros, she refused to tell who or exactly where the source was.

Some of Zepeda's customers referred to these votive offerings as *relíquias* (relics). She said others called the small figures of people *imágenes* (images), because man was created in God's image.

In 1974, the Ave María Shop sold milagros made of a cheap silver alloy for seventy-five cents apiece. As Zepeda pointed to the pieces, she said, "they call these 'silver' but there's only a little silver in them." Then she pointed to ten shiny gold-colored milagros, priced at $5. "Some people promise gold," she said, "but they're not 14-karat. There's just *some* gold in them."

By 1990, most people preferred "gold" milagros, according to Zepeda's niece Yvonne Zepeda, who began managing the shop after her aunt became ill. "They don't want silver at all," she said. "They want something more special because their manda is so important. But some people don't care. They'll buy cheap copper milagros or even some new ones we're carrying that look like stainless steel."

"More women than men buy them," she continued. "But one old man in his late 70s buys seven to twenty milagros each month. He buys so

many that we give him a discount. He lives by himself in a tiny house and has had a hard life. Now he dedicates his life to praying for different people. He just buys milagros of men because he's helping different men he meets."

In 1982, clerks at the store said sales of milagros were the same as in previous years. But in 1990, Yvonne Zepeda said sales had increased since 1985. "One reason for the increase," she said, "was that some Mexican Americans who had lost touch with their heritage were coming into the store and asking how to use milagros because they were having problems in their lives. They heard about [the custom] but didn't know what to do. After we explained how to use milagros, people chose the kind they wanted and usually brought them over to the cathedral."

The Ave María Shop could not fulfill requests for special milagros because the silver ones had to be ordered in lots of twenty-five, and the gold milagros five or ten at a time. Until 1969, if people wanted milagros that were not in stock, or they were looking for an unusual or finely crafted offering, Viola Zepeda would send them to Manuel Diaz Pulido, a goldsmith and jeweler on nearby Meyer Street who was known to take great pride in his handcrafted milagros. Most of the older Mexican Americans in Tucson who talked to me about milagros said he was the jeweler people went to if they wanted special offerings.

Pulido was born in Spain, in the town of Martos, in the state of Jaén, but he did not learn to make milagros there. Indeed, although milagros are made and offered in Spain, he told his son Charles that he had never seen them there.

Pulido left Spain when he was sixteen or seventeen, his son said. "He probably learned goldsmithing in El Paso because he practiced it there. When the family moved to Tucson, he worked for other jewelers for only a short period of time. Then he went into business for himself."

Using the ancient sand-casting method (explained in chapter 4), Pulido would make five or six milagros at a time. Charles Pulido, who used to watch his father work, kept five gold milagros as mementos. "My father cast gold and silver hearts, pancreases, arms, legs, and heads for brain tumors, as well as many other kinds," he said. "During World War II, my father made lots of soldier milagros of gold and silver. People would tell him about their mandas, and the mandas would include walking to San Xavier with the soldier milagros. When my oldest brother Joe

came back from World War II, he, our mother, and I walked from our house on Meyer Street to San Xavier, and she had one of our father's soldier milagros in her handbag to put on St. Francis."

Pulido made the cast-gold and -silver offerings until he retired in 1969, when his jewelry shop was demolished to make room for the Tucson Community Center. All his shop fixtures and furnishings were sold at auction.

Pulido died in 1974 at age eighty. A year later, his widow, Maria, proudly showed me two cast milagros she had kept: a small solid-gold foot and a sterling-silver hand. "My husband had many requests to make cast milagros," Mrs. Pulido said. "Now no one in Tucson makes them."

When Pulido first opened his jewelry shop, he sold only cast milagros, Charles said, "but later on, he carried some cheap stamped silver-alloy or aluminum ones. Some people no longer wanted to spend money on expensive gold and silver ones because milagros were being stolen from San Xavier. As a child, I saw hundreds of milagros on the statue of St. Francis at San Xavier. But then people started stealing them. My father began carrying the cheaper milagros to satisfy customers, but he did not make them himself. He bought them from Mexico, but I don't know from where or who. My father's sister, Mary Louise, has kept lots of them. Others were sold."

One of the buyers was Simon Perri, a jeweler and dealer in used merchandise downtown on West Congress Street who occasionally stocks milagros in his store, Perri Jewelers. In 1974, he told me he had just bought some silver milagros from Mateo Pulido, one of Manuel's brothers. According to Charles Pulido, these were the cheap (mass-produced) milagros his father had gotten from Mexico. "Before this," Perri said, "I could never get any milagros from the Pulidos. But then the other day they asked me if I wanted them. They offered them at a very low wholesale price from years ago, so it paid to buy them. It takes time to sell a seventy-five cent item, so it usually doesn't pay to carry milagros."

Perri said he occasionally got milagros cheaply by "horsetrading" with certain men who periodically came from Texas or across the border from Mexico bringing jewelry and milagros to exchange for used televisions, appliances, and other secondhand items.

When I spoke to him in March 1991, however, Perri said he had not sold any milagros recently and had only eight silver arms and two silver

heads left. He also said he could no longer get them from the Mexican traders. "The ones I have are left over from fifteen years ago."

The Nambé Outlet, a store on North Campbell Avenue that specializes in Guatemalan clothing and Mexican imports, occasionally has milagros for sale. The owner, Lori Amado, had sold out of milagros in August 1993, but she said she would get more whenever she "ran across them."

¡Aquí Está!, a large store on South Park Avenue selling Mexican furniture and accessories, offers a small selection of milagros. The owner, Martha Mendivil, originally from the mining town of Cananea in Sonora, Mexico, came to Tucson in 1986. She has a small shrine in the store consisting of a lithograph of El Santo Niño de Atocha given to her by her grandmother, and milagros given to her by a friend who was a priest in the state of Hidalgo, Mexico. When Mendivil opened her store in 1990, she began carrying milagros after customers started asking for them.

When I stopped by the store in April 1993, the silver- and gold-colored offerings were displayed in an attractive glass and brass jewelry box on a desk in the front of the store. The silver milagros, which sold for $2 or $3, were "like pewter," Mendivil said, "made of lead, nickel, and two other metals." They represented standing men, kneeling men and women, boys and girls, flame hearts, arms, legs, and keys (which a saleswoman at a religious goods shop in Magdalena told me are promised to prevent houses from being robbed).

Mendivil sells about a thousand silver-colored milagros a year. She also sells about fifty to sixty large, plain gold-plated hearts in five sizes priced between $5 and $50. Most people who buy the two largest sizes, the 4- and 6-inch hearts, are putting them in their homes, she said. Mendivil gets her silver milagros from Mexico City and the gold-plated ones from Guadalajara, but like others who sell milagros, she kept her sources secret. "No one wants to tell their exact source," she said, "because we're afraid of competition."

Mendivil believes 90 percent of her milagros are bought by Mexican Americans for religious purposes. She said the other 10 percent are bought "to make earrings, or because it's the first time a customer has seen them, and when I explain what they are used for, they buy one just to have. Sometimes they buy two or four."

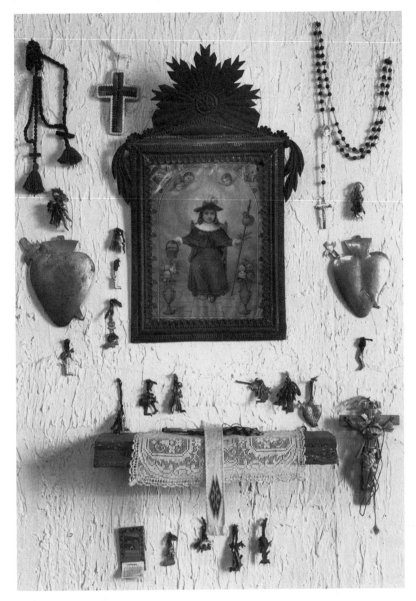

Shrine with milagros at Martha Mendivil's store ¡Aquí Está! Tucson, 1993. (Photograph by the author)

Arturo Mercado, a jovial antique dealer originally from Guadalajara, Mexico, sells milagros at his shop, Antigua del Barrio, on East Congress Street. In March 1993, hundreds were displayed in a show window in a large blue ceramic bowl next to a sign saying "Milagros/$1/ea." Inside the shop were two more bowls full of milagros, also priced at $1 each.

The most unusual pieces were automatic pistols and girls on bicycles. Mercado also sold 3-inch-high hearts and legs for $5, and three types of 1½-inch-high hearts—pierced, plain, and flame—for $3. "All of my milagros are aluminum," he said. "My extended family in Mexico makes them—three or four of my uncles and cousins working in a small factory the size of a garage in Guadalajara. They asked me to sell them for them."

Mercado says some people still buy the milagros for religious purposes and take them out to San Xavier. "Sometimes even relatively young people come in to buy one because 'Granny wanted one for her lung ailment,'" he said. Surprisingly, many people who buy his milagros are non-Hispanic. "I cannot believe it," Mercado said, "but about 60 percent of them are Anglos. They come back and say, 'A milagro works!'"

But Mercado, who sold about 4,500 milagros in 1992, said very few of the milagros are bought for religious reasons. "Most people buy them to make jewelry or crafts. Only today I sold sixty milagros to one person. I also sell them by the thousands wholesale. Sometimes one or two thousand to a man in Miami, Florida, and he resells them. I sold four to five thousand last year."

People used to be able to buy milagros from Rose Navarro at Bellas Artes Drugs, on the corner of Sixth Avenue and Twenty-Second Street, near South Tucson. Navarro had a small jewelry stall in a corner, where she also sold milagros. Since 1980, however, when Navarro moved downtown to Congress Street, milagros are no longer available at the drugstore. "Now that Rosie is gone, we just sell drugstore items and a few herbs," the owner of Bellas Artes told me in 1991. "If anyone wants to buy milagros in South Tucson, they should go to Flores Nacional, the herbería on South Twelfth Avenue, because they're the experts. They sell lots of herbs and milagros, too."

The exterior of Flores Nacional's adobe-block building has yellow-

and-black Western Union signs as well as signs in English and Spanish saying "Mailbox Rentals," "Check Cashing," and "Religious Articles." Other signs in Spanish advertise "Pesos Venta y Compra" (Pesos Sold and Bought) and "Medicinas/Yerbas * Revistas" (Medicines/Herbs * Magazines). Inside is an overwhelming display of guitars, cellular phones, and large framed paintings on velvet, and aisles full of candles, oils, potions, herbs, greeting cards, and drugstore items.

No one would ever know the store sells milagros. They are kept out of sight in a white wooden box on a shelf under the cash register. Although the clerk was reluctant to show me the box, he put it on the counter and opened the twenty round covered tins inside. Each one contained a different type of whole-body or body-part milagro.

In March 1993, Joe Flores Jr. told me his father started the business in 1919, and that milagros had been sold there since the 1950s, and probably much earlier. "Years ago we used to sell a lot more, but now only about two people a week are buying them," he said. When I asked where they obtained them, he replied matter-of-factly, "We don't reveal our sources but they come from Mexico."

Although none of the churches in Tucson sell milagros, people can buy them after Mass at St. Margaret's Church from Adelina Aros, whose statue of Jesus Scourged was described earlier. Known to members of the congregation because of her work with the Sacred Heart Society, Aros usually has several dozen milagros in a ziplock bag in her purse. She attends Mass at St. Margaret's virtually every day with her husband, and people approach her afterward if they want to buy milagros.

"I just stand at the back of the church or in the alcove by the Sacred Heart [of Jesus] statue and people come and buy them," she said. "I mostly sell babies, heads, eyes, ears, hearts, livers, bellies, arms, hands, legs, and feet. It was even advertised in the church bulletin that I sell them!"

Aros said she began selling milagros "because people were asking for them. When they saw the new display of milagros hanging in the church, even more people asked me 'Where can I get them?' The church doesn't sell them because it's too much of a hassle." At first, Aros bought milagros at the Ave María Shop. Now she buys them from Josefina Lizárraga. "I prefer gold ones," she said, "because that's what most people at St. Margaret's want. But Josie doesn't always have them."

Lizárraga later told me, "I give milagros to Adelina at a good discount. The profit she makes goes for flowers for the church."

Milagros were also sold at the swap meet on Westover Street in South Tucson, according to Yvonne Zepeda, former manager of the Ave María Shop. In 1990, she told me that "people from California who have a booth there selling collector's things and Disney things are also selling milagros for $5 and more apiece—more than at the Ave María Shop. They're bigger than the ones at the Ave María Shop, but not fancier." In 1993, several people told me that a Mexican American family was also selling milagros at the swap meet.

Custom-Made Milagros in Tucson

In general, stores sell relatively inexpensive mass-produced milagros, which satisfy most people. The few faithful who want a more costly custom-made offering must go to a jeweler who can make one.

One such jeweler is Agustin Calleros, a jewelry designer and owner of Artistic Jewelry Repair on East Tenth Street in downtown Tucson. Calleros, who used to cast gold and silver milagros in his native Mexico, can make either cast or engraved two-dimensional offerings, but he has made very few here. In fact, from the time he came to Tucson in 1960 until I met him in 1974, no one had *ever* asked him to make one. Calleros still had a few three-dimensional patterns for cast milagros that he had brought from Mexico, but he had never tried to develop a clientele for handcrafted milagros in Tucson. He thought people would not pay enough to cover the cost of his materials, time, and labor.

In 1987 or 1988, however, a friend asked Calleros to make two milagros. When we spoke in 1991, Calleros recalled that "one was a flat, plate-gold engraved house on fire that cost $35, and the other was two eyes for about the same price. That was my first order here. This month I have an order for a small cast-gold girl that I'll sell for $30. So now I'm getting a few more orders, but just a couple because, in the first place, people don't know who makes them. Then probably only people who immigrated from Mexico would want them."

When I visited Calleros in March 1993, he not only said that he had not received any more orders for milagros, but also that he thought he never would, and he graciously gave me his last pattern, a one-inch-high lead figure of a girl with her hands clasped in prayer.

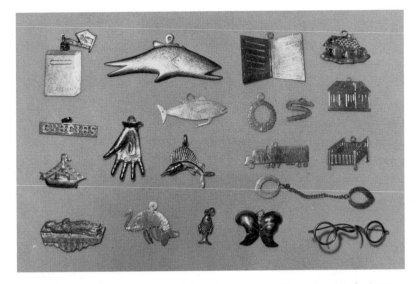

Unusual gold milagros offered at Magdalena, many of them handcrafted. (Photograph by Helga Teiwes)

Carlos Diaz, a renowned Tucson silversmith, occasionally makes engraved two-dimensional sterling silver milagros to order. Diaz's company, Carlos Diaz Goldsmiths and Silversmiths, is on North Campbell Avenue, between downtown and an affluent area in the foothills of the Santa Catalina Mountains.

Diaz, who immigrated to Tucson from Colombia in 1953, said the only milagros he saw in Colombia were made of wax. His first experience with metal milagros occurred in Tucson, "sometime in the 1970s," when a woman came into his store and asked him to make her a pair of silver eyes. Over the years, he has also made two-dimensional heads, arms, legs, and feet.

In the early 1980s, a plain 2½-inch arm milagro cost $30. A 2½-inch head and shoulders engraved with the features of the donor and his or her clothing was $60. Diaz said those prices had been the same since the price of silver rose six years before. In 1993, Diaz said the same head-and-shoulders milagro would cost $80 or $85. The price, he added, would always depend on the height and width of the milagro, the thickness of the silver, the amount of engraved detail, and the current price of silver.

Requests for handcrafted milagros are sporadic. In 1982, Diaz told me he received only two requests a year. Between 1988 and 1991, orders

had increased to about six a year, but that increase was short-lived: in April 1993, Diaz told me he had had no orders for the last two years. Then, in 1994, he had four orders.

Rose Navarro, who used to sell milagros in Bellas Artes Drugs, was making them at her shop, Divine Jewelers, on East Irvington Road, on the south side. In December 1991, most of her milagros were heads, whole bodies, and little doves representing the Holy Spirit.

"If I can get nice-looking milagros from a supplier, I buy them," she said. "Otherwise I make them or one of my employees makes them." They make both two-dimensional and cast offerings in gold and silver. "We can make any kind of milagro a customer wants, as long as they draw what they want so I'll know what it should look like," she said. "We're making right now a baby Jesus cast in gold because a lady promised it. She wanted it lying down on its back, and she couldn't find any like that so she asked us to make it. It's three-quarters of an inch long. The lady couldn't do the drawing for it, so my daughter, who's going to the University of Arizona, did it."

OTHER PLACES TO BUY MILAGROS

Outside the city, milagros are sometimes available at the gift shop at Mission San Xavier and at La Paloma, a boutique in Tubac, a small town on the road to Nogales.

Many people from Arizona say they get their milagros from Mexico, either in the border towns of Agua Prieta or Nogales or farther south in Magdalena or Hermosillo. If a milagro is intended for a statue in Mexico, the offerer often buys it on the way, but if the milagro is to be presented in Arizona, the offerer may ask a relative or friend to bring one back from Mexico.

In contrast to other stores in the region, whose ready-made milagros are virtually all inexpensive base metals or, at best, gold- or silver-plated, Joyería Haste in Agua Prieta carries only 10-karat gold and sterling-silver milagros. (*Haste* is the brand name of a watch that was popular in Mexico in the 1940s, and *Joyería* means jeweler's shop.) In January 1995, the gold and silver milagros sold for 40 (new) pesos ($8.33 U.S.) and 15 (new) pesos ($3.10 U.S.), respectively. The store had a large stock of kneeling men and women, babies, heads, pairs of eyes, hearts, arms, hands, and legs. One of the owners, Manuelita Íniguez de Silvas, said they were all

purchased from a man who makes them himself in Guadalajara and then travels around to sell them.

She said that although the gold ones are very thin (in fact, they were almost like foil), "people here want real gold milagros, not gold-plated ones, so they get these. We sold about three hundred last year. Most of them were taken to Magdalena, and some were taken to Parroquia de [Nuestra Señora de] Guadalupe.

"If anyone wants 14-karat or better, or thicker ones, we can take orders, and my husband, Miguel, can make them. Last year we had only about fifteen orders because of poor economic conditions."

It is easy to see why people would buy their milagros in Nogales, Mexico. They are cheaper and are sold in at least a dozen jewelry, gift, and religious goods stores, including one that rents space inside a church.

The Lazy Frog, an exclusive arts-and-crafts shop on Campillo Street near the U.S.-Mexico border crossing, was selling silver-plated milagros for only fifty cents apiece in March 1993. As in other stores in Nogales, the offerings were not displayed in the window and were not advertised. Eight different types, all whole people and body parts, were displayed in a glass showcase in the back of the store.

The owner, Señora Elena Serna, a friendly and attractive woman who speaks excellent English, said most people buy them to bring to Magdalena. She sells between 1,000 and 1,500 milagros a year, "but every year a little bit less." Since she has not been able to find a supplier, she travels to Mexico City at least once a year to buy them at El Mercado de San Juan, a large arts-and-crafts marketplace.

Silver-colored milagros were also selling for fifty cents apiece (in 1992) at Joyería Nogales, a small jewelry shop on Avenida Obregón. The pleasant, well-dressed owner, Señora Celia H. de Ochoa, was happy to show me her stock: kneeling men and women, standing boys and girls, pairs of eyes, flaming hearts, and right and left arms and legs. Each type was stored individually in gray cardboard boxes with a sample milagro glued to the cover. The boxes were neatly arranged on a shelf behind the counter with the covers facing out so customers could see which types she had.

The milagros in Alejandra Miscelánea, another shop on Avenida Obregón, were in little clear-plastic bags behind dozens of framed reli-

gious pictures in the show window. The bags contained only a few types of milagros: kneeling men, sitting infants, pierced hearts, and right and left arms. In May 1992, all the offerings were gold-colored and cost $1 each.

Probably the largest selection of milagros in Mexican Nogales is found at Joyería Titanea on Calle Torres. In May 1992, more than thirty types were displayed on two black velvet-covered trays in a glass show-case. There were gold horses and pigs, as well as whole people and the usual body parts. "If anybody needs another type, I can make it to order," said Señor Herman Romero, the owner, with confidence. "I have been a jeweler for sixteen years." Unlike most other stores closer to the border, prices here were quoted in pesos. The gold-colored milagros cost 2,000 (old) pesos, and the silver-plated ones 8,000 (or, at the time, about $.65 and $2.50, respectively). Specially made milagros cost much more.

Milagros are also available at Santuario de Nuestra Señora de Guadalupe, about a mile south of the border. They are sold by Librería Encuentro, a privately owned shop that rents space inside the church entrance. The tiny, 8-by-10-foot shop, open only a few hours a day, sells religious books and pictures as well as rosary beads, religious medals, and milagros. In October 1993, only eight kinds of milagros were in stock: gold-colored kneeling men and women, men's and women's heads, and right and left arms and legs. They were made in Guadalajara and were being sold for the remarkably low price of 1,000 (old) pesos, or thirty-three cents, each.

BUYING A MILAGRO IN MAGDALENA

Many people who have promised to bring a milagro to San Francisco in Magdalena wait until they arrive to buy their offering, partly because of the large selection available there and partly because they want to buy it in the famous pilgrimage town. There are more religious goods stores than any other type of business on the Plaza Monumental in Magdalena, and six out of seven sell a large selection of milagros.

Sagrado Corazón de Jesús offers mainly plaster religious statues made by the owner, Socorro V. de Lopez, and the store has a varied, but small, selection of milagros inside. The other six stores—San Francisco, La Providencia, Artemex, Portales, Portal Lorenia, and Portal Loly—have

stacks of cuerpecitos and racks of hábitos on the sidewalks, but again, milagros are displayed only inside. In March 1993, the prices at all six stores were the same: eight (new) pesos ($2.70 U.S.) for gold-plated milagros, and six (new) pesos ($2 U.S.) for silver-plated ones.

The choice of milagros in Magdalena is far greater than at most stores in Tucson and Nogales. Each of the six shops had at least twenty-eight different types. Saleswomen at three shops said that whole bodies and legs are the most popular offerings,[2] and all six shops carried whole bodies and body parts.[3] All six stores also had cows and horses because Magdalena is in a cattle-ranching region. Not only is there little variation in the types of milagros sold at these shops, there is also virtually no difference in the style. By the time one has looked at the arm milagros in each shop, they seem as indistinguishable as nails in a bin at a hardware store.

However, La Providencia also had goats, geese, dogs, cats, and fish; Portales was selling donkeys, turkeys, and peacocks; and San Francisco had geese and scorpions (in case someone had been bitten by one, according to Señora Socorro Abelais, the owner). All the shops sold houses; most of them sold cars, slat-sided trucks, and keys; and La Providencia also had padlocks, books, crowns, corn, and stalks of bananas. Only some stores carry the less-popular offerings such as tongues, lips, and scorpions, but by going from store to store, pilgrims can find just about any type of milagro they need.

Señora Abelais, who has owned and managed San Francisco since 1969, buys her milagros in Mexico City. She sells about a thousand milagros a year, most of them in October during the fiesta of San Francisco. So many people buy their milagros during the fiesta at Magdalena that some merchants seize the opportunity to raise prices temporarily. A few days before the fiesta in 1982, one shop was selling mass-produced silver-alloy milagros for seventy pesos, and mass-produced gold-alloy pieces for eighty. The day before the feast, prices rose to eighty pesos for silver-alloy and one hundred pesos for gold-alloy milagros. The day after the feast, prices returned to normal.

Other milagros seen occasionally on San Francisco's statue are stamped out of paper-thin copper or aluminum foil. These pieces, which have shallow features and very rough outlines, have no artistic merit and cost almost nothing. Although some people think they are acceptable offerings, most would never consider using them. No one, however,

could tell me exactly where they are sold or where they are made. I showed some from the church's collection to a man who lives in Magdalena and asked him, "How much do you think these cost? They weigh almost nothing." Laughing heartily, he replied, "And they're worth almost nothing!"

Custom-Made Milagros in Magdalena

At the other extreme are people who want expensive handcrafted milagros. In Mexico, as in the United States, anyone who wants a custom-made milagro must go to a jeweler, silversmith, or other artisan. At least three jewelry shops in Magdalena—Joyería Venecia, La Joya Moderna, and Joyería Nubes—make engraved sheet-gold and sheet-silver milagros to order. In the last eight years, no one has ordered a milagro from Joyería Venecia. Señor Manuel Solís, the owner of La Joya Moderna, was asked to make only two milagros in 1994. "Years ago," he said, "people used to ask for 14- or 22-karat milagros, but now most people want to pay only a little money for a 10- or 12-karat milagro, put it on San Francisco, and 'bye, bye,' they're gone."

Señor Ruben Nubes, the affable owner of Joyería Nubes, can also make sand-cast three-dimensional milagros in either silver or gold. His shop is in a street-front room of his home on Calle Bellevista, a residential area three blocks east of Highway 15. Since Señor Nubes does not advertise, people who want a handcrafted offering must already know about him or must find him by chance or by word of mouth.

When customers ask to buy a milagro, Señor Nubes first shows them the ready-made, sand-cast gold or silver offerings in his glass showcase. Often customers choose one of these, but if none of them meets their needs, or if Señor Nubes is out of the type desired, he can make one to order.

About half the time, Señor Nubes said, customers tell him all about the illness or other misfortune that prompted the offering. Because he is a Mexican Catholic, and he lives in the pilgrimage town of Magdalena, Señor Nubes understands the deep religious significance of the milagro tradition, and he takes pride in being able to provide customers with the kind of milagro promised.

Because customers specify the exact type of milagro in their mandas, all that Señor Nubes needs to know is precisely what kind of milagro

was promised, including the form, the size, the metal it must be made of, and when it is needed. Señor Nubes then discusses with the client the cost of his labor and materials, and, as is typical in Mexico, some bargaining may take place. Instead of paying cash, the customer may bring in a coin, an old watch, a piece of jewelry, or some other gold or silver object to be melted down for its precious metal. In that case, Señor Nubes uses part of the gold or silver to make the milagro, keeps part of it as payment, and reimburses the client for any metal left over.

Señor Nubes prices his milagros according to the time and skill required to make them and the amount of silver or gold they contain. In 1982, he told me he charged 300 (old) pesos for a foot cast in solid silver, and 9,000 pesos for one cast with ten grams of 14-karat gold (a gram is about ½₈ of an ounce). When I visited Señor Nubes in March 1993, he said he would charge 25,000 (old) pesos for the same foot in silver, and 250,000 for one in 14-karat gold. "But I hardly ever have an order for a real gold or silver milagro in recent years," he told me. "It's mostly because of the economic problems here in Mexico. People can't afford to spend so much on a milagro now."

4

Stamping, Engraving, and Casting Milagros

Milagros in the Sonoran region are made in four different ways. Most are stamped in sheet metal by hand or by machine; some are cut from sheet metal (and often engraved); some are cast in molds; and a handful are hand-carved.

STAMPED MILAGROS

Milagros stamped in sheet metal are made with dies: small sheets of bronze or other metal on which an image has been engraved in reverse. For hand-stamping, the back of the die is soldered to the blunt end of a short metal bar, often made of iron. To stamp a milagro, the silversmith or jeweler places a small, thin sheet of silver, gold, or other metal over a block of lead, which is a softer metal. Then he holds the die slightly above the sheet of metal and hits the opposite end of the bar with one sharp blow of a hammer to stamp the imprint of the die in the softer silver or gold.

Depending on the thickness of the sheet of metal, the smith uses

either a pair of scissors or a jeweler's saw to cut around the outline of the figure. Next, a hole is punched in the top of the figure so the milagro can be hung. After filing the edges to make them smooth, and then polishing the entire surface, the milagro is complete.

Unless they have no artistic ability at all, each smith or artisan usually makes his own dies. Some dies, however, are handed down from one craftsman to another, or from an older smith to his apprentice.

Most milagros offered in the Magdalena–San Xavier corridor are die-stamped not by hand but by machines or other mechanical devices. Sylvia Contreras, who wholesales milagros in Tucson, confirmed other people's reports that there are no *large* milagro factories, with many machines stamping out milagros, anywhere in Mexico. She said milagro manufacture is mainly a cottage industry, with some small metal "factories," which are actually just workshops, producing several different types of die-stamped objects, including milagros.

The milagros that Contreras wholesales are made at her mother-in-law's workshop, Novedades Contreras, in Mexico City. Her father-in-law, Señor Ramón Contreras, started the business fifty-two years ago, originally making religious lapel pins but soon after adding milagros. "Milagros are still not a big part of our business," Sylvia Contreras said. "Most of it is lapel pins and rosaries. The factory has fifteen employees, but only three of them work on milagros."

Contreras's mother-in-law, Señora Florentina Bolanos, has run the business, which is in her home, ever since her husband died thirteen years ago. Señora Bolanos lives on the first floor of a two-story white stucco house whose rooms face a central courtyard. Plating and polishing is done upstairs, and stamping is done in the courtyard under a metal-roofed ramada with a cement floor.

"We've made milagros the same way for fifty years," Contreras told me in August 1993. "There is a heavy steel cylinder with a smaller cylindrical die, also made of steel, attached to the bottom of it. The die has a picture of what you want engraved on it in reverse. Our dies are made by an old man in Mexico City who engraves them by hand. After the die is engraved, it needs to be tempered—heated to white hot. That makes it strong so it doesn't break when it strikes the metal piece that will become the milagro. Some of our dies have lasted fifty years. Some break after just a hundred stampings. If that happens, there was either a defect

in the metal or it wasn't tempered at a high enough temperature. Unless they break, the same dies are used for years and years. We don't change the design. If they break, we have the same dies made again.

"When the die is dropped onto a small flat piece of metal called a blank, the impression of the die is left on the piece. The blanks [usually brass at Novedades Contreras] onto which the die drops are slightly larger than the milagros will be. We get strips of brass from a factory, and here they're cut into little, roughly square pieces with something like a big paper cutter, but made for cutting metal. In turn, each blank is placed inside a square depression on a heavy metal table about waist high. That's all that holds the blank in place.

"How the die is dropped depends on how modern your machine is. What we use to stamp milagros is actually not a machine. It's a real old-fashioned device," Contreras said, laughing. "It's our original one. The heavy cylinder with the die attached to the bottom is connected at the top to a rope. The rope goes up over a pulley on a heavy metal bar over-head. A man pulls on the rope and raises the cylinder about five or six feet into the air. The cylinder weighs about twenty pounds. When he lets go of the rope, the die drops onto the small brass blank, imprinting the design of the milagro on it. A long piece of metal track that goes from top to bottom guides the cylinder, so it always drops straight down. The man then takes the stamped blank, puts it on a pile, replaces it with another blank, pulls the rope and repeats this process all day long.

"The man who pulls the rope has been with us for fifty years—ever since we started. His name is Benito. He's about sixty-five years old and has big biceps from doing this. He's in great shape. He can make about a thousand pieces a day. But that's a long day. He starts at 5 to 5:30 A.M. and finishes about 6 to 7 P.M. We just bought a new press that works electronically, and it can stamp about three thousand milagros a day.

"The brass stampings with the designs on them are given to cutters, who work in their homes and then bring the pieces back. They use hand-saws to cut the outline of the milagro. Some cutters do five hundred pieces a day. Others have a hard time doing one hundred. These people work on a daily basis—they are paid per piece on the day when they bring the milagros back.

"The cut milagros are then taken to a second-floor room, where someone polishes them with an electric grindstone and then with a finer

brush. Sometimes they are then nickel-plated or gold-plated in another room. But often they are left as plain brass. The brass ones look like gold, the nickel-plated ones look like silver, and the few aluminum ones we make look like pewter. When the factory first started making milagros, they were made of silver because it was cheap then. Now we mainly make brass ones, which we sell wholesale for twenty-five cents apiece.

"Even though the machines should make it cheaper, it is becoming more and more expensive to stamp milagros and buy the brass. Employees cost more because, since last year, we have to buy them health insurance, so it's better for us instead to keep them working on the lapel pins, where we make more money. So sometimes we get a better deal by buying cast milagros from other people making them in their homes.

"We have very poor people from small towns right around Mexico City coming by with bags of a thousand sand-cast milagros, and they want to make a deal. They may make them out of brass or melted-down pot metal. They come to places like my mother-in-law's, where they can sell all of them at once. One man comes by every two to four weeks with a bag full. We buy them for customers for our stores because we don't have time to make all that we can sell.

"I wholesale them all over the United States and my mother-in-law handles Mexico. Besides shops like Josefina Lizárraga's, El Santuario de Chimayo in New Mexico, and the California missions, I have other customers who buy them by the thousands—someone in New York, a lady in Louisiana, and others—for their arts and crafts."

CUT AND ENGRAVED MILAGROS

Carlos Diaz, the Tucson silversmith mentioned earlier, makes milagros at his shop on North Campbell Avenue cut from sheets of sterling silver (which is 925 parts silver and 75 parts copper). He uses sterling silver because pure silver, like pure gold, is too soft for jewelry or milagros. Both metals must be alloyed with other metals to make them harder and more durable. Diaz buys the silver from his friend Earl Starr, who is a small distributor and the owner of Starr Gems on Drachman Street.

When a customer orders a milagro from Diaz and both of them agree on a price, Diaz immediately decides what gauge of sheet silver to use:

the bigger the gauge number, the thinner the silver. "Thirty gauge is like cheap paper," Diaz said. "Twenty-four is like heavy quality letter paper. Twenty or eighteen gauge is good for bracelets, and sixteen is for heavier things. I usually use twenty or eighteen gauge for milagros, and they look nice. But for big ones, I may use sixteen gauge."

Regardless of the gauge, Diaz makes his milagros out of what he calls "clean white silver." This is silver that has been put in a solution of 10 percent sulfuric acid and 90 percent water, and "pickled" until the surface turns white. "I have to pickle it," he said, "because when it's annealed at the factory, the surface gets dark from the copper alloy."

Virtually all sterling silver is annealed because when a large ingot is rolled through a mill to form sheet silver, the compression makes the metal too hard and brittle to work. To soften the metal, it is annealed, or subjected to heat, which causes the copper alloy to come to the surface. The copper oxidizes and discolors the surface of the silver, so it must be taken off. "You don't lose any of the silver," Diaz said, "just the coppery part—unless of course you leave the silver in the solution overnight."

To make his pickling solution, Diaz pours a measured amount of cold water into a blue-and-white electric ceramic Crock-Pot, "the kind that costs about $35." (He uses a Crock-Pot because its ceramic interior will not be corroded by the acid, and because the pickling solution should be kept warm, "since then it works quicker on the silver.") Diaz adds the sulfuric acid, drop by drop, to the cold water. "I don't do it too fast," he said, "because then it reacts too violently with the water and jumps up. It would burn you if it hit you."

Most jewelers now use a newer, less dangerous pickling solution available at jewelry supply houses. Diaz, however, prefers pickling the old-fashioned way. "I've done this since I was a kid apprenticed to my uncle," he said, "so I know what I'm doing." Once the acid-and-water solution is prepared, he can use it for seven to ten days, "just depending on how clean it keeps, because three people are using it."

Next, Diaz lowers the piece of silver into the solution with copper tongs and waits until the surface turns white. If the solution is warm, he has to wait only about a minute. If it is cool, he has to wait a few minutes longer.

After "pickling" the silver, Diaz washes it under cold running water to remove all traces of the acid. The white coating will not wash off but can be removed later by polishing.

Diaz next makes a detailed drawing of the requested milagro. Unlike some silversmiths who use patterns to save time or because they cannot draw well, Diaz draws freehand. When he is satisfied with his drawing, he transfers it to tracing paper. Then he places carbon paper face down on the silver and puts the tracing paper on top of the carbon paper. As he retraces the drawing on the tracing paper with a sharp pencil, the carbon paper transfers the design to the white coating on the silver. Diaz then uses a jeweler's saw to cut around the outline of the piece.

To add the desired features, Diaz uses a variety of engraving tools known as burins. "If the customer is willing to pay extra, I also engrave the back of the milagro," he said. "The amount of detailed engraving always depends on how much the customer wants to pay."

"When I'm done engraving," Diaz continued, "I always put my mark on the milagro—'Made by Carlos Diaz' or 'Sterling by Carlos Diaz.' I stamp it on the back with a die."

After filing the edge of the milagro, Diaz smooths the edges and removes the white coating created by the "pickling" process with an electric buffer.

To give the milagro a more natural appearance, some silversmiths place the cut-out piece over a block of wood, lead, or pitch and gently hammer it into the relief shape most appropriate for what it represents. Some milagros, such as eyes, are given only a slight curve. Others, especially breasts and stomachs, are more rounded.

Occasionally milagros are cut out of a coin, the lid of an old watch, or another decorated piece of metal. In these cases, the smith usually uses the designs already engraved on the metal to enhance his own creation. A milagro representing a navel or a woman's breast, for example, would take advantage of the circular patterns popular on many pocketwatch lids. A head milagro offered at Magdalena incorporated the design elements on an old Mexican one-peso coin.

HAND-CAST MILAGROS

Some people promise a three-dimensional real gold or sterling-silver milagro made by the casting process. Only a few jewelers or silversmiths in

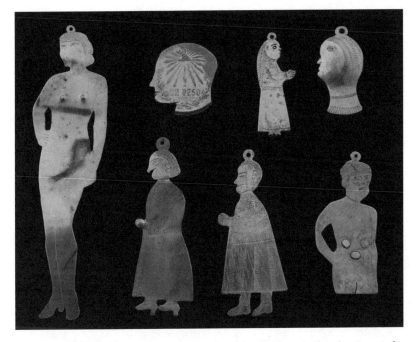

Handcrafted silver milagros offered at Magdalena. Note the head cut out of a Mexican peso *(top left)*. The five female figures include a large, almost nude woman *(far left)*, three praying women, and a three-quarter figure with three small gold shapes soldered to her abdomen. (Photograph by Helga Teiwes)

the area can, or will, make them. At the San Francisco fiesta in Magdalena in 1973, I stopped at every booth that was selling religious articles or jewelry and asked if hand-cast milagros were available. The answer was always "No."

I was about to give up when, at the last jewelry booth, two young women said that their father, a jeweler named Señor Ruben Nubes, made cast milagros to order. He was ordinarily at his store, they said, but a few days before the fiesta, the family had moved their merchandise and some of Señor Nubes's shop equipment to a stall in the arcade. While his wife and daughters took turns selling jewelry, milagros, and other religious objects, Señor Nubes sat at an improvised workshop inside the arcade repairing old jewelry and watches and adjusting new rings to fit.

Señor Nubes, who spoke only Spanish, told me with obvious pride that he was one of only a few people who still made cast milagros. A skilled and highly regarded silversmith and jeweler, he said he had

learned these crafts from his father. Like most Mexican silversmiths, Señor Nubes does not travel to sell his merchandise and does not sign his work. So although he is well esteemed for his craftsmanship locally, his name is generally unknown elsewhere.

When I told Señor Nubes I wanted to see how he cast milagros, he said he was too busy to do it during the fiesta, and he had already made all the milagros he would sell that week because he never had time to make them then. He did give me his telephone number, however, and politely asked me to come back another time if I wanted to see the casting process.

When I telephoned Señor Nubes a few months later, he said he would set aside an afternoon two weeks from that Friday for a demonstration. He repeated the date twice, very slowly, to make sure I understood his Spanish.

"But that's Good Friday!" exclaimed a friend who was going to accompany me. I knew that Catholics are supposed to spend Good Friday afternoon quietly or in prayer, but I also knew that Señor Nubes had been very clear about the date. I thought he had chosen it because he knew there would be no customers to interrupt the demonstration.

Two weeks later, my friend and I followed Señor Nubes's directions to his former store on Calle Juárez, one of Magdalena's residential streets. The street was deserted because in this heavily Catholic country, virtually everyone was observing Good Friday.

A white plastic sign saying "Haste Joyería Nubes" jutted out above a doorway halfway down the block. The sign was the only indication that there was a store inside Señor Nubes's pink stucco house. As is fairly common for jewelry shops in small Mexican villages, the store was in a street-front room of the house. There was no show window, so potential customers had to go inside to see the merchandise.

The door to the store was locked, so we knocked on the other door, which was reserved for the family's use. One of Señor Nubes's daughters opened the door, and we immediately saw the whole family praying in their living room. Señor Nubes looked up and appeared to be surprised to see us, but he invited us in. He quickly explained that he had chosen the date by mistake and assumed later that I would not come because it was Good Friday. He said he had planned to spend the afternoon praying and that he did not think it was right to work on such a holy day.

However, after hesitating for a minute, he said that because of what he called the deep religious significance of milagros, and because we had traveled so far, he thought it would be all right to do a brief mock demonstration of the casting process.

Inside his shop, gold and silver milagros were displayed on velvet-backed trays in one of the glass showcases. The flat, two-dimensional pieces were figures of a man, a woman, a girl, and an infant. Several three-dimensional cast milagros included a hand, a chest, and a heart, as well as several heads, arms, legs, and feet. One milagro was a representation of San Francisco reclining. There was also a figure of a nude woman, but after I asked permission to photograph the milagros, Señor Nubes, probably acting from modesty, quickly removed it.

Through an open doorway in back of the one-room store was a small rectangular workshop. A double door and windows on the rear wall of the workshop opened onto a courtyard filled with trees and shrubs.

For the next hour, Señor Nubes carefully explained the casting process. When he was done, he invited us to come back at another time to watch him actually cast a milagro.

I returned with Helga Teiwes, the photographer from the Arizona State Museum, late one afternoon in October 1982. Señor Nubes had just recently reopened his business in a new location on Calle Matamoros. This store had a large plate-glass window protected by wrought-iron grillwork, but none of his work was displayed there. Señor Nubes explained that he had moved to this new location because an infection in his mouth had left him paralyzed for two years and he had been forced, temporarily, to close his business, sell his home, and move his family in with relatives in another city. A cot and various food containers in the rear room made it seem that Señor Nubes was temporarily living there alone.

Señor Nubes told us he could do the demonstration "the first thing in the morning." When we appeared at 8 A.M., he had his materials set out and was ready to begin. After lighting the first of many cigarettes, Señor Nubes began to explain the ancient and inexpensive process known as sand-casting. In this method, gold, silver, or other metal is heated to a liquid state, poured into a mold—which traditionally is made of sandy clay, not pure sand—and allowed to cool and harden.

The main drawback to sand-casting is that the mold is often damaged

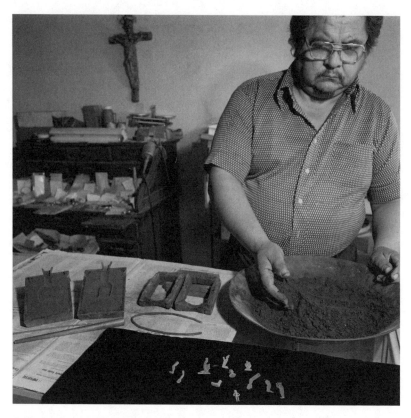

Señor Nubes with materials for casting a milagro in the round: *(left to right)* a
large, two-part metal flask; a small, two-part wooden flask; a large metal bowl
of cement; and milagro patterns. (Photograph by Helga Teiwes)

during casting or when the milagro is removed, so usually only one cast-
ing can be made from it. But even though Señor Nubes must make a new
mold for each casting, it still takes him "only an hour and a half to two
hours to make a milagro," he said with a shrug.

Instead of using the traditional fine sandy clay for his mold, Señor
Nubes prefers ordinary masonry cement because its extremely fine grain
permits him to produce sharp, detailed castings. He also likes cement
because he can easily obtain it at any hardware store.

To make a successful casting, the mold material must have several qual-
ities. It must be fine grained, its clay and moisture content must be high
enough to hold it together, it must have green strength (the ability to with-
stand the heat stresses of molten silver or gold), and it must be permeable

enough to permit steam and gases to escape. All of these qualities decrease the chance of casting defects known as blows, scabs, and veins.[1]

Rectangular forms known as flasks are used to hold the cement in which the mold is made. Señor Nubes has two flasks, a bronze one bought in Guadalajara, Mexico, and a smaller, wooden one he made himself in 1972. The bronze flask is composed of almost identical halves, each resembling an empty picture frame. Each half is 4 inches wide, 6 inches long, and ½ inch thick. One of the halves has pegs in the upper two corners that fit into sockets in the other half, so that they fit together perfectly with no movement. After the halves are brought together, they are backed by boards of the same height and width, and fastened with metal clamps to prevent the flask from opening.

When the halves of the flask are together and lying horizontally, the bottom half is called the "drag" and the top half is called the "cope." There is also a spout extending from the top of the flask. This is the "pouring gate" or "sprue opening" through which the molten silver or gold is poured into the mold.

Señor Nubes's wooden flask is a cruder version of the bronze one. Although not as refined-looking, it serves him just as well for making a small, single casting such as a milagro. Each half of the wooden flask measures 3 inches wide, 4¼ inches long, and ⅝ of an inch thick. Instead of pegs, two nails protrude from the sides of one of the frames. When the frames are put together, these nails fit a bit loosely into two holes on the matching half. Although the fit is not as tight as on the bronze flask, Señor Nubes assured me the wood flask works just as well. Unlike the bronze flask, the wood flask has no pouring gate. Instead, there is a vaguely funnel-shaped opening that Señor Nubes carved out of the top.

After emptying several metal patterns out of a plastic box, Señor Nubes spread them on his countertop. These are the models he uses to create impressions in the cement. When removed from the cement, they leave a cavity shaped like the pattern and known as a mold. This is the form into which the molten metal is poured. Most of the patterns were made of lead, but some were actually silver milagros, the original patterns of which had been misplaced. Señor Nubes said he can substitute milagros because they work as well as real patterns and are not damaged in the process.

Señor Nubes's three-dimensional patterns included a left arm, a right

arm, a left leg, a foot, a man's head, and a nude woman. He also had low-relief or half-face patterns, which have three-dimensional raised features on only one side. The low-relief patterns depicted a kneeling woman, the head of a moustached man, La Virgen de Guadalupe, and San Francisco on his deathbed. There were also flat, two-dimensional sheet-metal cutouts representing an arm, a leg, a kneeling man, and a man in uniform. "I made all the patterns myself about twenty years ago—except for the one of San Francisco," Señor Nubes said proudly, adding that the unusually detailed and elaborate San Francisco pattern had come from Italy.

A customer generally orders one of the common types of milagros for which Señor Nubes already has a pattern, but if a customer needs a different representation or one of unusual size, he makes a special pattern. For flat, two-dimensional milagros, Señor Nubes usually cuts the pattern out of sheet tin. For three-dimensional and low-relief cast milagros, Señor Nubes makes the pattern in lead, which is soft enough to be carved easily with a metal "graver."

For the demonstration, Señor Nubes chose the three-dimensional lead pattern of a left leg, and he began by placing several handsful of cement in a large metal bowl. He moistened the cement with motor oil, a technique he learned from his father, with whom he worked for twenty years. Señor Nubes said he prefers used motor oil because "when I pour hot molten metal into the mold, new motor oil could cause flames. Used motor oil isn't so bad. The more used it is, the better it is for the mold. I get it at any garage. They're just throwing it away anyhow, so they say I can have it for free." (Silversmiths who use the traditional sandy clay for their molds mix it with water, not oil.) Whatever liquid is used, Señor Nubes must take care to use only enough to bind the mixture sufficiently. If he uses too much liquid, it will produce excess steam when the hot metal is poured into the mold, causing a faulty casting or even an explosion.

Working the cement with his hands, Señor Nubes repeatedly squeezed and crumbled it before testing the mixture for the right consistency. He tested it by rolling some of the cement mix into a ball and then breaking it open. The clear, sharp edges showed it was just right. Then he worked the cement with a flat, rectangular metal "strike bar" to grind down and eliminate any small lumps.

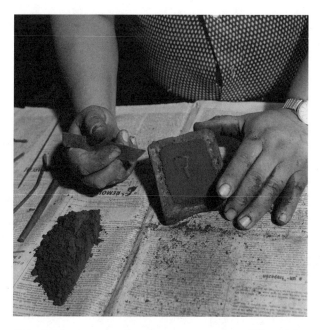

Señor Nubes scraping the cement away to the midline of the pattern. (Photograph by Helga Teiwes)

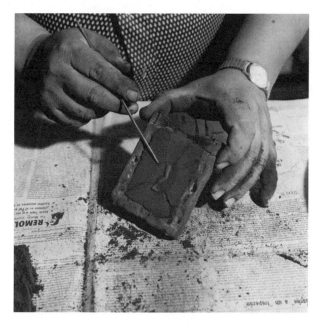

Señor Nubes carving the last vent with a *punta*. (Photograph by Helga Teiwes)

When the cement was ready, Señor Nubes took one half of the wooden flask and centered it around the pattern lying on its side on the countertop. Working very rapidly, he covered the pattern with several handsful of cement until the frame was completely filled and the cement was mounded up slightly over the top. After patting down the cement with his hand, he used a metal "sand rammer" to tamp the cement down with light blows, going over the entire surface several times until the whole frame was filled and well-packed. Just to be sure it was ready, he placed the flat metal strike bar across the drag and tamped on it as he moved it back and forth across the surface. He removed the excess cement by slowly scraping the strike bar across the surface, and then he allowed the cement to set for a few minutes.

When Señor Nubes thought the cement was firm, he turned the frame right side up. The pattern was barely visible in the center of the cement. He gently scraped around it with the pointed edge of the metal strike bar until he removed all the cement down to the midline of the pattern, leaving half of it exposed. The exposed half of the pattern would be used to form the second half of the mold.

Using a long, pointed wooden tool called a *punta* (a graver or engraving tool), Señor Nubes then carved into the cement a funnel-shaped channel known as a "downgate" or "runner" from the top of the pattern up to the pouring gate. This was the channel through which the molten silver would run into the mold cavity. Señor Nubes said he always carved outward from the pattern toward the pouring gate to draw the loose fragments of cement out of the mold.

Señor Nubes also carved four narrower channels known as vents. Two vents ran out from each side of the pattern to the adjacent long sides of the flask. He explained that the steam and gases that would be generated as he poured the molten silver would escape through these vents. Again he carved outward from the pattern, tilting the drag to let the loose particles of cement fall out of the vents. By now, the cement in the drag had become quite firm.

Señor Nubes then took the cope and fitted it to the drag. After ladling fresh, moist cement into the empty cope, he pressed and tamped it and scraped away the excess.

In just a few minutes, the cement in the cope had hardened, and Señor Nubes carefully lifted the cope off the drag. The pattern remained in the

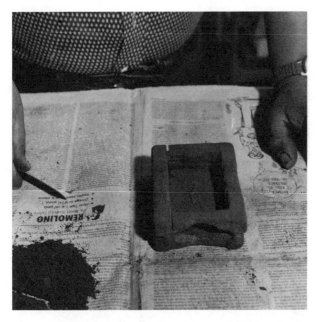

The flask, with the cope fitted to the top of the drag, ready to be filled with cement. (Photograph by Helga Teiwes)

Señor Nubes lifting the cope off to reveal the pattern in the drag. (Photograph by Helga Teiwes)

The milagro pattern is removed by inverting the drag, leaving a mold cavity in the cement. (Photograph by Helga Teiwes)

The flask is backed with blocks of wood before pouring. (Photograph by Helga Teiwes)

drag. The cement in the cope had the impression of half the pattern in its surface. It also had raised ridges of cement corresponding to the depressions of the downgate and vents in the drag.

Working first on the drag, Señor Nubes cleared the downgate and vents of any loose cement left after the cope was removed. Next, he took the punta and prodded very gently around the pattern, just enough to loosen it from the cement. Then, to my surprise, he suddenly flipped the drag upside down and the pattern fell out, leaving an almost perfect mold cavity.

Many smiths will not take the chance of removing a pattern that way because they are afraid that if the pattern falls out at an angle, it will knock off a corner of the mold. Instead, they press one or two wads of sticky modeling wax to the pattern and lift it straight up.[2] But Señor Nubes said he never worries about that possibility because it has virtually never happened to him.

He next worked on the cope. Where raised ridges of cement indicated the location of the sprue and vents in the drag, he carved away corresponding channels in the cope, again scraping away from the mold cavity in the center. After clearing away the loose cement, he used the punta and his fingers to pack down the vents and sprues in both the cope and the drag to prevent loose particles of cement from falling into the mold cavity when he would pour the silver in.

Now, Señor Nubes said, the mold was ready. He laid the two halves of the flask together side by side. "Next I close them like the covers of a book," he said. After putting them together, he placed the rectangular pieces of wood on both "covers" of the flask and secured them in place with a homemade metal clamp. He then carried the flask to his workbench and stood it upright on a round metal dish. The flask was ready to be filled.

Señor Nubes decided to make this milagro out of sterling silver. Depending on the market, gold costs at least fifty times, and occasionally more than a hundred times, as much per ounce as silver. Also, since gold is almost twice as heavy as silver, the same size milagro cast in gold would require almost twice as many ounces as the silver one.

Señor Nubes sometimes buys silver from Mexican mining companies, but usually his gold and sterling silver come from the Bank of Mexico in Hermosillo, 115 miles south of Magdalena. For this demonstration,

Señor Nubes finishes pouring molten silver into the sprue opening of the flask. (Photograph by Helga Teiwes)

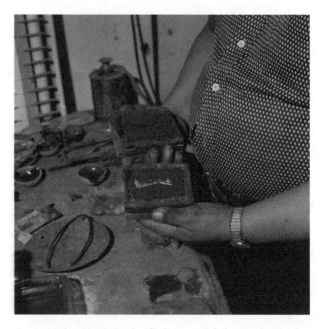

Señor Nubes opening the flask to reveal the newly cast leg milagro. (Photograph by Helga Teiwes)

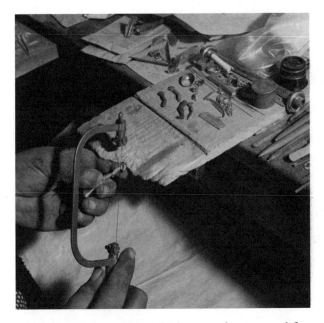

Using a jeweler's saw, Señor Nubes cuts the vents and fins off the leg milagro. (Photograph by Helga Teiwes)

Señor Nubes selected an ingot that he had cast from silver left over from other castings. The ingot contained enough silver to fill the mold cavity, the sprue channel, and the vents—with some left over. The extra silver would ensure that even if he spilled some, he would still have enough to complete the pour, which must be carried out without interruption.

To avoid burning his wooden workbench, Señor Nubes heated the ingot in a crucible on top of an old broken brick. After lighting the oxyacetylene torch with his cigarette lighter, he adjusted the flame to a high heat and held the torch about four inches above the crucible, with the flame playing on the ingot.

As the silver started to melt, Señor Nubes tilted the crucible with hollow tongs and sprinkled the silver with borax, which he explained is not like Borax laundry detergent but is instead a flux, a substance that promotes the fusion of metals. Without the borax, he said, the copper in the alloy would separate from the silver and rise to the top of the casting, forming an ugly dark patch.

The silver melted in a few minutes, but because the ideal casting temperature of sterling silver is slightly higher than its melting point ($893°C$,

or 1,640°F), Señor Nubes kept the flame on the liquid silver a little longer.

It is equally important, however, not to overheat the metal, Señor Nubes said, because pouring overheated metal generates too much steam, which could destroy the mold. Also, the hotter the metal, the longer it takes to cool and solidify. That, in turn, increases the likelihood of cracks and porosity in the cast piece.

After years of apprenticeship and practice, Señor Nubes knew the proper time to pour, and using the tongs, he brought the crucible as close as possible to the flask's sprue opening. This would minimize air contact with the silver and avoid unnecessary cooling of the metal.

Tilting the crucible, Señor Nubes quickly poured the silver as steadily as he could, directly into the middle of the sprue opening. He explained that if he pours too fast, the silver becomes agitated and the impurities in the molten metal do not rise to the sprue opening as they should, but are trapped in the milagro.

On the other hand, if he pours too slowly, the silver can harden in the flask before it is completely filled. Then, even if he continued pouring the molten silver into the flask, it would not fuse with the hardened metal already there. Instead, there would be a crack between the surfaces, known as a "cold shut."[3] To keep the silver liquid until the flask is full, Señor Nubes keeps the flame on it and pours quickly enough to fill the flask before the metal hardens, avoiding a cold shut.

Since Señor Nubes was working alone that day, he left the flask upright during the entire pour. He explained that sometimes he has a helper tilt the flask so gases can escape more easily. The helper would only gradually move the flask to an upright position by the end of the pour.

When the molten silver filled the mold almost to the top of the sprue opening, Señor Nubes stopped pouring. Acrid smoke and steam rose from its rim, filling the air with the smell of burning cement. While waiting for the casting to harden, Señor Nubes turned the crucible upside down and aimed the flame into it to melt the silver residue. It fell onto the workbench in small droplets that he recovered for future use.

The mold cooled quickly. When there was no longer any smoke and the silver had hardened in the top of the sprue, Señor Nubes unfastened the metal clamp. Then he held the flask horizontally and carefully

lifted the cope off of the drag. The milagro, looking very rough, remained in the drag.

Señor Nubes lifted the milagro out with tweezers, an easy task because the surface tension of the metal and the formation of gases between the silver and the mold had prevented adhesion. Stalklike projections known as fins jutted from the surface of the milagro where silver had leaked out between the cope and the drag. There were also protrusions where the silver solidified in the vent and sprue channels.

Although with careful handling Señor Nubes might have been able to salvage the mold to use again, he said he never reuses his molds. After one casting, the cement in the sprue channel and mold cavity is hardened and black from the heat of the molten silver, and the mold also shrinks and would no longer be accurate. "So if I used it again," he said, "I could only make a very crude milagro."

Señor Nubes took the milagro to a low table, spread a piece of heavy paper across his lap, and propped the newly cast milagro against a piece of unfinished lumber. He began cutting off the adhering vents and fins with a jeweler's saw, but he temporarily left the sprue attached to the top of the milagro, using it as a handle. Whenever the saw got too hot, he cooled it by putting the blade in his mouth. After using successively finer files to remove all traces of the vents and fins, finally he cut off the sprue with the jeweler's saw and filed away all signs of it. The sprue, vents, fins, and filings had all fallen into the paper on his lap, to be saved for future castings.

Señor Nubes erased the file marks with very fine sandpaper and polished the leg milagro with an electric buffer. To determine a price for the finished piece, he placed it on a jeweler's scale. It weighed five grams, and he said he would charge 250 pesos for it. (At the time, mid-October of 1982, the peso, which had been rapidly falling in value, was worth one U.S. cent.) Suddenly, to my surprise, Señor Nubes handed me the milagro and said it was a gift.

LOST-WAX CASTING

When Agustin Calleros, the Tucson jewelry designer mentioned earlier, lived in Colima, Mexico, he "mass-produced" cast milagros for the jewelry shops there not by sand-casting but by the lost-wax method. Years

later, when he cast single milagros for his customers in Tucson, he used the same method. "You can make one milagro at a time or one hundred at a time—all in one flask," he said, "but the most I ever made at one time was fifty."

According to Calleros, Josefina Lizárraga, and several other knowledgeable people, this method is typical. In Mexico, cast milagros are not made in large factories. Instead, they are "mass-produced" in small shops by individual smiths who may work alone or have only one or two assistants.

Calleros made only fifty milagros at a time because he produced high-quality pieces. "If I cast fifty on Monday," he said, "I might finish them by the weekend because it takes a lot of time to file them down and polish them." Other people who mass-produce inexpensive cast milagros of cheap alloys may leave them with rough edges and not polish them so they can finish them more quickly.

Since Calleros no longer makes quantities of milagros, he offered to do a lengthy mock demonstration for me in March 1993. Lost-wax casting requires many steps, and as Calleros explained, "Every time you cast you need to make new wax patterns." Wax patterns are made in rubber molds that are themselves made with metal patterns. Calleros said he used to have about fifty different metal patterns, "each about one inch high. I had just one of each type—a standing man, a kneeling man, a person lying down, a house, animals, and so on—whatever people made promises for. I made mine of nickel and silver or just silver—I can't remember which because it was a long time ago. You use the metal patterns to make rubber molds with a special kind of rubber that goldsmiths use."

The rubber he referred to is a pure, natural yellow gum rubber, and as he talked, Calleros demonstrated how two quarter-inch-thick sheets of rubber are placed in the drag, or bottom, of an aluminum mold frame similar to those that Señor Nubes uses. The inner dimensions of the frame were two inches by three inches by one-half-inch deep.

Next Calleros demonstrated how he soldered one end of a wire to the end of a metal pattern, and the other end of the wire to a homemade metal sprue cup. (The wire and the sprue cup formed the pattern for the opening into which wax would later be injected into the mold.) Then he laid the metal milagro pattern, with the attached wire and sprue cup, on

top of the layers of rubber, carefully positioning them in the middle of the frame. After placing the cope, or top, of the mold frame onto the drag, he gently placed two more quarter-inch-thick sheets of rubber in the cope to cover the pattern. "It's like a sandwich with one-half inch of rubber on the top and bottom and the pattern in between," he said. Then he used two rectangular metal plates, known as mold-frame plates, to cover the open outer sides of the frame, creating a flask. Calleros then placed the flask horizontally on a "rubber mold holder," which is a metal clamp, tightened with a wing nut, that holds the halves of the flask tightly together.

"Then I used to put the whole thing in an oven to melt the rubber," Calleros said. "If I were doing it today, I would use a special machine— an electric rubber-mold vulcanizer—but in those days I used a gas oven, like the kind you cook with. It was a separate one from my house oven because of the smell of the melting wax. . . . To melt the rubber, I heated the oven up to about 350 degrees [Fahrenheit]."

When the rubber became semi-liquid, it flowed around and into all the crevices of the metal pattern and then fused together, usually in about an hour. Too short a time would result in a mold that was too soft and had air bubbles. Too much time, however, would decrease the rubber's resilience.

After the flask was taken out of the oven, the rubber was allowed to cool to room temperature. To expose the pattern sandwiched between the rubber layers, Calleros used "a special knife like a surgeon's knife to cut the rubber through the middle. When I cut," he said, "I did *not* cut straight, so that when I wanted to put [the rubber mold] together again, the two halves would go back together exactly as they came apart and hold together without moving." As he spoke, he drew a jagged line to show me the kind of uneven cut he used to make.

Calleros said he would then take out the metal pattern and sprue, leaving an empty mold cavity for the wax casting. The rubber mold was reused hundreds of times. "I used it two or three times a week for over twenty years," Calleros said. "I had about fifty different rubber molds made from my fifty or so metal patterns. But I only had one rubber mold of each design. So if I wanted to make fifty identical wax patterns, I had to make them one at a time using the same rubber mold."

To make a wax pattern, Calleros rejoined the halves of the rubber

mold (still in their mold frames), replaced the mold-frame plates, and clamped the flask together one more time with the rubber mold holder. Next, he placed the flask upside down with the sprue over the opening of what he called "another special machine," a wax-injector machine. The "special machine" Calleros used was a pot with an electric heater and a built-in thermostat. "I pushed a switch to set the temperature—just one temperature, not different settings," Calleros said. Anticipating my next question, he smiled and said, "I don't know how hot it was."

In the center of the pot was an injector nozzle that fit into the sprue. The molten wax could be pumped out of the nozzle under pressure when Calleros pulled out a plunger on a piston and then pushed it down gently. "If you push too hard," he said, "the wax goes all over and you have a mess. You can even get burned by it. Just one touch and it's full. You learn from experience how much pressure to use and how much wax you want to come out." The wax was not candle wax but a special casting wax. "It could come in any color," he said. "Usually it was green."[4]

After injecting the wax into the flask, he would wait about five minutes, Calleros said. Then he would take the flask out of the clamp, open the rubber mold, and inside would be the wax pattern, which he would remove while it was still warm enough to flex a little without breaking.

Calleros said that after making the fifty wax patterns for milagros, he would connect them into a "wax tree" with a central "trunk" and fifty "branches" pointing upward, with a wax milagro pattern at the end of each branch. The "trunk" was the pattern for the sprue channel into which the gold would be poured. The "branches" were patterns for the runners through which the molten gold would flow out to each milagro mold cavity.

To make the "tree," Calleros used casting-wax wire, which as its name suggests is simply a long, thin wirelike piece of casting wax. Using a small, heated metal wire, he would fuse each wax milagro pattern to the end of short casting-wax wire "branches." A thicker piece of wax wire became the trunk of the tree as Calleros fused the branches to it in evenly spaced tiers around the trunk.

"With the wax tree, I made another mold in something called 'investment' that's like plaster mixed with water," Calleros said, referring to a special plaster used in hot-wax casting. Calleros would make the invest-

ment mold in a 5-by-3½-inch cylindrical steel casting flask that, once assembled, looked like a tin can with the top removed. Its base was a round rubber dish with concentric raised ridges and a hole in the center for the sprue.

After putting the wax "tree" on the base so that the "branches" pointed upwards and the sprue opening was directly over the hole in the center, Calleros said he would slide the steel cylinder over the "tree" and onto the base, fitting it securely inside the rubber ridges.

Then he would prepare the investment. After mixing a measured amount of powdered investment with water, he would put the bowl containing the mixture on a vacuum machine, which was in turn covered with a glass bell jar. When turned on, the machine created a vacuum that sucked some of the air bubbles from the investment. After about three minutes, Calleros took the bowl out and carefully poured the investment into the cylindrical flask, completely covering the wax "tree" in the center. He then put the uncovered flask in the vacuum machine for about a minute and a half to suck out more air. Otherwise there would still have been too many air bubbles in the investment and the resulting mold would have been weak.

"I let it dry for an hour or so until the investment got hard and then took the rubber base off," Calleros said. "Then I put the flask into my oven upside down with the sprue facing down and the branches pointing up so the melted wax would run out easily. Today for my castings I use a burn-out oven and I heat it up to 1,600 degrees [Fahrenheit]—more or less—depending on how big the piece is—for about three hours. But back then I used my gas stove. I set it at 500 degrees [Fahrenheit] for about ten or twelve hours."

To make sure the investment would be hard and dry, and that all the wax had come out of the mold, he would take the flask out with pliers and put it, still upside down, on a piece of glass. If any wax dripped out, it needed more time in the oven. If no wax came out, the mold was ready for casting.

While the investment mold was still hot, he put it back on the vacuum machine to get it ready for the pour. "You have to use it while it's still hot," Calleros said, "because otherwise, if the investment is cool, it cracks from the heat of the melted gold." This time he placed the flask upright with the sprue hole facing up so he could pour the gold into it.

The "branches" of the "tree" now pointed downwards so the gold could easily flow into them and into the empty molds for the milagros.

Calleros did not use the bell jar for this step. Instead, he said, "I just put the flask in the center of the machine over the hole connected to the tube for sucking air out. I pulled the switch to get the suction working. There was no channel between the mold [cavity] and the suction tube of the machine, but the air still got sucked out of the mold cavity through the tiny holes in the investment. I wanted this suction already working so when I poured the gold, the suction would already be taking the air out of the mold cavities and would suck the gold into them."

While the mold was on the vacuum machine, Calleros would use a torch to melt the gold in a crucible. As it melted, Calleros sprinkled it with crystallized boric acid to prevent oxidation. When he judged that the gold was ready, he poured it quickly and steadily into the mold.

"I let the gold cool for awhile and then took the entire mold and put it in a bucket of water until the investment dissolved—about thirty minutes to an hour. When the investment dissolved into the water, just the casting was left. If I was in a hurry, I put the flask in the water right away—it wouldn't hurt anything. Then the water turns to steam and blows the investment apart but it doesn't hurt the casting. I took the casting out of the water and cut the milagros off with a jeweler's saw. The milagros were not darkened from casting, just dull. So after I filed them down I polished them."

Although a few milagros in the region—such as the large fishing boat offered at Magdalena—have been carved of wood, bone, or shell, such handmade offerings, as well as the milagros made by jewelers and silversmiths like Carlos Diaz, Ruben Nubes, and Agustin Calleros, are only a fraction of the milagros seen in the region. Instead, the thousands of milagros mass-produced in Mexico in workshops like Novedades Contreras make up the vast majority of offerings left at sites in and around the Tucson-Magdalena corridor today.

5

From Heads to Handcuffs: Many Kinds of Milagros

The hundreds of thousands of milagros offered over the years at San Xavier and Magdalena provide a rich sample of the many kinds of milagros used in the Arizona-Sonora region and show that milagros were offered for almost every imaginable situation or problem. Since both the identity of the donors of these milagros and the nature of their mandas are unknown, one can only guess why each one was offered. However, many people in cultures where milagros are used enjoy explaining the meaning and use of each type, so I was not surprised that while I was sifting through the trunksful of milagros in Padre Santos's closet, he enthusiastically offered opinions about many of the offerings.

A few weeks later, as Helga Teiwes was photographing part of Padre Santos's collection, she and I had an extremely lively and laughter-filled conversation with Padre Santos, Señora María Castillos (the former directress of the parish school), and other people who worked at the rectory, as they speculated about the more unusual milagros. Later, other people, including Josefina Lizárraga, who sells milagros in Tucson and

is familiar with them from years of living in Mexico, also helped explain the offerings.

Almost all the milagros left at Magdalena and San Xavier are less than 1¼ inch high and are "mass-produced" by die-stamping or casting cheap metal. It is impossible to tell how old they are on sight because the designs rarely, if ever, change.

An analysis of 3,045 milagros offered at San Xavier between 1969 and 1974, and 43,891 milagros offered at Magdalena between October 1988 and March 1993, suggests that about 90 percent of the milagros offered at both shrines depict the human body or its parts. This reflects the fact that the vast majority of milagros are offered for cures from disease, bodily injury, or mental distress. In the same two collections, about half of the milagros are representations of an entire person (see the appendix for charts listing the number and percentages of each type of milagro at San Xavier and Magdalena).

WHOLE-BODY MILAGROS

Although figures of men, women, and children of both sexes are found, images of adults predominate. These whole-body milagros are usually offered when a disease affects the entire body, or the donor is unsure which part of the body *is* affected. A donor might also offer a whole-body milagro when he or she knows the source of the problem but cannot find the appropriate milagro to portray it, or when he or she simply wants to ensure that all possibilities are represented.[1] Whole-body milagros are also offered for the resolution of unhappy love affairs and other personal problems. As a saleswoman at the former Ave María Shop in Tucson said, "A whole body—that covers everything!"

Almost all milagros of men are kneeling figures with their hands together in prayer. Most people say a kneeling figure, male or female, represents a prayer answered, but others say it represents a plea. Most of the kneeling men are in profile, but some are in three-quarter view. Most are shown in long pants and short, *charro*-style jackets or mariachi outfits; virtually all other kneeling-men milagros have mid-twentieth-century suits. A few custom-made kneeling men are dressed in ethnic clothes.[2]

Some custom-made offerings combine other elements to give the kneeling man more meaning. A half-face cast-gold man in a suit, offered at San Xavier, is kneeling in prayer on a brick pavement. At Magdalena,

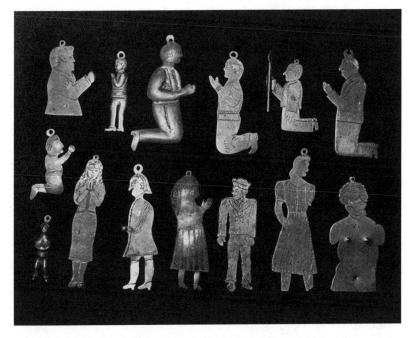

Silver milagros offered at Magdalena: *(top row, second from right)* a kneeling man in a short, charro-style jacket holding a long, three-dimensional burning candle; *(bottom right)* an engraved figure reminiscent of the Venus de Milo. (Photograph by Helga Teiwes)

a two-dimensional engraved-silver kneeling man has a three-dimensional burning candle soldered to his right hand. The candle is almost half as tall as he is. According to Lizárraga, this type of milagro was popular in the 1930s and commemorates the donor approaching on his knees to offer a very large candle to St. Francis.

Figures of standing men are usually in profile or frontal view. Their hands are either clasped in prayer in front of their chests or simply hanging at their sides. The clothing is usually no different from that of the kneeling-men milagros, but some custom-made figures wear uniforms, work clothes, or ethnic outfits. One heavy sheet-gold monk has a long, hooded habit. One smiling fellow wears a sailor's uniform. Another man, his hands behind his back, wears the uniform of a Mexican traffic policeman or immigration officer, according to Lizárraga; it includes a waist-length Eisenhower jacket, which she said was a very popular uniform in the 1950s. Another man is dressed as a railroad conductor. All of these

offerings were left at Magdalena, but there are scores of men milagros in ethnic outfits at both shrines. A few other offerings have clothing and hairstyles of the colonial period.

Men are also occasionally portrayed without clothes. At Magdalena there is an engraved sheet-silver nude man in profile, walking with his hands outstretched in prayer. Another nude man at Magdalena is cast in the round in silver, with a gold heart soldered to his chest. Neither offering portrays the male sex organs, however.

Like milagros of men, those of women are usually kneeling in prayer. The praying hands often hold a psalm book or cross. Sometimes rosary beads hang from the fingers. Most wear long, flowing dresses and have long shawls covering their heads and draping over their arms, but some are dressed in more modern clothes. One woman milagro at Magdalena has an apron with a big pocket.

Some milagros, especially those that have been custom-made, depict standing females dressed in a wide variety of clothing. At Magdalena, many wear everyday clothes such as simple dresses or skirts and blouses. One young woman is wearing a suit, and others wear ankle-length dresses. A few even wear hábitos. At San Xavier, one older woman engraved on sheet-silver wears a skirt, a long jacket, and a long *mantilla* over her hair. Some standing women at both sites are in costumes reflecting their Indian or colonial heritage. At San Xavier, one two-dimensional silver piece, engraved on both sides, portrays the front and back of a woman in what looks like a long, fringed buckskin dress, the ceremonial dress of an Apache, perhaps, but not an O'odham or Yaqui. One milagro at Magdalena shows a woman lying down. The engraved sheet-gold offering portrays her in profile, fully clothed. She reclines on a thick mattress with its stitching represented by rows of finely detailed zigzagging lines.

Although there were no totally nude women in the two smaller collections, I did find a daring, handmade sheet-silver image of an *almost* nude woman in the three trunksful of milagros at Magdalena. She stands in a pinup pose, her right hand on her hip and her left hand at her side. At first glance, she seems to be wearing only high heels. Raised and colored nipples, a recessed navel, and an incised pubic area make her appear nude, but faint lines indicating a V-neck and the ends of sleeves suggest she is wearing a very sheer, see-through garment.

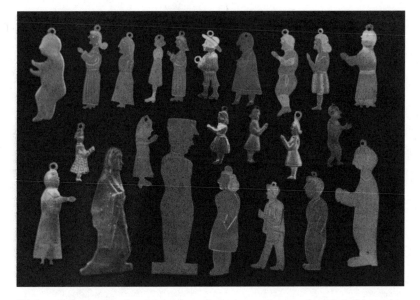

Silver milagros offered at Magdalena depicting various styles of clothing: *(top, second and fifth from left)* women wearing hábitos; *(bottom, third from left)* a man in a conductor's uniform, with "CONDUCTOR" engraved on his cap, and the initials "T.M.G." engraved at the bottom. (Photograph by Helga Teiwes)

Whole-body milagros almost always depict only one person. One exception is an engraved sheet-silver bride and groom standing arm-in-arm. He is wearing boots, pants, and a charro-style jacket, which Lizárraga said was popular among poor people in Mexico in the 1930s and 1940s. The woman is wearing high heels, a dress with a tiered skirt, and a long mantilla or bridal veil. Another couple is represented by two inexpensive silver-colored half-face castings: a kneeling man in a charro-style jacket, and a kneeling woman in a long dress and head shawl. They are tied together, face-to-face and body-to-body, by several strands of orange thread wound around both their waists. When Padre Santos saw these offerings, he laughed and speculated that they could have been offered for finding a suitable spouse, for marital harmony, or even for the return of an estranged spouse.

Unlike milagros of adults, virtually all those of children portray them standing and facing forward. Their hands are usually held together in prayer, but occasionally they hang at their sides or are clasped across their abdomens. One exception is a two-dimensional engraved-silver mi-

lagro at Magdalena depicting a girl in a 1940s or 1950s dress walking with several books under her right arm. Another rarity, at San Xavier, is a half-face cast-silver offering of a boy wearing a suit with a baseball cap, reportedly a common combination from the 1930s to the 1950s. He is striding along with his face turned three-quarters away from view.

Most of the mass-produced milagros of children depict short haircuts and clothing styles of past decades. Girls wear pleated or scalloped dresses; boys wear knickers. A few half-face cast girls are designed in the "Shirley Temple style," according to Lizárraga. They have long curly hair and short dresses with short puffed sleeves and wide, rounded collars.

People say that milagros of infants are most often offered for the conception or safe delivery of a child. Sometimes they are given for the survival of premature babies or for an infant's recovery from a birth defect, disease, or accident. At Magdalena, there are many milagros of very young nude children with their knees partly bent, their hands clasped over their breasts, their mouths open, and their eyes closed. They are cast

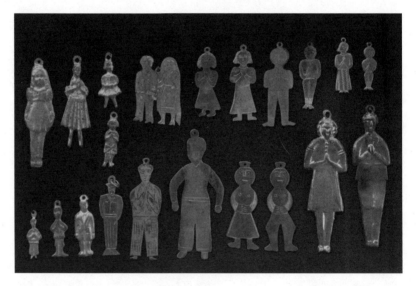

Silver whole-body milagros offered at Magdalena: *(top, far left)* Shirley Temple–style girl; *(third from left)* two of the most common types of girl milagros; *(fourth from left)* an engraved bride and groom; *(bottom left)* the two most common types of boy milagros; *(fourth from left)* a man in a uniform with an Eisenhower-style jacket. (Photograph by Helga Teiwes)

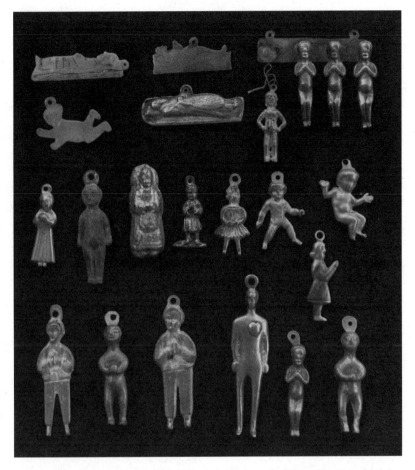

Sheet-silver and cast-silver milagros of children and adults offered at Magdalena: *(second row, center)* the reclining figure of San Francisco; *(upper right)* three nude infants, probably part of a set of quadruplets; *(center)* common types of boy and girl milagros; *(bottom, third from right)* a cast nude man with a gold heart soldered on his chest. (Photograph by Helga Teiwes)

in the round in silver and appear to be made from the same mold. One offering, probably representing quadruplets, is composed of three of these children in a row; the backs of their heads are soldered to a flat, oblong piece of silver with an open space and solder mark where a fourth milagro was probably attached. A similar child milagro is soldered, face-up, onto a custom-made miniature cast-iron bed to more clearly convey a message to San Francisco. People at the rectory wondered whether it represented a bedridden child or one who recovered from an illness.

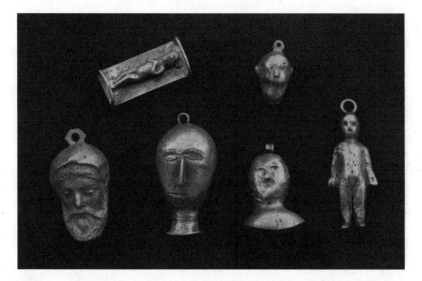

Cast-silver milagros offered at Magdalena include a child soldered to a hand-made bed. The crude ovoid heads and the center head with its schematized features contrast sharply with the realistic head on the left. The schematized head has a gold band around its neck. (Photograph by Helga Teiwes)

Infants and toddlers are usually portrayed nude. Most mass-produced infant milagros are sitting up with widespread legs and open arms, but some lie on their stomachs or sides. Custom-made infant milagros are more varied. At Magdalena, a sitting infant artistically engraved on sheet silver is wearing fancy trimmed underpants and, curiously, a man's tie or scarf around his neck. Another engraved sheet-silver infant is crawling, dressed only in socks and shoes. A few large milagros of toddlers at Magdalena stand out because even though they are cast in the round in silver, they are very crude. Their facial features are amorphous or only roughly indicated. In contrast, one half-face gold casting at San Xavier is an elaborately detailed standing infant with curly hair and staring eyes, dressed in a diaper and a sleeveless undershirt.

BODY-PART MILAGROS

An analysis of the two smaller milagro collections suggests that slightly more than half of those offered at both shrines depict not a whole person but only a *part* of the body.

Some milagros represent just the upper half of the body. Most are custom-made, two-dimensional engraved pieces that attempt to show the particular physical features of the donor, including his or her face. One detailed offering at San Xavier portrays a girl with curly hair wearing a V-neck sleeveless blouse. An engraved sheet-silver milagro at Magdalena, reminiscent of the classic Greek statue of the Venus de Milo, depicts a woman from her head to below her waist. Her arms are cut off a few inches below the shoulders, and her bare breasts are curved outward in repoussé (that is, formed in relief by being pushed out from the back). A drape hangs below her midriff, and her head, covered with tight curls, is tilted slightly downward.

Two silver milagros at Magdalena depict headless bodies. One is a profile of a male dressed in a shirt, pants, and boots. The other, probably also a male, is only an outline of a figure in frontal view with legs apart.

A few milagros represent torsos, or bodies from mid-thigh to shoulder with neither heads nor arms. Two at Magdalena are male; one is nude, the other wears only boxer shorts.

Some offerings at Magdalena represent only an upper torso. A few are women's torsos with breasts raised in repoussé. One is a man's torso with the entire stomach area raised in repoussé.

Another milagro at Magdalena shows a nude body, probably female, from just above the navel to just below the crotch. Although it may represent a problem with a sex organ, no genitalia are indicated. (In the Sonoran region, propriety usually prohibits milagros depicting sex organs even if they are the locus of the disease or injury.)

Some milagros show the body from the waist down. A sheet-silver offering at San Xavier is a nude profile of legs walking; the rear leg is soldered on so crudely, with many long scratches, that it is either an inept repair or a deliberate attempt to show a leg saved from amputation or a severed leg that was reattached. At Magdalena, a two-dimensional gold milagro represents the lower half of a body in frontal view with the legs separated. The feet, however, are in profile and both point to the right, possibly indicating a deformity. Unlike these two apparently nude offerings, two other lower half-body milagros at Magdalena are depicted in long pants.

Some of the most common body-part milagros are heads. These are offered for headaches, mental illness, memory loss, learning disabilities,

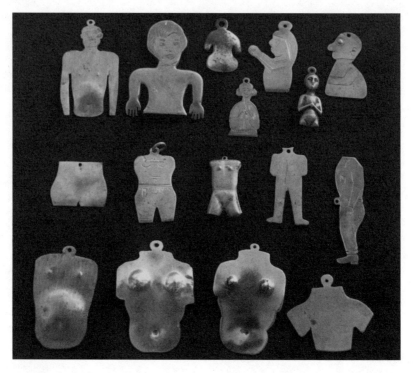

Handcrafted silver milagros of body sections offered at Magdalena. (Photograph by Helga Teiwes)

and head injuries. Heads of men, women, and children represent all ages. Men's heads often have beards, moustaches, or eyeglasses; most have full heads of hair but a few are balding. Female heads may have plain or elaborate hairdos as well as earrings or other adornments. Distinctive facial expressions, features, and hairstyles make many custom-made heads look like representations of particular people.

Aesthetically, head milagros vary greatly. A few of the three-dimensional offerings at Magdalena are just crude ovoids with an amorphous nose, no mouth, and mere indentations for eyes. Some have only schematized features. In contrast, one very realistic and detailed silver man's head has downcast eyes, a full beard, and a moustache.

Other milagros depict only parts of the head. A few engraved sheet-silver offerings at Magdalena represent sets of teeth and gums. All of them portray complete and perfectly even rows of teeth. Some depict only the upper or lower teeth; others show both rows, often clenched shut. Milagros of teeth are offered for relief from toothache or a gum

disease such as pyorrhea alveolaris. Engraved patterns on the gums of two of these milagros may indicate infection, or they may be merely decoration.

Virtually all eye milagros at Magdalena and San Xavier are stylized, two-dimensional representations of staring eyes seen from the front. Most have incised details. There are numerous half-face castings and die-stamped pieces, but only one cast in the round at Magdalena. Some of the handmade sheet-gold and sheet-silver eyes are flat, but most were hammered from behind in repoussé to give the entire eye or the iris a natural convex form.

The majority of eye milagros at both sites depict pairs of eyes, but people also offer single right and left eyes when only one eye is injured, infected, or losing its sight. In that case, people try to obtain either a right or left eye, but if the needed eye is not available, they may substitute double eyes. (The desire for proper representation of right and left pertains not just to eyes but also to arms, legs and all other body parts occurring in pairs.)[3]

Some eye milagros are quite unusual. One offered at Magdalena has

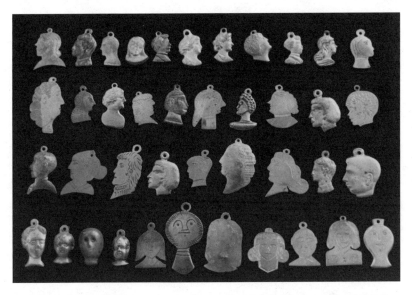

A variety of engraved sheet-silver and cast-silver head milagros offered at Magdalena. Note the tumor bulging at the base of a woman's head *(third row, third from right)*, and the girl's head with a protruding mouth *(bottom, fifth from right)*. (Photograph by Helga Teiwes)

a blue iris and white cornea made of glass, and the entire piece is rimmed by a silver band. A similar eye milagro is in the collection of la Iglesia de San Ignacio de Cabúrica, just north of Magdalena. This type of milagro is very common in Cuban areas of Miami and Tampa, Florida, and religious-goods dealers there say they are imported from Italy. One pair of gold eyes offered at San Xavier has scalloped edges and the words "SANTA LUCIA" incised in capital letters between the two eyes. No one but the donor knows why a milagro inscribed to St. Lucy was offered at a shrine of St. Francis.[4]

The designs on eye milagros at both shrines vary from the simplest to the most fanciful. One of the plainest is an incised pair of sheet-gold eyes offered at San Xavier that has only two dots indicating the pupils, and two zigzagging lines representing eyebrows. At the other extreme is a detailed pair of silver eyes at Magdalena with elaborate scrollwork filling the space around the eyes and eyebrows. Perhaps more than any other type, milagros representing eyes lend themselves to pure design.

Much less common than eye milagros are representations of ears. These are offered in cases of deafness and ear infection. Indentations or perforations near the eardrums may indicate the effects of *otitis media*, a common disease of the middle ear that causes inflammation and, in serious cases, spontaneous rupture of the eardrum. So many females in this region have their ears pierced for earrings that ear milagros are also given by women and girls who suffer from earlobe infections. Only single ears, both right and left, are mass-produced, but left ears are rare. If someone wants to offer both ears, he or she usually attaches them to form a pair.

Milagros representing throats are extremely rare. I have seen only two, both at San Xavier. One is made from a small rectangular piece of sheet gold beaten into a curved form to suggest the front or back of a neck or throat. The other, cut from a flat piece of sheet silver, has incised designs crisscrossing the throat. Both may have been offered for cures of diseased throats or injured necks, or for being saved from choking or drowning. (In 1982, one old Mexican woman on pilgrimage to Magdalena told me, "I promised a throat milagro when I was close to drowning and I was swallowing too much water. Now I can't find one for sale and I don't know what to do.")

Much more common are milagros of arms, and right arms outnumber left at both shrines. Most arm milagros include the hand and terminate either in the middle of the upper arm or just below the shoulder; a few, however, include a small part of the shoulder. Two-dimensional and half-face cast arms are virtually always in profile. Most are bent at the elbow, and many have lines or bands of decoration at the wrist and/or at the end of the upper arm. Arms cast in the round are usually bent at the elbow, too, but they lack decorative bands. Of all the arm milagros at both shrines, only one is not made of metal: a two-dimensional mother-of-pearl left arm offered at Magdalena.

There are fewer milagros of hands than arms. These offerings almost always depict the back of a single right or left hand that ends abruptly at the wrist or a fancy cuff. All the fingers are extended, and fingernails, joints, and knuckles are usually indicated.

Some hand milagros, however, are unusual. A two-dimensional silver offering at Magdalena is a rare depiction of two hands, side-by-side, with thumbs and cuffs touching. The fingers of a large, three-dimensional silver hand, also at Magdalena, are bent at right angles as if clawing something. One detailed sheet-gold milagro at San Xavier is a short, fat right hand that ends abruptly below the wrist in a ragged edge. Since the custom-made hand was skillfully done, the uneven edge may indicate that someone's hand was torn off in an accident.

Some milagros are single fingers. Several fully extended fingers ending just below the knuckle are found at Magdalena. At San Xavier a sheet-silver offering portrays a slightly curved index finger in profile. At Magdalena, a milagro cast in the round represents just the end of a finger, probably a thumb.

Many leg milagros are also found at both shrines, and all but one include the foot. The exception is a two-dimensional sheet-gold offering at San Xavier that extends only from mid-thigh to ankle. Most leg milagros end at the middle or upper thigh, but a few even include the hip. Many have decorative bands that indicate the tops of socks or high stockings. All legs at both shrines are metal, except for one at Magdalena that was carved from bone.

Nearly all leg milagros show the limb in profile. The only frontal views of legs I have seen in the region are two hand-cut right legs at

Magdalena. One is sheet silver; the other is gold, and its foot has only four toes.

Almost all leg milagros depict just one leg, not two. If a person has two diseased or injured legs, he or she usually offers both a right leg and a left, often attached by pins or ribbons. One of the few milagros portraying both legs is an elaborate sheet-silver engraving offered at Magdalena that is nearly covered with leaf designs. It shows two legs connected at the hips and extended in opposite directions in a pose even a contortionist could not replicate.

A couple of leg milagros at Magdalena also depict boots. The most dramatic is a half-face silver leg with a high gold boot soldered to it. The other, in silver, has a pant leg hanging over a cowboy boot.

Just as there are fewer hand than arm milagros, there are also fewer foot than leg milagros. These offerings clearly portray either a right or left foot. Two-dimensional and half-face feet milagros almost always present the foot in profile with all the toes indicated. Only one two-dimensional offering at Magdalena depicts a top view of the entire foot.

All foot milagros at both shrines are metal—with one conspicuous exception: a finely carved, three-dimensional balsa-wood foot that is as big as a child's foot. This milagro—5¼ inches long and almost 2½ inches high—was left at San Xavier sometime between 1969 and 1974. The toes are separated and have incised toenails and wrinkles at the joints. A small, braided, white cloth bow is fastened to the front of the ankle. In the center of the bow is a tiny, quarter-inch medal engraved with the words "SAINT FRANCIS OF ASSISI." Like the eye milagro incised with St. Lucy's name, the foot with the St. Francis of Assisi medal was also left on a statue of St. Francis Xavier. Perhaps the offering was intended for the statue of St. Francis of Assisi that stands in a niche behind the reclining Xavier statue and about twenty feet above it—too high for a donor to reach. Or perhaps the donor, like many people, simply fused the two St. Francises into a composite saint.

Milagros portraying two feet together are very rare. One, a silver pair of feet side by side, cast in the round, was on the reclining statue of St. Francis at San Xavier in November 1984.

Relatively few milagros represent other parts of the body. Only two

Carved balsa-wood foot offered at Mission San Xavier. (Photograph by Helga Teiwes)

milagros at Magdalena, both custom-made, portray the back. One has the spinal column recessed in a crease. The other shows the individual vertebrae raised in repoussé.

Milagros also depict women's breasts, both singly and in pairs. Breast milagros at Magdalena and San Xavier were once only custom-made pieces, usually in silver. In the 1980s, however, mass-produced breast milagros began to appear.

Breasts are offered for cures from disease and by new mothers for sufficient milk to nurse their babies. Two at Magdalena have darkened nipples. Another has two clearly incised lines on either side of the nipple, probably representing surgical incisions to remove cysts or tumors.

Ruptured or infected navels are represented by milagros depicting just the navel or the entire abdominal area. Local people have told me that since problems with the navel are most often encountered in infants, milagros of toddlers are sometimes used instead.

INTERNAL-ORGAN MILAGROS

Although only a small percent of the total, some of the most interesting milagros at both shrines are internal organs. An organ milagro may be

promised when the donor believes that a specific organ is responsible for a health problem.

The most popular organ milagros at both shrines are hearts. Anatomically correct and perfect valentine-shaped hearts are rare. The most common offerings are mass-produced *nearly* valentine-shaped hearts pierced by a sword, or with a flame at the top, or with a crown of thorns encircling the heart.

In Christian symbolism, a heart pierced by a sword signifies the Sacred Heart of Mary and symbolizes her sorrow as well as the faithful's contrition for sins; hearts with a crown of thorns or a flame signify the Sacred Heart of Jesus, and the flame connotes His love for mankind as well as religious fervor. In *popular* symbolism, plain valentine-shaped hearts indicate human love. Since anatomically accurate hearts are not mass-produced, people who want an inexpensive offering for heart disease must substitute one of the four symbolic hearts. Most people say the four types can be used interchangeably for any heart problem. Josefina Lizárraga says that "when people come into my store to buy a heart milagro, they don't check to see whether it has a flame or a sword. They're not very concerned about how it looks—they just want a heart."

The most common mass-produced hearts are those pierced by a sword and usually covered with incised blood vessels. Many of the custom-made sheet-silver pierced hearts, on the other hand, are covered with fanciful engraved designs. These pieces can be quite large. Two at Magdalena, for example, are 5⅛ inches and 4½ inches high. One offered at San Xavier is 3⅛ inches high, raised in repoussé and elaborately engraved with a cross, leaves, and other designs.

The second most common mass-produced hearts are those with a flame rising from the top. By far the least common are those with a crown of thorns. Strangely, I have seen no custom-made examples of either one.

Perfect valentine hearts, although rare, are the preferred offerings for unhappy love affairs or the loss of close relatives or friends. Most are custom made. Many have plain surfaces, but some are engraved with designs and names.

Unlike the four symbolic types, handmade anatomically correct

Large, 3⅛-inch engraved silver heart pierced with a dagger, offered at Mission San Xavier. (Photograph by Helga Teiwes)

hearts are almost definitely offered only for cures from heart disease, recovery from heart attacks, or successful heart operations. One especially detailed, two-dimensional engraved silver heart at Magdalena depicts not only the organ but also the veins and arteries protruding from it.

Unlike heart milagros, offerings of lungs are rare. Both lungs are usually represented. Some show the folds, veins, and arteries, and a few custom-made milagros at Magdalena also portray the bronchi, the trachea, and even the larynx. Lungs are offered for cures from pneumonia, asthma, emphysema, and lung cancer, and for being saved from drowning.

Milagros of stomachs are also rare. Most are plain two-dimensional pieces showing the esophagus protruding from the top of the organ, and the duodenum projecting from the bottom. One milagro left at Magdalena, however, is a detailed half-face silver casting incised with lines depicting the folds of the stomach's inner lining.

At Magdalena, kidneys are less common than lungs and stomachs,

but at San Xavier they greatly outnumber the other two organs. Kidneys occur in the body as a pair, but until recently only single-kidney milagros were mass-produced. Even now, people with problems in both organs often leave two single kidney milagros connected by a wire, ribbon, or safety pin. Almost all kidney milagros are mass-produced silver- or gold-colored half-face castings with projecting ureters and incised calyces, or sacks.

One artistic exception, at Magdalena, is a large, almost 2-inch-high hand-cast silver kidney. The raised outer vascular or cortical portion of the kidney, the calyces, and the ureter are bright silver, while the recessed, tubular central portion has been darkened to create a clear contrast between the parts. Probably the whole piece was dipped in acid to blacken the silver, then only the raised areas were polished (a method some Hopi Indians use in their distinctive silver overlay jewelry).

MILAGROS DEPICTING BONES

Milagros of bones are far rarer than milagros of internal organs. I have seen only three—all custom-made silver pieces at Magdalena. One is a

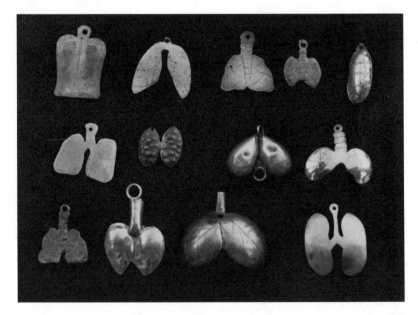

Gold and silver lung milagros offered at Magdalena. The sheet-silver torso (*upper left*) has one lung incised with designs on each side of its back. (Photograph by Helga Teiwes)

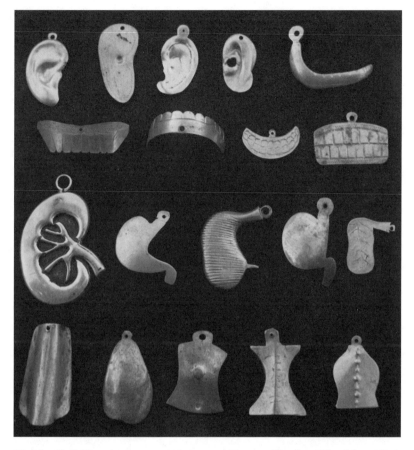

Handcrafted silver body-part and organ milagros offered at Magdalena: *(top)* four ear milagros, three of which have punctured eardrums; *(third row)* a large, detailed kidney *(far left)* and four stomachs, including one with horizontal lines depicting its folds; *(bottom right)* two backs, one with an incised spinal column *(left)* and one with the vertebrae raised in repoussé. (Photograph by Helga Teiwes)

small, 1½-inch-high model of all the body's ribs and much of the spine. Every rib was carefully cut out of sheet silver and then bent to create a three-dimensional offering that actually looks like part of a skeleton. Another piece, 1⅝ inch high, is a less realistic sheet-silver representation of the ribs on only one side of the body. Both milagros were probably offered for broken ribs.

The third bone milagro was a half-face cast model of a human skull with traces of an unidentified hard black substance in the left eye socket.

Padre Santos and other people at the rectory said it was probably offered by someone who narrowly escaped death.

Another milagro at Magdalena—an engraved sheet-silver bust of a hairless man with feathered angel's wings spreading upward from the shoulders—may represent a dead person's soul. Everyone at the rectory agreed that it probably had been offered to assure that someone who had died or was about to die would go directly to Heaven.

MILAGROS DEPICTING AFFLICTIONS

A handful of custom-made milagros clearly depict the nature of an affliction. An engraved 3½-inch-high sheet-silver standing woman wearing a thick hair net and a short sleeveless mid-1940s dress shows her left sleeve hanging limply because her arm is missing. An engraved sheet-silver profile of a woman's head has a large tumor bulging out of the base of her skull and surrounded by her long wavy hair. One small, ¾-inch-wide pair of silver lungs is covered with lumps in repoussé that may represent tumors. A silver woman's breast displays a diseased nipple. Two other breasts have concave nipples, a condition that can make breast-feeding difficult or sometimes impossible. A sheet-silver milagro depicts a child with crossed eyes, its mouth and jaw twisted to the left, and deformed arms. All these offerings were left at Magdalena.

At San Xavier, milagros depicting the nature of an affliction are even rarer. One silver left foot and lower leg is twisted in an exaggerated curve, possibly representing a leg deformed by polio or arthritis. A half-face cast-silver hand with elongated and twisted fingers may also show the effects of arthritis. The most poignant offering is an artistically engraved sheet-silver head of a young woman with large sad-looking eyes and a cleft lip.[5]

Sometimes the afflicted body part is emphasized by making it a different color metal than the main body. One boy at Magdalena, for example, has brass arms on a silver body. Also, if the ailment involves an internal organ, a gold model of the organ may be superimposed on a partial or whole-body silver milagro.

A few of these composite milagros were offered at Magdalena. One engraved sheet-silver nude figure, probably a woman, is depicted in three-quarter view down to the thighs, and three nearly oval gold shapes

are soldered in a triangular formation onto the abdomen. On another milagro, soldered to the left side of the chest of a 2⅜-inch-high nude silver man cast in the round, is a gold heart. Another gold heart is soldered to an engraved sheet-silver bust of a matronly woman with dangling earrings and her hair tied in a bun. Perhaps because her detailed head and face might be recognized, she is clothed in a print dress for propriety.

Sometimes an afflicted internal organ is merely engraved on the surface of a torso or whole-body milagro. At Magdalena, two lungs decorated with designs are crudely incised on the back of a sheet-silver torso. Two more lungs, or possibly shoulder blades, are represented by two rough trapezoids engraved on the back of another sheet-silver torso.

Occasionally someone tries to emphasize a sick part of the body by raising one part of a milagro in repoussé. One such milagro of a male torso had a raised abdomen. Another milagro at Magdalena, a handmade, engraved sheet-silver girl's head in frontal view, is flat except for the mouth, which has been hammered from behind to make it protrude abnormally.

OTHER MILAGROS

So many milagros are offered for human diseases, injuries, or social dilemmas that only about 10 percent represent other problems. These offerings include everything from a half-face cast-silver clam shell to a pair of gold handcuffs.

Some milagros depict agricultural products. Several are gold, including a ¾-inch-long half-face cast cluster of grapes and a three-dimensional tomato, chili pepper, and cucumber linked by a thick gold wire. One milagro is reminiscent of the ancient Egyptian artist's method of portraying rows of fruit trees without using one-point perspective: a 1⅛-inch-by-2⅜-inch gold sheet, folded down the middle like a slightly peaked roof, has several rows of fruit trees engraved one above the other with every tree, even those in the distance, the same size. The offering appears to symbolize an orchard on both sides of a hill.

Another offering is an elaborate, engraved sheet-silver rosebush, 3⅞ inches high including its roots. There are also several silver ears of corn, including one large, 4½-inch-long engraved two-dimensional offering

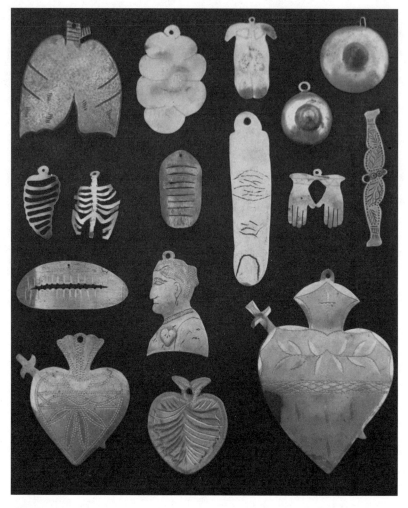

Handcrafted silver body-part and organ milagros offered at Magdalena: *(top left)* a pair of lungs; *(top right)* two breasts with darkened nipples. In the second row are two rib cages *(far left)* and a fanciful pair of legs *(far right)*. In the third row is a set of teeth and gums *(far left)* and a bust of a matronly woman with a gold heart soldered on top of her print dress. (Photograph by Helga Teiwes)

and one small, 1⅛-inch half-face casting. Another, extremely detailed sheet-silver sheaf of wheat is carefully cut out by hand.

No milagros of plants or trees were found in the San Xavier collection, but there is a sheet-gold plow that may have been offered for a successful planting season.

There are more milagros of domestic animals than agricultural products at both shrines. In the collection from San Xavier there were only three cows, but offerings at Magdalena included a number of cows, bulls, horses, sheep, goats, pigs, mules, burros, hens, roosters, turkeys, cats, dogs, and an incised sheet-silver parrot. Most of these milagros probably were offered for the animal's recovery from disease or an accident. (I saw no milagros of animal body parts, although they *are* found in other countries, such as Brazil.)[6] A milagro might also be offered if an escaped animal is found unharmed, and it did not cause costly damage to neighbors' crops or other property. In rare instances, milagros attempt to demonstrate an animal's fertility or reproductive ability. For example, an engraved, two-dimensional sow offered at Magdalena is lying on her side with five piglets sucking at her teats.

A few sea-life milagros, all gold, were also left at Magdalena. A whale, a tuna, and a spiny lobster, all hand cut, and half-face castings of a sailfish and a butter clam are easily identifiable. Another half-face casting of a fish is probably a snapper, a grouper, or a snork, but it may be a totoaba, according to Dr. Donald Thomson, a marine biologist at the University of Arizona.[7]

Several boat milagros were left at Magdalena, all custom-made. One is a cast-gold yacht with eleven flags in its rigging, but most of the others are fishing boats. One is gold; the others—except for the large wood model described in chapter 7—are silver. A unique three-dimensional fishing boat made of pieces of sheet silver skillfully soldered together is 5¾ inches long and 3⅜ inches high. The cabin is engraved with windows and doors, the hull is decorated with incised lines and flower patterns, and braided silver wire forms the rigging for the nets.

The other boat milagros are less elaborate two-dimensional engraved pieces. Some are simple dinghies; others have cabins and rigging for nets. The fishing boats may have been offered for salvation from a storm at sea, abundant fishing, or money to buy a boat. In 1982, one fisherman asked Señor Ruben Nubes, the jeweler I met in Magdalena, to make five gold boats to represent five years of successful fishing.

Another two-dimensional silver boat milagro is a freighter with two large sails, smoke billowing from its stack, and bales of cargo on its deck. An incised rope ladder hanging from the deck down to the ocean waves

below may indicate that the donor escaped from a burning or sinking ship.

Padre Santos told me that boat milagros are offered at Magdalena by people living on the Gulf of California, especially in the town of Guaymas. At San Xavier, however, which is about the same distance from the gulf, there were neither boat milagros nor sea-life milagros. This is probably because the fishermen and lobstermen are Mexican and would naturally go to Magdalena instead of San Xavier.

Since far more people own cars and trucks than boats, it is not surprising to find milagros depicting them at both shrines. Unlike boats, most car and truck milagros are "mass-produced" in workshops, and most are silver. Custom-made offerings often depict not only recognizable makes and models but also details that identify individual vehicles. These are the donor's way of saying to St. Francis, "Remember that this milagro represents my car or truck, distinct from all others."

It is difficult to tell whether some strange-looking custom-made car milagros are the result of the makers' struggles with perspective or are accurate representations of vehicles after accidents. On one station-wagon milagro at Magdalena, the two front wheels are on the right side of the body, and the right front fender and right headlight both twist to the left. Another milagro at Magdalena depicts an older-model car with the engine compartment and hood tilted upward and a tow bar attached to the front bumper. These may have been offered for surviving accidents or for getting money for repairs. At Magdalena, another older-model car, with its hood open and an unidentifiable bulbous object protruding from the engine, may also have symbolized a car needing repairs.

The most elaborate car milagro at Magdalena was a large, 2¼-inch-long, all-gold casting of a circa-1950 Volkswagen "Beetle." All the details of the chassis are clearly indicated. Padre Santos playfully demonstrated that the car can even be rolled because its axles rotate.

Custom-made truck milagros at Magdalena include an incised sheet-silver, older-model 1½-ton slat-sided truck and a sheet-silver dump truck. Two more offerings are carefully cut out and engraved with all the details of a large, eighteen-wheel diesel semitrailer; one is silver, the other is real gold. They may have been given in gratitude for acquiring a truck, avoiding an accident, or getting a job driving a truck.

Cast-gold circa-1950 Volkswagen and 1902 U.S. Liberty Head half dollar offered at Magdalena. (Photograph by Helga Teiwes)

Even more common than vehicle milagros are house milagros. People promise to offer a house milagro when they need money to pay the rent or mortgage, or to make a down payment on a home. A house milagro might also represent a home spared from a disaster such as a fire or a severe storm. Most of them are "mass-produced" images of small two-story houses with peaked roofs seen from the right side. They all have a front door with one window above it and one to six windows on the right side.

Like custom-made milagros of vehicles, specially made offerings of houses often have details that the donors believe distinguish their homes from others. One half-face cast-gold house at Magdalena has incised adobe bricks, recessed windows, and a Spanish tile roof. Another house milagro, 1⅛ inch high and cut out of sheet gold, is extremely detailed. The brick chimney, shingled roof, and fieldstone facade are all carefully engraved; a front door, complete with doorknob, is soldered onto the house. Also offered at Magdalena was a unique three-dimensional house made of pieces of sheet silver soldered together; it has a floor, a peaked roof, and incised pediments above each window and door.

A few milagros are offered for success in sports. An engraved sheet-gold football and several baseball bats, cast in either gold or silver, have been left at Magdalena. Some of these may have been offered

A large engraved, three-dimensional silver house offered at Magdalena. (Photograph by Helga Teiwes)

by people who wanted to play on semiprofessional or professional teams.

A handful of milagros may represent addictions that the offerers have overcome or want to overcome. A half-face cast-gold milagro depicting a liquor bottle with a glass in front of it was left at San Xavier. At Magdalena, the word "TEQUILA" is inscribed in capital letters on another cast-gold liquor bottle. Also offered there was an incised sheet-silver martini glass and a 2⅜-inch-long sheet-gold cigarette with an engraved filter and a burning tip. (Padre Santos picked up the cigarette and pretended to smoke it. Then he pondered it at arm's length for a moment and announced, "Someone finally stopped smoking.") These offerings were probably made by people who stopped drinking or smoking, but it is possible that bartenders or a cigarette vendor offered them in thanks for good business.

Some of the most unusual milagros at Magdalena have to do with law enforcement. At least two represent jails. One is just a simple silver arched doorway with crisscrossed bars. The other is a three-dimensional, 1¾-inch-high, roofless and floorless triangular structure made of sheet gold folded at the corners. The door has an open

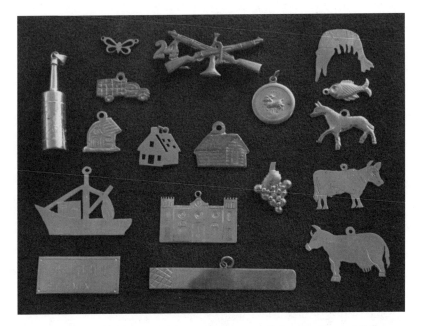

Gold milagros offered at Magdalena: *(top left)* a tequila bottle; *(bottom left)* license plate; *(bottom center)* cigarette. (Photograph by Helga Teiwes)

grillwork of bars as well as engraved hinges, a latch, and a padlock and the word CARCEL (Spanish for jail) inscribed above it in capital letters. A sheet-gold man is standing inside, his feet and arms attached to the bars of the cell door. Padre Santos rotated the miniature jail in his right hand and said thoughtfully, "Someone was going to jail. Then the judge let him go." Then he paused and said dramatically, "Or maybe he escaped."

A miniature pair of gold handcuffs was probably offered for one of the reasons a jail might be offered, but Señora María Castillos thought it may have been given by a police officer thankful for an important arrest, a new job, or a promotion. The handcuffs have movable hinges and are attached to each other by a gold chain.[8]

Other unusual milagros at Magdalena may represent the specific causes of problems. Both an incised snake cut out of sheet gold and an incised sheet-silver milagro of crossed hand-to-hand combat knives may have been offered after the donor either avoided or survived

an attack. Gold and silver nails may represent rusty nails people stepped on.

Other milagros, especially those at Magdalena, may represent wishes fulfilled. As I held up the offerings, Padre Santos and the others commented on their possible meanings. They concluded that a detailed, custom-made sheet-silver milagro of a well-tooled leather saddle may have been offered by someone who managed to buy or win a fancy saddle. A silver miner's pick, cast in the round, may symbolize a prospector's lucky strike. A homemade, crudely incised sheet-metal milagro of an RCA radio probably represents a radio somebody wanted. (However, Señora Castillos thought a gold crib was probably offered by someone who wanted a baby as well as a crib.) A detailed silver suitcase, its surface tooled to look like leather, may represent a trip, a vacation, or even a chance to emigrate. Miniature gold wire-rimmed spectacles with movable hinged bows (the curved ends that pass over the ears) may symbolize a special pair of glasses or improved eyesight.

A handmade sheet-silver guitar may express gratitude for obtaining a guitar or a job as a musician. Herbie Martinez, of Crowhang on the Sells Reservation, told me he made a guitar milagro in 1975 and offered it at

Three-dimensional sheet-gold jail and prisoner offered at Magdalena. (Photograph by Helga Teiwes)

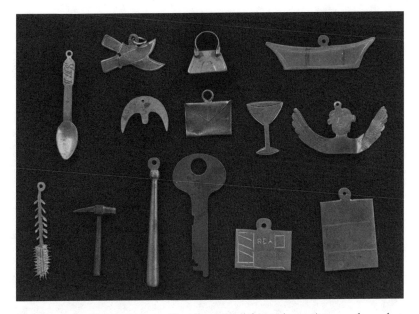

Handcrafted silver milagros offered at Magdalena: *(top row)* crossed combat knives and a handbag; *(second row)* a portfolio, a martini glass, and a bust with wings (which may represent a dead person's soul); *(bottom row)* a miner's pick, a baseball bat, and an RCA radio. (Photograph by Helga Teiwes)

Magdalena because he wanted to have his own band. By 1982 Martinez was the leader of a popular band on the reservation.

Other milagros may symbolize lost or stolen objects later recovered. When I held up a three-dimensional handbag made of pieces of sheet silver soldered together, I said, "Maybe this represents a lost handbag that someone recovered." Padre Santos replied, "Or maybe someone stopped a purse snatcher."

Milagros may also symbolize occupations. The handbag, for example, could have been offered by a manufacturer or a store owner thankful for a successful business. So could the wire-rimmed spectacles or a gold tire left at Magdalena. The sheet-silver parrot offered at Magdalena could have been left by one of the parrot vendors who sometimes come to town during the San Francisco fiesta. The gold nails at Magdalena may be gifts of successful carpenters, and the silver miner's pick may symbolize a job in the mines. A three-dimensional silver attaché case or

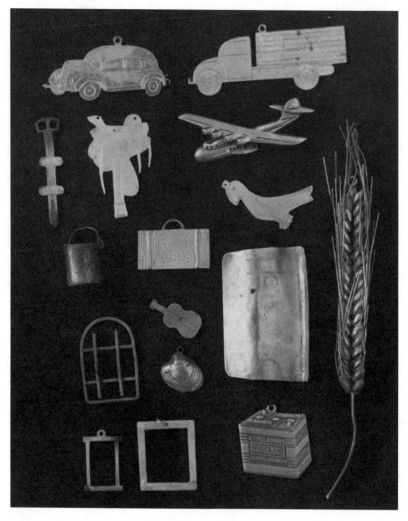

Unusual silver milagros offered at Magdalena: *(second row)* an engraved saddle and a parrot; *(third row)* a bucket and a suitcase; *(fourth row)* a jail-cell door, a guitar, and butter clam; *(bottom right)* a car battery. (Photograph by Helga Teiwes)

portfolio, also offered at Magdalena, may signify obtaining a white-collar job.

The purpose of some milagros is impossible for anyone but the donor to know. One is a carefully handcrafted miniature, three-dimensional silver pail that swings from its handle. Another is a silver spoon artistically

engraved with what appear to be the initials "S.F.E." Both were left at Magdalena. Padre Santos and I also speculated about the meaning of dozens of other milagros. We could not even figure out what some milagros represented, much less their significance. A sheet-silver rectangle incised with two, equidistant parallel lines, like many other unusual offerings, left us baffled.

A small number of people use jewelry charms or other objects as milagros, especially when they cannot buy the traditional milagro they need. Several such offerings at Magdalena included a gold-plated charm of the horoscope sign Aries, several gold basketball charms, a small aluminum advertising device depicting a Cardenas brand automotive battery, a pin with the insignia of a paratrooper, another pin with the insignia of the Twenty-Fourth Infantry, and a small gold-alloy treasure chest full of coins commonly used in wedding ceremonies in Mexico.

Although not technically milagros, several large baseball and swimming trophies have also been left at Magdalena, and an even larger trophy was offered at San Xavier. In 1982, as Father Kieran McCarty emerged from the sacristy one Sunday morning to say Mass, something unusual caught his eye: St. Francis and his bier were draped with a huge horse blanket with the words "Rillito Race Track" on it. Father McCarty jokingly suggested that the winner should have given St. Francis the horse instead of the blanket.[9]

A very few people actually forget the customary symbolic milagros altogether and instead promise St. Francis a milagro of himself. The one depiction of St. Francis in the five-year collection from San Xavier is a gold relief-casting of the saint in the center of a flat, round gold piece. At Magdalena, almost all of the milagros depicting the saint show him lying on his funeral bier. Two are simple 3¼-inch-long solid-gold castings that are almost identical except for the length of the saint's beard.

The most impressive St. Francis milagro is a 4¾-inch-long solid-gold statuette. The hair, beard, moustache, and facial features are carefully rendered, and the figure even has movable arms and legs. Dressed in the brown habit and white cord sash of a late-nineteenth-century Franciscan, this statue of a Jesuit lies face up inside a silver and glass casket. The

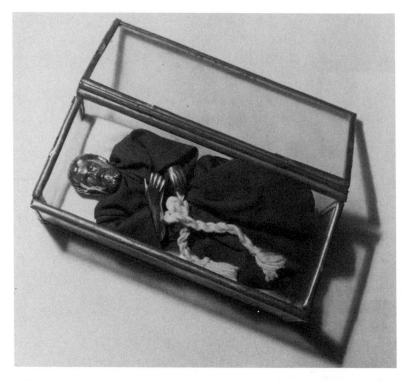

Solid-gold milagro of San Francisco in a glass and metal casket, offered at Magdalena. (Photograph by Helga Teiwes)

donor probably dressed the statue this way, instead of in a black robe, because he or she had observed that all the small cuerpecitos of San Francisco sold in Magdalena have brown robes. It may also just be another case of someone fusing San Francisco Xavier with San Francisco de Asis.

MULTIPLE OFFERINGS

In contrast to the milagros that Padre Santos had stored in the three trunks—almost all of which had been separated from any attached offerings—the 1988–1993 collection at Magdalena includes thirty-one multiple offerings: two or more milagros connected with safety pins, ribbons, threads, or tape. Twelve combine whole figures of people with body-part milagros. Two combine only whole figures; one, probably representing quintuplets, consists of five copper-foil reclining infants

strung on a safety pin; the other is two silver kneeling men, side by side, held together with masking tape.

The other seventeen multiple offerings indicate the donors' attempts to compensate for the lack of certain types of milagros. Thirteen people had attached right and left legs to form pairs: nine gold, and four silver. Three donors created couples by attaching a gold kneeling man to a gold kneeling woman. One person compensated for the unavailability of left ears by connecting two right ears and a gold milagro of a woman's head.

COMPARING THE TWO SHRINES

Exactly how many milagros of each type are offered at each shrine? No one can know for sure, of course, but the five-year collection of milagros offered at San Xavier and the fifty-two-month collection of milagros offered at Magdalena are suggestive. The San Xavier collection contains a total of 3,045 pieces, including 1,232 whole persons, 1,802 body parts, and 11 milagros of other types (see charts 1, 3, and 5 in the appendix).[10] The fifty-two-month collection of 43,891 milagros at Magdalena includes 20,670 whole bodies, 22,664 body parts and 557 other types (see charts 2, 4, and 6 in the appendix).[11]

The two collections suggest that the percentages of different kinds of milagros left at both San Xavier and Magdalena are very similar. The most common whole-body milagros at both shrines—nearly two out of three—are adults. Adults are also a nearly identical percentage of each total: 64.4 percent of whole bodies at San Xavier, 63.74 percent at Magdalena. Also, the number of men and women milagros is almost equal within each collection: 395 men and 399 women at San Xavier, and 6,434 men and 6,742 women at Magdalena. At both shrines, virtually all adults—98.9 percent at San Xavier and 99.59 at Magdalena—are kneeling.

Milagros of both boys and girls comprise almost the same percentage of whole-body milagros at both shrines. Boys are 15.58 percent of the total at San Xavier, 16.27 percent at Magdalena. Girls are 15.75 percent of the total at San Xavier, 16.23 percent at Magdalena. Even more remarkably, the number of boy and girl milagros is almost equal at each shrine: 192 boys and 194 girls at San Xavier—a difference of only 2—

and 3,364 boys and 3,354 girls at Magdalena—a difference of just 10. The percentage of infant milagros is also similar: only 4.22 percent of whole-body milagros at San Xavier and only 3.75 percent at Magdalena.

Moreover, the order of frequency of the most common body-part milagros is nearly the same at both shrines. The first, second, fifth, sixth, and seventh most numerous body-part milagros are *identical*. The most numerous body-part milagros at both shrines are legs; heads are second. Eyes or arms are either the third or fourth most common: eyes are third and arms fourth at San Xavier, but at Magdalena the order is reversed. The fifth, sixth, and seventh most common body-part milagros at both sites are hearts, feet, and hands, in that order.

The major differences in offerings between the two shrines are the percentages of kidneys, stomachs, lungs, and breasts in the total numbers of body-part milagros. The percentage of kidneys at San Xavier is ten times greater than at Magdalena. However, the percentage of stomachs at Magdalena is almost four times larger than at San Xavier, the percentage of lungs almost ten times greater, and the percentage of breasts almost thirteen times larger.

The higher percentage of kidneys at San Xavier may be partly due to the high incidence of diabetes and associated kidney problems among the Tohono O'odham who live nearby. The lower percentage of breasts at San Xavier may reflect the fact that the San Xavier collection is about twenty years older than the Magdalena collection; most of its milagros were offered before mass-produced breast milagros became available in shops. Anyone who wanted a breast milagro at that time would have had to have it made to order, at greater expense, so many women probably offered whole-body milagros instead.

Felipe de Jesús Valenzuela, a physician in Magdalena, attributes the higher percentage of stomach milagros at Magdalena to a high incidence of ulcers in that area.[12] He believes that the number of lung milagros offered at Magdalena is so high "because many people here are miners and they suffer from tuberculosis and other lung problems. Also, many people suffer from Valley Fever, an acute respiratory disease caused by a fungus in the soil[13] in this region. The disease is especially common among migrant [field] workers and people who come here from the south of Mexico and are exposed to it for the first time."

When considering the number of each type of body-part milagro offered, one must remember that some people leave whole-body milagros even when only one part of the body is afflicted. Therefore these statistics are only rough indicators of the types of problems for which people have offered milagros.

6

What Becomes of Milagros?

What becomes of the thousands of milagros left at San Xavier, Magdalena, and the other religious sites in the region?

In Arizona, at least, their fate is not determined by church rules. As Father Kieran McCarty, the resident historian at Mission San Xavier, explains, "the position of our theologians would be that the action of having the milagros made and giving them out of a motive of piety would be sacred; the material objects themselves would not." Thus the Roman Catholic Church has never tried to control them, Father McCarty said.[1] Since the milagros are not considered sacred, their fate is determined separately by each parish or by the owners of private shrines.

Milagros offered in the Magdalena–San Xavier corridor are usually left indefinitely on the images where they were offered. The most impressive example of this is at St. Anthony's Chapel in South Tucson, where 102 gold and silver milagros, which have been left at the shrine over the last forty years, dangle on long, brightly colored ribbons and strings draped over the beautiful statue of St. Lucy.

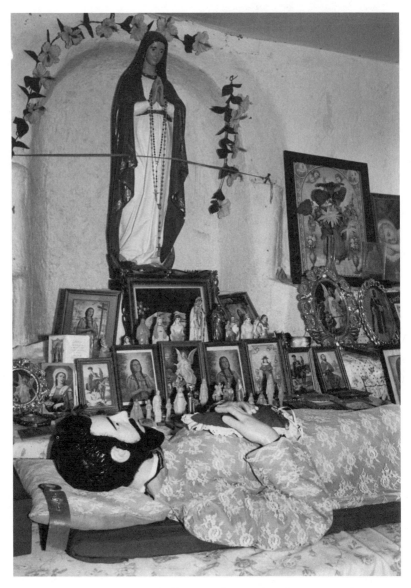

Statue of St. Francis Xavier holding a pillow with milagros pinned to it. St. Mary's Church, Hickiwan, Sells Papago Indian Reservation, 1993. (Photograph by the author)

At Our Lady of the Sacred Heart Church on the Sells Reservation, milagros offered on the statue of St. Francis have been periodically transferred to a series of ever-changing decorative pillows beneath or next to the statue's head. The offerings are not left on the statue because it is sometimes taken to other churches for the October 4 St. Francis celebration. However, the pillow and the milagros, which at last count totaled 53, remain permanently in Sells. At Hickiwan, farther north on the Sells Reservation, milagros are also kept in place on a pillow in the hands of the St. Francis Xavier statue in St. Mary's Church. Offerings are also allowed to remain indefinitely on images at Santa Cruz Church in Tucson, Sacred Heart and San Felipe de Jesus in Nogales, Arizona, and la Iglesia de la Sagrada Familia in Nogales, Sonora. St. Mary's Hospital in Tucson leaves milagros on images because, according to Sister Alberta Cammack, the hospital archivist, "the hospital is very careful not to offend people's religious practices."

Usually, milagros offered at household shrines are also left there indefinitely. "Why would you want to take them off the statues?" one Mexican American woman asked me. "While we were living in the state of Durango, Mexico, every time someone in the family got sick, my mother put a milagro on her statue of the Virgin of San Juan de Los Lagos [St. John of the Lakes]. They're still on, even though my mother carried it all the way to Chihuahua, where she lives now."

At other sites, the offerings are removed from the images, sometimes to prevent theft, sometimes to make room for future offerings, and sometimes because a priest does not want them left on the statues. The cleaning woman at one church told me that the priest instructed her "to leave the milagros on awhile and then take them down, because he doesn't like a lot of stuff hanging on the statues."

In contrast, Father Cyprian Killackey, the pastor of St. Margaret's in Tucson, said, "Milagros will be left on the statues where people hung them, as an expression of gratitude, until or unless someone removes them—either the offerers themselves or thieves." However, that was in 1982, and since 1990, all new offerings have been placed in the display created by Adelina Aros and protected by a high, locked wrought-iron gate. Another collection now secured against theft is at Holy Family Church in Tucson. The milagros had hung in a display case undisturbed for decades, but now they are safeguarded in the church office.

Some parishes periodically remove milagros from church statues and store them permanently in the sacristy or rectory.[2] At Magdalena, the hundreds of thousands of milagros saved by Padre Santos for over forty years are still in the three trunks he put them in. Reflecting modern times, more recent offerings have been stored in new five-gallon plastic wastebaskets. Following the tradition set by Padre Santos, Padre Salcido continues to have not only the most expensive milagros but also the most unusual ones set aside. Padre Salcido has no plans to break up the collection. In contrast to what priests in Arizona say, Padre Salcido told me that before either he or the parish can dispose of the milagros in any way, he must get permission from Rome. Padre Santos used to tell me the same thing.

By custom, all milagros offered at most other shrines in the Magdalena parish district had been brought to the church each year, usually during the celebration of the San Francisco fiesta in October.[3] Señora Josefina Gallego, the sacristana of Iglesia de San Ignacio, said that when Padre Santos was pastor, he sometimes came around to collect them himself. But in 1992, she said, "For the last five or six years, the milagros are no longer taken to Magdalena. The priest who says Mass here wants them to stay in San Ignacio. The new pastor in Magdalena, Padre Salcido, doesn't mention anything about milagros. So they stay here."[4]

Although milagros are left indefinitely on other statues at Holy Cross Hospital in Nogales, Arizona, those left on the statue of St. Martin de Porres are taken off and stored in the chapel. Sister Augustina Hernandez occasionally removes milagros from the statue "because so many people leave offerings on it. About two or three times a year—whenever it's too crowded—I take ten or fifteen or twenty milagros off it and leave the rest on," she said in April 1993. "That way it never looks bare."[5]

Milagros left at the three side-yard shrines in Tucson are also removed occasionally and stored in what each owner calls "a safe place." Edith Espino and Pauline Romo have regularly removed offerings at their shrines. Jimmy Campbell, however, permanently removed milagros from his shrine only once, and even then he took them off only one image, the 3-foot-high statue of the patroness of the shrine, St. Theresa. "Once, years back," he said, "I took everything off the statue and cleaned it and then put everything back on. Not this time—because the statue

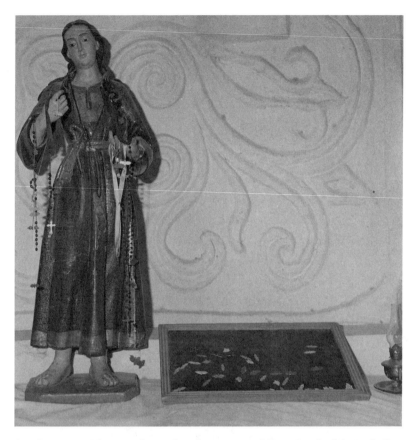

A velvet tray with eye milagros beside a statue of Santa Lucía. Iglesia de San Ignacio de Cabúrica, San Ignacio, Sonora, 1982. (Photograph by Helga Teiwes)

was just loaded with too many things. Before the mass held here last October [1992], first I cleaned everything off St. Theresa. I put it all in an iron box in a safe place in the house. The people who left the things can have them any time, if they want to."

Milagros left at a few sites are not stored, but buried. "Whatever you ask for, when a miracle is completed and fulfilled, it's over," one Yaqui man told me in 1993. "So the Yaquis take the milagros off the statues and bury them. You can't keep these things forever." A woman from Barrio Libre told me that Yaquis bury milagros in a garden where a shrine is or by the main cross in a cemetery. "My mom has her own garden where some milagros are buried," the woman said, "and she believes that's what makes the flowers and everything grow."[6]

Señora Delfina López, the caretaker of the shrine of Juan Soldado in Magdalena, told me there are many milagros buried in cement behind the altar. "There once were 500 to 700 milagros inside the chapel," she said, "and they looked very shiny, so someone who saw them thought they were gold and stole most of them. I put the rest of them in cement. Now I lock the chapel so no one can steal the milagros left on the statues."

Some milagros are now in museums. Sixty-six milagros offered at San Xavier are displayed on pale purple velvet in a glass case in the mission's museum. A large sign above the case explains that these "symbols of physical and mental pain and joy are placed with images of saints to relay messages to God." In 1974, Father Kieran McCarty donated 3,045 milagros that had been offered at San Xavier to the Arizona State Museum at the University of Arizona in Tucson. In the following years, he and other friars gave more milagros to the museum. Since 1991, Father Michael Dallmeier has permitted Dr. Bernard Fontana, formerly of the University of Arizona, to examine milagros left at the mission, and Fontana has added the most unusual ones to the Arizona State Museum collection.

Many people wonder who takes the offerings off St. Francis's statue at the mission, because except at the October 4 celebration, the faithful never see them being removed. Even many local O'odham do not know that it is Matilda Garcia, a sixty-year-old O'odham woman who used to wash the floors of the church. In early April 1993, she told me, "I take all the offerings off the statue whenever its clothes get dirty from people's hands touching it. I've done it a long time. I even used to help my mother when she did it. I'll go over before Easter next week and take the milagros and everything off St. Francis and change his clothes, too. I leave the milagros in the sacristy. I don't know what the priests do with them."

Some milagros left at St. Joseph's Hospital in Tucson have been placed in the hospital's archives. The policy at the hospital had always been to leave milagros wherever the offerers placed them, which most often was on the statue of the Infant of Prague. But in 1991, some of the nurses heard about the "necklace" of milagros that Sister Alberta Cammack made for the statue of the Infant of Prague at St. Mary's Hospital. According to one of the nurses, they thought that the cape, which was totally covered with milagros and Miraculous Medals, was too clut-

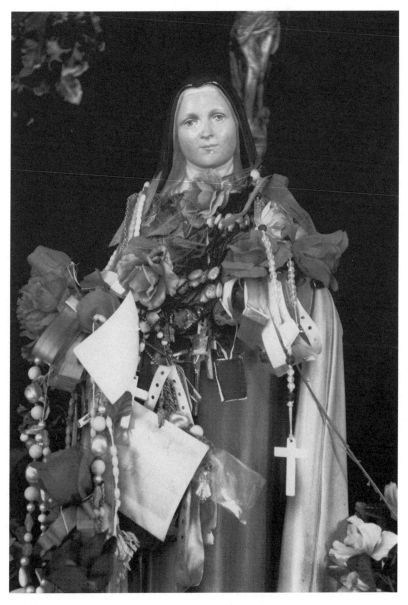

Statue of St. Therésè adorned with offerings at Jimmy Campbell's Chapel of St. Theresa, Tucson, 1992. (Photograph by the author)

tered, and so old that it looked "messy and dirty." They wanted to fol-
low Sister Alberta's example and make their statue look better, too.

They removed the offerings from the cape, which Polly Phillips, the
director of the maternity ward, said was "so old and in such bad shape
that it really couldn't be cleaned." Even after Jane Van Wie, the mother
of one of the nurses, made a new set of clothes for the statue, the nurses
decided not to put the offerings back on it. Phillips said she contacted
several places for suggestions on what to do with the milagros, and when
she called San Xavier to ask if they accepted them, "they said theirs were
sent to a museum and asked if we had some appropriate way of preserv-
ing them. So I sent them over to archives."

Still other milagros have been sent to a smelter to be melted down for
their silver or gold. Father Kieran McCarty said the "old-timers" at San
Xavier told him that "on occasion they had offered milagros back to the
silversmiths who made them. But the silversmiths complained that they
were not worth melting down due to the high percentage of baser metals
in their content."[7] So the friars sent milagros to smelters instead. "The
offerings were periodically removed from the statues and stored until a
good number had accumulated," he said. "The last batch that went to a
smelter was sent to Denver for the silver content around 1968."[8] The
money "was most probably used for the expensive upkeep of this two-
hundred-year-old church. It always needs something done to it."

Occasionally milagros have been melted down to make something for
the church where they were offered. Silversmith Ruben Nubes told me
that in about 1941, he helped arrange the casting of a large bell for the
church in Magdalena using milagros left there. The bell was so large that
they could not make it at his shop, so it had to be cast at the railroad
workshop. "The bell had such a sweet sound," he said, "because it was
made of so many different kinds of metal in the milagros."

The jeweler Agustin Calleros told me that in 1956 a priest asked him
to make the front half of a gold crown to attach to a painting of the
Virgin of Guadalupe in his church in Huatabampo, Sonora, Mexico.
"The priest gave me milagros to melt to get the gold for it. The crown
was about ten or twelve inches across and set with synthetic jewels. The
priest hung it on the painting during the mass for her feast day, Decem-
ber 12."

A few milagros are simply discarded. When I asked one priest about

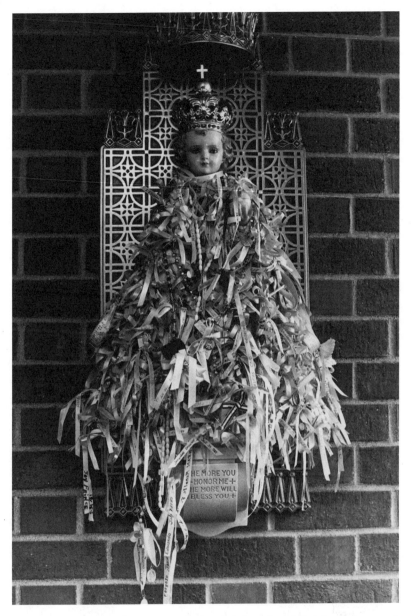

Statue of the Infant of Prague covered with Miraculous Medals, ribbons, and milagros. St. Joseph's Hospital, Tucson, 1985. (Photograph by the author)

the milagros left at his church, he startled me by saying, "I threw some of them away."

Some people who offer milagros end up taking them home. At Santa Cruz Church in Tucson, the donors sometimes take their milagros home after about a month. Father Killackey, the pastor there from 1985 to 1989, suggested that after recovering from an injury or illness, people might be retrieving their milagros and putting them in their shrines at home. But he said he was not sure if that explained the practice.

Jimmy Campbell said that some people also take their milagros home from his Chapel of St. Theresa. "They call me up and say, 'We picked up a little thing we left at the shrine and we took it home,'" he said, adding that he did not care if people retrieved their milagros.

Other milagros are stolen. In 1991, the church secretary at St. Augustine's Cathedral in Tucson, Barbara Valenzuela, said, "We only have three janitors and it's a big church. They can't always be watching all the statues. So the priests are asking people to leave their offerings on statues at home because they would be safer there than in the church."

Milagros used to be stolen from St. Margaret's Church, too. "Poor people who came into the church to get out of the cold took them to sell, and children took them too, maybe just out of curiosity," said Yolanda Grijalva, the church secretary. Now that all the church's milagros are safely displayed behind a locked gate, only new offerings left on statues outside the gate are in danger of being stolen.

Milagros are still stolen occasionally from Holy Family and Santa Cruz Churches, but Betty Galaz of Santa Cruz Church believes the people who take them are usually just children, "and they don't know what they're doing." "Maybe they think they're toys," she said. "We tell them to put them back if we see them doing it. Sometimes adults take them too—they can't find the kind they're looking for [elsewhere], so they take one and bring it somewhere else."

Milagros are stolen from St. Mary's Hospital, but Sister Alberta Cammack says, "The people who do it think they need the milagros more, and they can't see why God wouldn't want them to have them."

People sometimes steal not just the milagros but also the statues. Sister Alberta said several statues have been taken from St. Mary's Hospital, including the statue of St. Joseph the Worker, which used to be by the former front door, and the statue of St. Gerard Majella,[9] "where lots of

people used to leave milagros." Sister Alberta said that "having the statues gives the people status, so they steal them."

Not all milagros disappear forever, though. In 1982, I saw a collection of 130 whole-figure and body-part milagros and one very detailed miniature pair of sandals at Holy Family Church. Soon after, the old gray wooden case containing the collection was removed when the interior of the church was refurbished, and it was missing when I visited Holy Family again in 1985. Connie Molina, then the church secretary, said they had looked for it everywhere and had decided that the workmen, not knowing what it was, probably threw the case in the trash. However, in July 1990, the new secretary, Victoria Orosco, discovered that the church cleaning woman, Alice Gallardo, had the case at her home.

"I found it when I was cleaning," Gallardo told me, "but I didn't like the looks of it—it was ugly." She said her husband was "fixing the case" and that she had bought new felt for the backing. When I called Gallardo three months later, she gave me new reports on the progress of the repairs and then laughingly added, "By the time your book gets published, the case and the milagros will probably be back in the church."

She was right. In May 1992, the case was back at Holy Family with 160 milagros pinned to a red velvet backing. Gallardo later told me, "When my husband and I were cleaning the case and I was running around getting things for it, it all meant a lot to me, and having the milagros here seemed kind of holy—it touched us. You touched each one and thought of the person who brought it."

Perhaps someone will also find the dozen milagros I saw pinned to the brown cloth robe of a statue of St. Francis Xavier at St. Catherine's Mission in Topawa, a small village on the Sells Reservation. Two years later, in October 1982, all of them were gone and neither the new pastor nor anyone else seemed to know what had happened to them.

Possibly the only fate milagros in this region do not meet is being burned, although they are burned in other parts of Mexico as well as in Colombia, northeastern Brazil, and Spain.[10]

Some people who notice that the milagros they offered are gone may wonder what happened to them. Many of the faithful think that milagros left at a church are saved by the church, but almost no one knows for certain, and few care.

Some people who offer milagros say they have never considered what becomes of them. To them the question is irrelevant. Their only concern is completing their part of the bargain with the saint. They believe that once they have fulfilled their mandas by offering milagros, the saints know it and nothing else matters. Others disagree, and say people who offer milagros in petition, for example, might want their offerings to stay on the images at least until their requests are granted.

Some of the faithful believe there is simply no reason to take the offerings off. One Mexican American man asked me, "Why do the priests remove milagros from the statue of St. Francis at Mission San Xavier? At the Capilla de San Lorenzo, in the outskirts of Juárez, Mexico, by El Paso, there are red cloths covered with thousands of milagros left on forever. No one takes them. People take money, not milagros."

Still others believe that milagros are symbols that should be left where people can see them. As one fifty-five-year-old Mexican man said, "People shouldn't remove milagros from the statues. They're proof that the saint is powerful."

7

The New Milagro Art

Although twenty-three wooden crosses, covered with milagros, hang in groups on two walls, this is not a church, or a shrine, but the living room in an adobe house in Tucson. Three colorful wood nichos, each twenty-two to thirty-two inches high, contain statues of saints and are decorated with more than a hundred milagros. A one-foot-high wood statue of Nuestra Señora de San Juan de Los Lagos, also covered with milagros, stands in the center of a glass-topped coffee table. In the corners are two hand-carved Mexican chairs, each of their splats adorned with twenty-five milagros. Milagros also decorate two candle sconces on the wall behind one of the nichos. Interspersed with these pieces are twelve eighteenth- and nineteenth-century South American and Mexican wood *santos* (statues of saints), twenty old free-standing crucifixes, and many other antiques.

The milagro crosses, some black, some brightly painted, and others partially covered with tin, range in height from three to twelve inches. Ron MacBain and Gus Carrasco told me they started buying them about

Nicho decorated with milagros and other objects, made by Ron MacBain and Gus Carrasco. Tucson, 1993. (Photograph by the author)

four or five years ago from a Mexican man who occasionally comes to Tucson. The same man sold them the statue of Nuestra Señora de San Juan de Los Lagos, which was made in southern Mexico.

MacBain and Carrasco made both the pink and yellow nichos. The pink nicho contains a finely detailed statue of Jesus Christ holding a large cross. The image, which they bought in San Antonio five years ago, is known in the Mexican culture as El Divino Pastor (the Divine Shepherd). They decorated the inside and outside of the nicho by gluing on 141 milagros, 23 small crucifixes, 3 scapulars, 2 small white doves, 27 religious stamps depicting different saints,[1] a long string of pearls, and other decorative objects.

The yellow nicho is decorated with about fifty milagros, several scapulars, religious stamps, Mexican coins, and many pieces of jewelry that once belonged to MacBain's mother. "After she died, we considered giving the jewelry away," Carrasco said, "but then we thought it should be saved and something special done with it." The nicho also contains several rosaries and small statues of St. Joseph and the Virgin of Guadalupe given to Carrasco by members of his family in Chihuahua, Mexico. "Every time I go home, somebody gives me religious things belonging to the family and says, 'You can have it because we know you're going to put it in a good place.'"

Carrasco and MacBain sometimes call their nichos "santo boxes" because there are so many pictures and small statues of saints inside. "Gus got the idea of making the santo boxes when we were down at an exhibit at the Tucson Museum of Art and we saw a santo box done by a New Mexican artist," MacBain said. Although only Carrasco is Catholic, both men told me they were making these nichos "with respect" for the statues, the milagros, and the other religious objects used on them. They then showed me plastic bags full of milagros they had bought and intended to use to create yet another nicho.

The aqua-colored nicho, with about two hundred milagros on it, was made by Kim Yubeta, a jeweler in Tumacacori, a tiny town about forty-five miles south of Tucson. That nicho, which had been priced at $1,000, had been a gift to MacBain from friends.

Yubeta, who also uses milagros to make jewelry and to decorate mirror frames, works in a studio behind her tree-shaded adobe brick shop, Kim Yubeta Designs, across from Mission Tumacacori. She calls her

Kim Yubeta wearing one of her milagro necklaces. Tumacacori, Arizona, 1993. (Photograph by the author)

nichos "shrine cupboards" because she makes them with doors so that people can store things in them. Yubeta began making nichos about five years ago and now produces about two a year. The smaller 18-inch-high, 12-inch-wide nichos sell for $200. The larger 24-by-18-inch nichos sell for $800 and are decorated with about two hundred Peruvian and Mexican milagros as well as religious stamps, wood crosses, amulets,[2] glass beads, rhinestones, pictures, and small clay figures of Our Lady of Guadalupe.

About eight years ago, Yubeta began making milagro jewelry by combining milagros with semiprecious stones such as lapis lazuli, amethyst, and turquoise, and also glass African trade beads from Venice, Italy, and Czechoslovakia. "My milagro jewelry has a limited audience," she said as she modeled a necklace for me in April 1993. "The people who buy it

are about 50 percent Anglo and 50 percent Mexican American. Necklaces are the most popular. Some people have even brought me milagros that meant something special to them and asked me to incorporate them in a piece of jewelry."

"The milagros are recycled from their original use," she said, "and I hope with what I create with them that they give someone else a spiritual uplifting. Milagros touch something very basic in a lot of people—a private wish for a little extra protection from daily trials. We all have that need for a little protective magic, and with my milagro jewelry I'm trying to pass that on."

Displayed in her shop in April 1993 were twenty milagro necklaces selling for $100 to $300 apiece, forty-three pairs of milagro earrings priced between $15 and $45, and a nicho selling for $800. Yubeta also sells her work at the shop in the Tucson Museum of Art and at two stores in Tucson: berta wright gallery shops and Wright Designs and Associates. Yubeta has also collected one piece of milagro art—a wood statue of Nuestra Señora de San Juan de Los Lagos, whose cape is covered with silver milagros.

In Tucson, Martha Mendivil and her husband Ricardo make many of the milagro-decorated crosses and mirrors that she sells in her store ¡Aquí Está! Ricardo makes the wood pieces in their carpentry shop, and she attaches the milagros. "I make only three or four mirrors a year," Mendivil said, "because each one has about 140 milagros on it, and I nail them on one by one. So it takes a long time, and I have lots of other things to do running this business." In 1993, the Mendivils were making fifty to sixty milagro crosses a year and also selling others obtained from Guadalajara. Milagro-art collectors (97 percent of whom are Anglos, Mendivil said) can order other pieces after looking at a catalog from Mendivil's supplier in Guadalajara. The color pictures show milagro crosses as tall as thirty-three inches, as well as milagro-covered wood carvings of fish, shoes, horse heads, and Nuestra Señora de San Juan de Los Lagos. Although Mendivil does not sell milagro jewelry, her attitude about it is interesting. "People wear Our Lady of Guadalupe medals on necklaces and earrings, and that's okay," she said. "And the milagros are very pretty, so why not wear them, too?"

A wide variety of milagro crosses are sold at several other stores in Tucson. The UNICEF store on Grant Road in Tucson was selling black

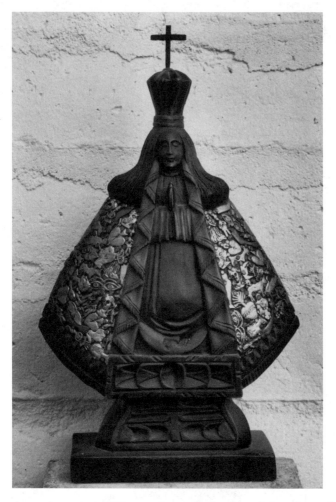

A wooden statue of Nuestra Señora de San Juan de Los Lagos decorated with milagros. Owned by Kim Yubeta, Tumacacori, Arizona, 1993. (Photograph by the author)

wood milagro crosses, including a 16-inch-high Celtic cross priced at $200. Picante, a clothing store on East Congress Street, was selling 2½-inch-high yellow wood crosses for only $10. They were decorated with only four milagros, one religious stamp, and a cluster of small multicolored metallic stars.

In 1993, ever-changing styles of skillfully made milagro crosses were available at berta wright gallery shops in the upscale Foothills Center

shopping mall in northwest Tucson. The crosses ranged in size from five to eight inches high, and in price from $43 to $158. The small crosses had forty-two milagros, the larger ones, ninety-three.

Berta Wright said she began selling milagro crosses in about 1983 at her downtown store, Wright Designs and Associates, now on East Congress Street. She buys the crosses from two men, one from Mexico and another from New Mexico. She was also selling two sizes of weathered wooden milagro mirrors made by Kim Yubeta. The 14-by-16-inch pieces covered with 121 milagros cost $210. The 24-by-20-inch mirrors with 144 milagros on them were priced at $300.

Amazingly, some of the milagro jewelry sold at Wright Designs is made entirely in India. According to one salesperson, Mexican milagros were taken to India and used to make dies to cast milagros there. The Indian milagros, which had very indistinct features, were combined with miniature Indian temple bells on glass bead necklaces that sold for $45. Cards saying "Milagros/Brass Reproductions/Made in India" were attached to dangling milagro earrings selling for only $5. The cards also explained the religious use of milagros in Mexico.

In April 1993, next door to Wright Designs, Arturo Mercado was bursting with enthusiasm as he described his plans to make new kinds of milagro art for his antique shop, Antigua del Barrio. "I'm going to make lots of different things," he told me. Pointing to a painted china plate, he said, "I'm going to take that plate with a picture of St. Anthony and attach it to a piece of wood and cover the wood with milagros. And crosses—I want to make a *big* one—at least three feet high, with rhinestones and milagros, or turquoise and milagros. I'll do it when I have nobody in the store."

Mercado first noticed milagro art about fifteen years ago in San Pedro, near Guadalajara, where he saw milagros attached to shoe lasts, the foot-shaped forms used in shoe making. Later he saw milagros on wooden boxes and picture frames. He began making milagro art himself two years ago, he said, when a lady came into his shop and asked the price of a "very beautiful old dovetailed wood jewelry box from Mexico." He told her it cost $30 and she said that was too much. "I was really disgusted," Mercado recalled, "and I said to myself, 'I'm going to cover it with milagros!' Then I sold it for a good price. So I put milagros on

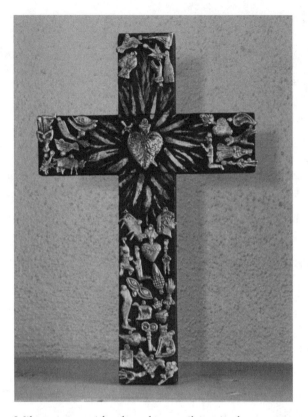

Milagro cross with a large heart milagro in the center surrounded by painted rays of light. Made by Arturo Mercado, Tucson, 1993. (Photograph by the author)

more boxes. And on crosses, too. Then I started painting designs of the Sacred Heart and other things in the center of the crosses and put milagros just on the arms. People even ask me to autograph them!"

Mercado makes all his black wood crosses himself, some with paintings and others with religious stamps or one large milagro in the center. Some have a large milagro in the center surrounded by painted religious designs. Mercado uses the aluminum milagros made by his extended family in Mexico—the same ones he sells to his customers for $1 apiece. Depending on the design and the number of milagros used, the 10½-inch-by-7-inch crosses cost between $85 and $95.

Mercado showed me a dovetailed, natural wood jewelry box from Guadalajara that he had recently covered with about 500 milagros, including a 3-inch-high silver heart in the center of the lid. The 11-inch-

long, 6-inch-wide, 5-inch-high box was marked $350. "It took me four days," he said, "but only two hours a day, because otherwise it gets boring."

Mercado has also sold milagros wholesale to Tucsonans with still other ideas for milagro art. One woman makes wearable milagro art clothes, another person makes milagro-covered sombreros, and one man makes blown-glass vases with milagros embedded in the glass.

Antigua de Mexico, a Latin American import store on North Oracle Road, sells stained wood statues of St. Francis of Assisi with milagros covering his robe. "We got four of them last month, and they sold right away," a saleswoman told me in August 1993. The statues are made in Tlaquepaque, Jalisco, Mexico, and sell for $240.

In the United States, milagro art is available not only in regional stores. Milagro-decorated nichos and other objects have also been advertised in pricey gift catalogs bulk-mailed all over the country.[3]

Several craft shops and furniture stores in Nogales, Mexico, also sell milagro crosses. Casa Bonita on Avenida Obregón was selling 9-inch-high black crosses for $68.95 in October 1993. These and other stores selling milagro crosses, such as the Lazy Frog, are all close to the border, where most Arizonans, tourists, and prosperous Mexicans shop, which suggests that the more costly milagro art is bought mainly by relatively affluent people.

Milagros have also been used by Tucson artist Allan Mardon, who nailed approximately six hundred whole-body, body-part, and animal milagros to the frame of his 50-square-inch oil painting of the history of Mission San Xavier, which used to hang in the library of the Arizona Inn. Mardon bought most of the milagros in Guadalajara in 1980. "At the time I didn't know why I was buying them," he told me in 1992. "I just bought a couple of pounds on the street from different vendors in kiosks across from the cathedral. Then I decided to use them for the frame and realized I needed more, so my wife's relatives in Mexico bought me another two kilos."

Because so many milagros are offered at Mission San Xavier, it seems appropriate that the wooden frame is decorated with these offerings, but some people believe it is wrong to use milagros for anything other than religious offerings. When I showed one middle-aged Mexican American

woman a picture of a milagro cross, she said, "I don't think it's right. I don't approve of it. God belongs in the middle of the cross, not milagros."

However, at least some milagro art has been made solely for religious purposes—perhaps leading to a trend within a trend. And some of this religious milagro art has been made by a Catholic nun, Sister Alberta Cammack, who is the archivist at St. Mary's Hospital as well as an artist. In 1994, she took all the milagros off the hospital's Infant of Prague statue and attached them to three wood crosses left over from some her brother had made for Stations of the Cross.[4] Sister Alberta said she got the idea after she saw milagro crosses for sale in a boutique. She thought it was permissible to use the crosses in this way because all four arms are of equal length, so they are not shaped like a crucifix. In February 1995, her milagro-decorated crosses were lying at the base of the Infant of Prague statue—an attractive 1990s display for the centuries-old custom of offering milagros.

Although the idea of creating milagro art solely for religious purposes was new to Sister Alberta, a saleswoman at berta wright gallery shops said that when she lived in Texas in the 1950s, she saw milagro-decorated crosses used as crucifixes in several Mexican American homes. Following Sister Alberta's example, more people may decide to use milagro art in this way. Thus, the custom of using milagros continues to change and renew itself.

In any event, people who make or sell milagro art, and most of those who sell milagros wholesale to craftspeople, are enthusiastic about the new trend. Josefina Lizárraga, who sells craftspeople milagros and other things they need for their creations, said, "There's nothing wrong with it. If the milagros aren't blessed, they're just a piece of metal."

"These people have respect," Lizárraga said. "They're not doing anything wrong—they're just making things. And it makes me feel good because they want to represent the old Mexico. They're bringing the old Mexico back to life. And there is a fever for it right now."

8

The Future of Milagros

If one looks only at *minor* offering sites in the San Xavier–Magdalena area—places where, historically, relatively few milagros have been left—one might think that the custom is waning. At a number of places, for example, the faithful have completely stopped bringing milagros. St. Augustine's Cathedral, a beautiful Spanish-colonial-style church with twin bell towers and an elaborate carved sandstone facade, was once a popular place for people to leave milagros in Tucson. But the number of offerings dwindled in the late 1980s and almost totally stopped by 1990.

People offer different explanations for the change. Some say it was because the offerings were being stolen from the statues. One priest reportedly asked parishioners to leave their milagros on statues at home, where they would be safe, instead of in the cathedral.

Geraldine Bartlett, who was the sacristan of the church, speculated in 1993 that people stopped bringing milagros because twice in the last ten years, the statues where people had left milagros had been smashed. "They were thrown off their pedestals and really broken," she said.

"Another thing is that people are guided. When they don't see anything on the statues any more, then they don't leave anything either. Maybe they bring them down to San Xavier instead."

Another factor in the decline of milagro offerings may have been the closing of the Ave María Shop across the street. Some people have told me that after the shop closed in 1991, its customers did not know where else to buy milagros in the Tucson area and therefore stopped promising them.

People in Tucson also used to leave milagros on the group of life-size religious sculptures in the Garden of Gethsemane[1] in Felix Lucero Park on Congress Street, just west of the Santa Cruz River. Josefina Lizárraga said she saw "lots of milagros there, especially on the feet of Jesus on the cross," when she moved to Tucson in 1963, but later on the number of offerings declined. According to many local people, the milagros were stolen from the statues, which probably discouraged many of the faithful from leaving their offerings, especially those who might have left them in petition. In Lizárraga's opinion, "what really stopped people from bringing milagros was that about fourteen years ago vandals started breaking the statues." The statues are always repaired by a small group of local people who care for them, and flowers and small coins are still offered on them, but people no longer leave milagros.

At another site, the statue on which people offered milagros disappeared. The large image of San Martín de Porres used to stand in the waiting room of Mama Chatman, a popular and charismatic African American faith healer who lived in a predominantly Mexican American neighborhood in southwest Tucson. In April 1975, when I visited Chatman, about two dozen milagros were hanging on the statue. She told me her clients had hung them there. When I returned in 1980, her house was vacant. People told me Chatman had died, but no one knew what had become of the statue or its milagros.

At one of Tucson's oldest offering sites, the Benedictine monastery (formerly the Benedictine convent), the statues on which people used to leave milagros are no longer easily accessible to laypeople. The monastery's original Infant of Prague statue, which had received the most offerings, was stolen, and its replacement, which also received many offerings, is now on the second floor of the convent. Only a Pietà and the statue of St. Joseph remain in the public chapel, but the latter is too

high for people to reach easily. In 1994, one of the nuns told me, "We took the Infant of Prague and other statues out of the chapel because there were too many statues there and people went from one to the other and didn't pay attention to the Blessed Sacrament.... People stopped bringing milagros to the monastery three or four years ago."

The prioress, Delores Dowling, told me that the nuns have nothing against statues, and in fact, "they can be good," she said. "But our order, the Benedictine Sisters of Perpetual Adoration, has a particular devotion to Christ in the Eucharist. We would like people's devotions focused on the essential, which for us is Christ in the Blessed Sacrament. Vatican II asked Catholics to focus more on the essentials of our faith. We feel that additional minor devotions should be private, and not displayed in the chapel."

One very popular offering site, three miles south of the border in Nogales, Sonora, was dismantled. The shrine, la Capilla del Santo Niño (Chapel of the Holy Child), was in the front room of a small, pale-blue plastered house with concrete steps leading down toward Calle Ruiz Cortines. But that is about all that people agree on. Past and present neighbors and members of the extended family tell different stories about the beginnings of the shrine and even differ in their opinions about whether the main object of devotion was a statue or a picture.

Señora Lucía López said that the chapel, containing a picture of El Santo Niño, was already there when her father-in-law, a rancher named Jesús López del Cid, and his wife, Francisca Campa de López, bought the house in 1924. They wanted their home to be private, so they kept the chapel closed. However, so many people kept asking to see the picture that Francisca, who was very religious, decided to open the chapel to the public and bought a statue of El Santo Niño to place on a table altar. Padre Ignacio de la Torre, popularly known as Padre Nacho, and Padre Luis López occasionally said Mass in the chapel. So many people came to visit the shrine and leave offerings of money, milagros, and candles that Padre Nacho periodically took the money and milagros to Parroquia de la Purísima Concepción, the church near the border.

According to the jeweler Agustin Calleros in Tucson, the shrine was still very popular in 1958 when he lived in Nogales, and people were still offering milagros there in 1963 when Josefina Lizárraga moved from Nogales to Tucson. After his wife died, however, Jesús López became ill and

moved to the home of his son, Alberto, and his daughter-in-law, Lucía. Even before that, the number of offerings had greatly declined. Lizárraga, a friend of the family, thinks most of the older people who once used the chapel had either died or moved away. The abandoned house and chapel were vandalized, Lucía said, so about twenty years ago the family razed it.

However, the Santo Niño may soon have a new shrine. Although the Lópezes' daughter, Señora María Teresa López Campa, still has the picture that once hung in the old chapel, a copy was given to the wife of a nearby bakery owner three years ago, Lucía said. Since then, the woman has been raising money to build a new chapel for the Santo Niño.

Until Clínica del Sagrado Corazón (Clinic of the Sacred Heart) in Magdalena closed in the mid-1980s, milagros were jammed into the frames of the holy pictures hanging in the lobby and above patients' beds. Every year these offerings were brought to the church and placed in the alms chest at the feet of San Francisco, but they were soon replaced by others.

At one former shrine in the region, offerings may have declined because as one man familiar with the site said, "there were rumors that the owners of the shrine took the milagros off the statue after awhile and had them melted down to get extra cash." Although family members and some others deny the allegations, another woman who lived nearby said, "That family was just living off the saint."

People have also stopped leaving milagros at St. Catherine's Mission and a few other churches on the Sells Reservation, as well as at many roadside shrines throughout the region.

At other sites, offerings of milagros have not stopped but they have declined, sometimes sharply. In 1992, Betty Galaz, the secretary at Tucson's Santa Cruz Church, said, "When I first started working here thirty years ago, I used to see a lot of milagros by Our Lady of Guadalupe. But I don't see that anymore. Just once in awhile on St. Anthony and the Infant of Prague. The custom is dying out as the old people who did it die."

"But," she added, "the use of milagros does come back in stages, depending on what we're [the United States is] doing. Like during the Saudi Arabia [Gulf War] crisis, it increased. People have to be in some

Statue of the Infant of Prague with milagros, Santa Cruz Church, Tucson, 1985.
(Photograph by the author)

kind of danger. Then they remember God and bring a milagro and say,
'This is for my son.' But when the danger is over, their devotion goes
away again. Now very few people take the trouble to buy a milagro. They
don't forget the custom, but they don't do it."

At all three Yaqui Indian chapels "not so many milagros are left
now," according to Anselmo Valencia, the Yaqui spiritual leader. "Most
Yaquis who still use milagros bring them to San Francisco on October
fourth," he told me in March 1993. "When I was a boy, my parents
brought me to Magdalena and I brought milagros to San Francisco. I
still believe in him, but I don't use milagros any more."

Offerings may also have declined because for several years, two of the Yaqui chapels have usually been locked, and at one of them—San Ignacio—Mass is no longer said.

Besides the effects of vandalism, theft, nasty rumors, and the removal of statues, some people say the negative attitudes of a few priests in the region have also contributed to the cessation or decline of offerings at some churches. In fact, the churches of most of these priests have few milagros and/or have suffered a decline in offerings. Although none of those priests has openly condemned or opposed the custom, they have expressed their disapproval in private. "It's a superstition—we don't pay much attention to it," one priest said. More than one parishioner at that church has told me, "I wish we had some of the old priests back who believed in these things."

At another church, a priest once told me, "People here leave milagros once in awhile, and candles and hair quite often—maybe once a week. Blows your mind, doesn't it?" A third priest said he was not opposed to people offering milagros; he just did not like them "cluttering up the statues." Another pastor actually forbid the offering of milagros. A woman working at that church said, "We don't allow milagros by rules of the pastor. We pick them up as soon as we see them, so then the people know it. And when they see someone else putting a milagro on a statue, they say, 'Don't leave it because it will be taken.' That way you train people."

Although these priests do not publicly denounce the custom, the faithful may sense their disapproval when they ask them to bless milagros or when they see offerings quickly removed from statues in their churches. Then, as some of the faithful have told me, they may take their milagros to San Xavier or Magdalena instead.

Of course, priests' attitudes do not *necessarily* cause fewer milagros to be left at their churches, nor is there always even a correlation between a priest's attitude and the number of offerings. For instance, one priest at a church where offerings have declined speaks approvingly of the offerings. In 1993 he told me, "Milagros are the Indians' way of saying 'Thanks for a blessing.'"

Although many shrines have fewer milagros than they used to, or none at all, in some places, including the two major offering sites of San Xa-

vier and Magdalena, the popularity of milagros is not declining at all. Instead, the number of offerings remains largely unchanged or is even growing.

At Santuario de Nuestra Señora de Guadalupe in Nogales, Sonora, people have been leaving "twenty to thirty milagros a year for the past several years," Padre Ramón Landavazo told me in October 1993. The relative ease with which the faithful can buy milagros at the shop in the rear of the church may account in part for the continued offerings at this site.

At Magdalena, where people now leave approximately ten thousand milagros a year, the number of offerings has been roughly consistent for the last decade, according to Señora Consuelo Ochoa Cantua, who until 1994 removed milagros from the statue of St. Francis nearly every day. Her information matches reports from saleswomen at religious goods stores in Magdalena who say they have sold about the same number of milagros each year for the past ten years.[2]

Although an antireligious government temporarily closed the church in 1934, and officials destroyed the elaborate San Francisco statue, the cult of San Francisco continued. As soon as the statue was replaced in the 1940s, pilgrims again flocked to the shrine, providing one of the "many examples" in Mexico of what Turner and Turner see as "the perseverance of pilgrims in the teeth of antireligious governmental pressures."[3] Because of the long folk history of favors and miracles granted at this principal shrine of the most popular saint in the region, even the daily removal of offerings from San Francisco's statue does not deter offerers.

The negative attitudes of a few priests may have affected the decline of offerings at some sites, but the more accepting attitudes of most other priests in the region have permitted an environment where the custom of offering milagros has continued unabated. Although these priests do not encourage people to use milagros, they do nothing to hinder the practice.

Magdalena's former pastor Padre Santos, who was respected and loved by so many of the faithful, had a tolerant view of folk religious practices. He used to say, "This is what the people want to do." He also recognized the piety in their acts of offering milagros, which he said represent promises between the people and God. The people's memory of Padre Santos and the accepting attitude of Padre Salcido combine with

the aura of the centuries-old pilgrimage site and the people's belief in San Francisco to create a setting where the use of milagros seems most natural. Almost no one can imagine San Francisco's statue without milagros and other offerings lying on it.

At San Xavier, the second most important offering site in the region, the number of milagros has remained nearly constant and has occasionally increased, according to Dr. Bernard Fontana. "Especially during the Gulf War," he said, "there were lots of full-body figures of men."

The friars at the mission seem especially accepting of and comfortable with the customs of both the O'odham and Mexican Americans. According to Father Kieran McCarty, "the Roman Church has never promoted milagros but in the light of acts of piety involved it has not discouraged them." On another occasion, he said, "Milagros are very sacred little things, you know."

On October 4, 1993, after participating in the procession with the reclining statue of St. Francis Xavier at the mission, Father Michael Dallmeier told me, "the milagros are symbols—the Indians' and the Mexican Americans' way of expressing their gratitude." He laments only that the custom leads the poor to spend some of their scarce resources on these offerings. "Especially in Mexico," he said, "a milagro costs some people a day's wages."

More people have been bringing milagros to St. Margaret's Church in Tucson as well. In 1982 Father Cyprian Killackey said the number of milagros left at the church was "very much less than before, as the younger generations are not enthusiastic." But in 1990, after Adelina Aros's milagro display was hung in the church, more people started bringing offerings. Church secretary Yolanda Grijalva said, "People don't come in hordes, but they come, probably because they have seen the collection of milagros hanging there."

Because milagros are usually offered after a prayer is answered, a display like that at St. Margaret's is visible proof to the faithful that the custom works. People whose offerings hang in the display, as well as those who have stopped using milagros or have never used them at all, may therefore feel encouraged to promise milagros the next time a serious problem arises in their lives. As Vidal wrote about the custom in Puerto Rico, seeing so many milagros offered to images was one factor

that increased both the "miraculous fame" of those statues "and the fervor with which the believers made new votive promises to them."[4]

Like most priests in the Magdalena–San Xavier corridor, St. Margaret's pastor is relaxed about people offering milagros. Because of his willingness to bless the offerings, and his approval of Aros's display and her sales of milagros inside his church, he has conveyed the message that it is acceptable to come to the rectory and leave a milagro to be placed on the display. "If this is what they believe," Father Killackey wrote me in 1993, "I accept it as *their* way of expressing their faith in the power of God—part of their culture and, of course, not condemned by the Church."

At Holy Family Church the tradition of leaving milagros came to a temporary halt in 1990, but this trend reversed after Alice Gallardo, who used to clean the church, finished refurbishing the church's missing milagro display case, which was put in the church office next door. While she was repairing the case, Gallardo told me, "People used to see milagros hanging in the church and think it was okay to offer them there. But now they don't see any. When they see the collection back in the church, they'll begin bringing milagros once more." Although the case is in the office, not the church, most of the faithful know it is back on the church grounds, and the number of offerings has slowly increased, with four milagros offered between April 1 and July 26, 1993.

At St. Joseph's Hospital the number of offerings had sharply declined from about twenty-five a year to almost none in 1993. After renovations on the third floor were completed in 1991, the Infant of Prague statue, which had always received the most offerings, was not returned to its prominent position near the main elevator. "After we had new clothes made for Him, we put Him by the less-used back elevator because it's a setting more conducive to quiet prayer," said Polly Phillips, director of maternal child services.

That area gets little traffic, and there were only two milagros on the statue when I saw it in March 1993. But in September 1994, Phillips told me, "It took awhile, but people have found Him, and He's fairly well decorated with things now." She counted ten milagros, four ultrasound pictures of fetuses, eight prayer cards, and four photographs of babies and children on the statue. "After we renovated, a decorator hired by the

hospital suggested a plexiglass case for the statue and future offerings," Phillips said. "But we felt a case would have given a hands-off message and that for the families that want to leave things on the statue, it's important to them to be able to put them *right on* the statue."

"People take care of the statues in their own area," Sister Patrick Bernard told me in September 1994, "and they take a possessive interest in them." This interest and the staff's sensitivity to the needs of Catholics who use the hospital provide an environment where the custom of offering milagros has survived and perhaps will continue to grow.

People are also bringing more milagros to Jimmy Campbell's shrine of St. Theresa. While only fifty were left permanently on the statue of St. Theresa from 1969 to 1992, seventeen milagros were left at the shrine between October 1992 and October 1993.

Furthermore, in recent years people have begun leaving milagros at one new site, the newly built Church of San Felipe de Jesus in Nogales, Arizona.

Although the use of milagros has declined at some sites in the region, that does not mean that the custom as a whole is dying out. It means only that certain statues at certain places are receiving fewer offerings.

Historically, the vast majority of milagros offered in the region—at least nine out of ten and probably many more—have been brought to just two statues: the reclining images of St. Francis Xavier at Mission San Xavier and Magdalena. Therefore, the fate of the custom of offering milagros in this region will be determined almost entirely at these two shrines, not at the lesser sites in the area. For at least the past decade, the number of milagros left at San Xavier and Magdalena has not been declining.

People keep offering milagros for two reasons: They believe they are efficacious and, consciously or subconsciously, they sense that the custom provides many other benefits. Whenever I asked one of the faithful why they used a milagro instead of another kind of offering, inevitably his or her immediate response was "because they work."

Adelina Aros, whose statue of Jesus Scourged has gained a reputation for answered prayers, has long been one of the faithful. She believes that when people offer milagros, "In their desperate need, God hears them and answers their prayers." Aros said that she offers milagros instead of

something else "because they've helped so many other people." Almost everyone who uses milagros has a story illustrating their unwavering faith in the effectiveness of the offerings, and Aros is no exception.

"Like when I had a lot of problems with my eyes," Aros recalled in 1993. "My one eye was very bad. My doctor told me, 'In a year and a half, you'll lose the other one, too.'" But Aros was afraid to have surgery because the same doctor had operated on her aunt, "and she lost her vision. So I didn't want him to operate on mine." After going from doctor to doctor looking for help, Aros finally offered an eye milagro by her statue and asked God to save her sight. "I just felt that would work because I knew a person who was going to have a leg amputated, and he gave a leg milagro and he didn't have it amputated," she said. "Well, I didn't have the eye operation, and I was supposed to be blind, but I'm not. And that was eleven and a half or twelve years ago."

Although the faithful do not generally cite other benefits of the milagro custom, the tradition also serves important social functions. Participating in a pilgrimage, making a manda, and offering a milagro all help to integrate a sick person and his family into their community, whose members also believe in these rites. Also, by carrying out these acts, people receive social approval that enhances their feelings of self-worth. If a friend or relative has undertaken the obligation of making and fulfilling a manda for a sick person, the patient feels that someone else cares deeply about his recovery, and the relationship with that relative or friend is thereby strengthened.

People who bring their milagros to Magdalena and San Xavier during the St. Francis feast-day celebrations experience, at least temporarily, a strong sense of fellowship and community, not only with people they know, but also with strangers. No one strives to create this phenomenon. Almost every person, family, or group of friends goes to the shrine independently and carries out their acts of devotion alone; there is no authority in charge and no organized plan of action. What is more, as their clothing indicates, the pilgrims come from vastly different economic and cultural backgrounds. Yet a strong sense of communion and camaraderie seems to arise spontaneously in this setting, where everyone shares similar beliefs and carries out similar acts of piety to honor the saint whose protection and patronage they all recognize and receive. And as physician Dean Ornish of the School of Medicine at the University of Cali-

fornia in San Francisco has noted, "Anything that promotes a sense of intimacy, community, and connection can be healing."[5]

Offering a milagro may also benefit the patient in another way. Because the body is not separate from the mind, the expectation or even hope of a divine cure may actually help people get better. C. Kerényi attributed such psychophysiological effects to the ancient Greek shrines of Asclepius when he wrote: "The patient was offered an opportunity to bring about the cure whose elements he bore within himself.... The religious atmosphere also helped man's innermost depths to accomplish their curative potentialities."[6]

Visiting San Xavier or Magdalena on or near a feast day also involves sick or troubled people in the atmosphere of the celebration, where relatives and friends renew their ties. They can enjoy pleasant conversations, eat tasty foods, and hear festive music and the joyful sounds of the bustling crowd. All of these things can raise people's spirits and make them feel better.

Offering a milagro can also fulfill a person's intense emotional need to do something—anything—to try to effect a cure. Some of the faithful offer milagros only after they have exhausted every other possible remedy. They have "tried everything," and everything has failed. Thus, making a manda, obtaining the correct milagro, and making the pilgrimage to offer it are all psychologically satisfying actions that fulfill the pilgrims' urgent need to "do something." Even if one's prayers are not answered, offering a milagro leaves the offerer with the feeling that he or she did everything one could possibly do to find a cure. If no cure is found, there is no need later for regret or self-recrimination.

Milagros also lighten the burden of the sufferer and of those caring for him or her, because when a milagro is offered, one gains powerful partners—the saints and God—who become partly, if not totally, responsible for bringing about a cure.

The St. Francis celebrations, during which many milagros are offered, also provide another benefit of milagros: a welcome break for the sick person's family. At home, the family may have to dedicate much of its time and effort to the patient's care and, possibly, his complaints. The pilgrimage provides an acceptable excuse to travel to a different place, to meet people, to shop, and to enjoy the pleasures of the fiesta. Some To-

hono O'odham and Mexican American families have told me they have never had even a short vacation away from home; money was so scarce, they said, that it would have seemed frivolous. Yet when someone in the family is sick, they manage to "scrape together" enough money to go to Magdalena for a few days. The experience renews the family's own inner resources, and they are often better able to cope with the problem after returning home. Even a pilgrimage to San Xavier or another nearby shrine still provides a needed break for the family.

The faithful may also sense that religious traditions such as offering milagros keep their faith more "alive." As Sister Mary Gregory Cushing, the archivist at the Benedictine monastery in Tucson, told me in 1994, "the Mexican American people show their faith by symbolic acts like offering milagros. But we [non-Mexican Catholics] have given up some of the symbolism that we grew up with and that nourished our faith. Everything we had then, like the statues and other symbols, spoke to our humanness. But the new symbolism of the Church does not speak as eloquently to the older people who remember the way things used to be. I think the old symbolism keeps the Mexican Americans' faith alive and strong."

One priest at another church told me, "Vatican II took away the symbolism and didn't give the people anything to replace it."

Like a church, statues, and burning votive candles, a milagro helps to focus its offerer's mind on the acts of venerating and thanking the saint. Compared to dropping an offering of money into a safe beside the statue, placing a milagro on an image is a much more emotional experience. I have never seen a person start crying when he or she dropped money into the safe by San Francisco's statue in Magdalena. But I have seen donors' eyes fill with tears as they placed milagros on his image. Because offering a milagro intensifies the religious experience of the pilgrimage, the act may deepen the pilgrim's commitment to his faith.

One's faith may also be deepened by the emotional impact of seeing a statue covered with milagros and other offerings. Each milagro placed on the statue helps in a small way to transform the image. When it is laden with offerings, it grips one's attention and can evoke powerful feelings even in nonbelievers, creating "a world of magic and tenderness,

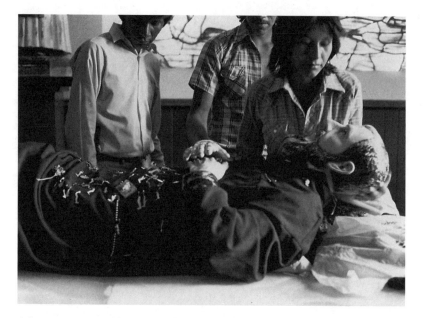

After pinning a milagro on San Francisco's robe, a crying woman gently lifts the statue's head, Magdalena, 1985. (Photograph by the author)

which clothes the images of the most generous saints."[7] The little metal arms and legs hanging on the statues speak poignantly of the faith of the individuals who offer them, and of the efficacy of prayer and the power of the saint and God.

Especially for the poor, the custom of offering milagros provides a source of hope. As Fatima Bercht writes of the *milagres* of northeastern Brazil, the transcendent "power, to which these images bear witness, is the only realm visible to the ... faithful that allows hope for healing, achievement, and change, in an otherwise painfully deprived world."[8] Describing the votive offerings that Mexican Indians left on their statues of saints, Francis Toor wrote, "through them they expressed their ... gratitude for the miracles that make their lives bearable."[9]

Ultimately, the value of milagros is contextual. The skeptic perceives no value in the custom and therefore derives no value from it. But deeply religious Indians, Mexicans, Mexican Americans, and other people believe that God and the saints play major roles in their lives. To these people, offering a milagro is not an archaic superstitious behavior. It is, on the contrary, a profoundly reasonable act.

Of course, the outcome of the worldwide and never-ending conflict between modernization and old cultural traditions will determine whether the custom of offering milagros continues in this region. But for the near future at least, the custom seems secure. As long as the faithful continue to believe in the efficacy of milagros and the power of St. Francis, the custom will not die.

APPENDIX

Table 1 Number of Whole-Body Milagros at San Xavier, 1969–1974

Type of Milagro	Number	Percentage of Whole-Body Milagros	Percentage of All Milagros ($N = 3{,}045$)	Gold	Silver	Other
Total Men	395	32.06	12.97	33	318	44
Kneeling Men	390	31.66	12.81	33	315	42
Standing Men	5	.40	.16	0	3	2
Total Women	399	32.38	13.10	47	310	42
Kneeling Women	395	32.06	12.97	47	306	42
Standing Women	4	.32	.13	0	4	0
Standing Boys	192	15.58	6.31	29	159	4
Standing Girls	194	15.75	6.37	9	173	12

Table 1 *continued*

Type of Milagro	Number	Percentage of Whole-Body Milagros	Percentage of All Milagros ($N = 3,045$)	Gold	Silver	Other
Total Infants	52	4.22	1.71	3	32	17
Sitting Infants	30	2.44	.99	2	27	1
Reclining Infants	11	.89	.36	0	5	6
Crawling Infants	10	.81	.33	0	0	10
Standing Infants	1	.08	.03	1	0	0
Total	1,232	100.	40.	121	992	119

Table 2 Number of Whole-Body Milagros at Magdalena, October 1988–March 1993 in Descending Order

Type of Milagro	Number	Percentage of Whole-Body Milagros	Percentage of All Milagros ($N = 43,891$)	Gold	Silver	Other
Total Men	6,434	31.13	14.66	3,466	2,468	500
Kneeling Men	6,403	30.98	14.59	3,449	2,467	487
Standing Men	31	0.15	0.07	17	1	13
Total Women	6,742	32.61	15.4	3,313	2,818	611
Kneeling Women	6,719	32.5	15.3	3,308	2,818	593
Standing Women	23	0.11	0.05	5	0	18
Standing Boys	3,364	16.27	7.6	1,955	1,267	142
Total Girls	3,354	16.2	7.6	1,842	1,319	193
Standing Girls	3,152	15.25	7.18	1,679	1,319	154
Kneeling Girls	202	0.97	0.46	163	0	39

Table 2 *continued*

Type of Milagro	Number	Percentage of Whole-Body Milagros	Percentage of All Milagros ($N = 43,891$)	Gold	Silver	Other
Total Infants	776	3.75	1.76	374	280	122
Sitting Infants	622	3.0	1.4	371	250	1
Reclining Infants	154	0.74	0.35	3	30	121
Total	20,670	100.	47.09	10,950	8,152	1,568

Table 3 Number of Body-Part Milagros at San Xavier, 1969–1974

Type of Milagro	Number	Percentage of Body-Part Milagros	Percentage of All Milagros ($N = 3,045$)	Gold	Silver	Other
Total Legs	446	24.76	14.66	49	359	38
Right Legs	201	11.16	6.61	26	159	16
Left Legs	243	13.49	7.99	22	199	22
Pairs of Legs	2	.11	.07	1	1	0
Total Heads	340	18.87	11.17	41	280	19
Men's Heads	188	10.44	6.18	31	157	0
Women's Heads	147	8.16	4.83	10	118	19
Children's Heads*	5	.28	.16	0	5	0
Total Eyes	258	14.33	8.48	15	238	5
Single Eyes	121	6.71	3.98	5	115	1
Pairs Of Eyes	137	7.61	4.50	10	123	4
Total Arms	189	10.49	6.21	12	162	15
Right Arms	100	5.56	3.29	7	85	8
Left Arms	89	4.94	2.92	5	77	7

Table 3 *continued*

Type of Milagro	Number	Percentage of Body-Part Milagros	Percentage of All Milagros ($N = 3{,}045$)	Gold	Silver	Other
Total Hearts	144	7.99	4.70	16	121	7
Sword Hearts	118	6.55	3.84	11	100	7
Flame Hearts	17	.94	.56	0	17	0
Plain Hearts	9	.50	.30	5	4	0
Total Feet	143	7.94	4.70	8	126	9
Right Feet	34	1.89	1.12	3	29	2
Left Feet	109	6.05	3.58	5	97	7
Total Hands	137	7.61	4.50	6	123	8
Right Hands	71	3.94	2.33	3	63	5
Left Hands	66	3.66	2.17	3	60	3
Single Kidneys	76	4.22	2.50	0	76	0
Ears (All Right)	61	3.39	2.00	0	61	0
Stomachs	3	.167	.099	0	3	0
Single Breasts	1	.056	.033	0	1	0
Girl's Bust	1	.056	.033	0	1	0
Throats	1	.056	.033	0	1	0
Finger	1	.056	.033	0	1	0
Pair of Lungs	1	.056	.033	0	1	0
Total	1,802	100.	58.50	147	1,554	101

*Impossible to discern whether girls' or boys' heads.

Table 4 Number of Body-Part Milagros at Magdalena, October 1988–March 1993 in Descending Order

Type of Milagro	Number	Percentage of Body-Part Milagros	Percentage of All Milagros (N = 43,891)	Gold	Silver	Other
Total Legs	8,989	39.7	20.5	4,126	4,359	504
Right Legs	5,224	23.1	11.9	2,606	2,477	141
Left Legs	3,764	16.6	8.6	1,519	1,882	363
Pairs of Legs	1	.004	.002	1	0	0
Total Heads	3,524	15.6	8.0	1,809	1,323	392
Men's Heads	1,836	8.1	4.2	853	695	288
Women's Heads	1,686	7.4	3.8	955	627	104
Boys' Heads	1	.004	.002	0	1	0
Girls' Heads	1	.004	.002	1	0	0
Total Arms	3,285	14.5	7.5	1,654	1,410	221
Right Arms	2,013	8.9	4.6	985	902	126
Left Arms	1,272	5.6	2.9	669	508	95
Total Eyes	2,227	9.8	5.1	1,050	785	392
Single Eyes	636	2.8	1.5	432	147	57
Pairs of Eyes	1,591	7.0	3.6	618	638	335
Total Hearts	1,312	5.79	2.99	683	452	177
Sword Hearts	967	4.27	2.20	551	352	64
Flame Hearts	172	.76	.39	108	62	2
Crown-of- Thorn Hearts	74	.33	.17	4	22	48
Plain Hearts	64	.28	.150	0	2	62
Striated Hearts	34	.15	.08	20	14	0
Anatomically Correct Hearts	1	.004	.002	0	0	1
Total Feet	1,182	5.22	2.69	517	588	77
Right Feet	372	1.64	.85	162	192	18
Left Feet	810	3.57	1.85	355	396	59

Table 4 *continued*

Type of Milagro	Number	Percentage of Body-Part Milagros	Percentage of All Milagros ($N = 43,891$)	Gold	Silver	Other
Total Hands	1,069	4.71	2.44	617	423	29
Right Hands	453	2.0	1.03	215	217	21
Left Hands	616	2.72	1.40	402	206	8
Ears (All Right)	331	1.46	.75	179	125	27
Navels	193	.85	.44	116	67	10
Total Breasts	160	.71	.36	68	44	48
Single Breasts	4	.02	.01	0	4	0
Double Breasts	156	.69	.36	68	40	48
Stomachs	140	.62	.32	30	33	77
Total Lungs	127	.56	.29	61	40	26
Single Lungs	1	.004	.002	0	0	1
Double Lungs	126	.56	.29	61	40	25
Total Kidneys	93	.41	.21	42	21	30
Double Kidneys	33	.15	.08	0	7	26
Single Kidneys	60	.26	.14	42	14	4
Lips	26	.11	.06	2	15	9
Tongues	6	.03	.01	1	0	5
Total	22,664	100.	51.63	10,955	9,685	2,024

Table 5 Number of Other Milagros at San Xavier, 1969–1974

Type of Milagro	Total	Gold	Silver
Cars	4		4
Houses	3		3
Cows	3		3
Liquor Bottles	I		I
Total	II		II

Table 6 Number of Other Milagros at Magdalena, October 1988–March 1993

	Total	Gold	Silver	Copper or Bronze	Copper Foil	Aluminum Foil
Houses	176	84	91			I
Trucks	84	57	26		I	
Cars	83	29	54			
Keys	7	5	I		I	
Books	2		2			
Boats	I	I				
Liquor Bottles	I		I			
Leaves	I		I			
Cows	97	4I	48	8		
Horses	52	22	30			
Dogs	2I	I8	3			
Pigs	I8	I	I6		I	
Sheep	3		3			
Goats	3	I	2			
Cats	I	I				
Hens	I		I			
Roosters	I		I			
Donkeys	I		I			
Burros	I		I			
Whales	I	I				

Table 6 *continued*

	Total	Gold	Silver	Copper or Bronze	Copper Foil	Aluminum Foil
Fish	I					I
Shrimp	I	I				
Total	557	262	282	8	3	2

NOTES

PREFACE

1. *Bac,* the local O'odham name for the site of the mission, means "a place in a stream bed where the water re-emerges from its underground flow, however momentarily" (Fontana 1961:2). The missionaries made a habit of combining their Christian name for a mission with the local Indian name for the site.

2. Prat 1972:159.

3. Since it took six people four days to sort and count the 43,891 milagros in the 52-month collection at Magdalena in 1993, it probably would have taken me many months to sort and count the 350,000 to 500,000 milagros in Padre Santos's trunks.

INTRODUCTION: *Milagros and the Cult of St. Francis*

1. Maringer 1960:38–49.

2. Huot 1965:11; Garbini 1966:12–13; Marinatos and Hirmer 1960:50, 119; Von Matt et al. 1968:19–20; Lamb 1969:19–28; Woldering 1967:10; Mazar 1960:167.

3. Rouse 1902:66, 118, 122–123, 201–202, 206–210, 215–216, 260; Lamb 1969:39–40, 91–93; Lullies and Hirmer 1960:58; Meletzis and Papadakis 1967:33, 40; 1964:34; 1968:xviii.

4. Vidal 1974:14–15; Sambon 1895:148–150, 217–219.

5. Cuadrado Díaz 1950:454–455.

6. Caro Baroja 1957:194.

7. García y Bellido 1947b:217–219, 222.

8. Schlunk 1947:312–313.

9. Vidal 1974:56. Royalty in other countries also used milagros. After finally giving birth to Louis XIV, Anne of Austria dedicated a silver model of an angel presenting a gold model of the infant Louis to the Madonna; the statue of Louis weighed as much as the prince weighed at birth. Anne dedicated this offering at the Casa Santa at Loreto, according to DeBrosses (in Rouse:210).

10. Muller 1972:32–33; Vidal 1974:22.

11. Euler 1984:9–32; Bray 1979:30; LaFarge 1981:142; Furst and Furst 1980:98; Thorndike 1979:52; Coggins and Shane 1984:7.

12. Benedictine Monks 1966:290.

13. Goss 1974:68.

14. Brodrick 1952:117.

15. Quoted in Brodrick, 145.

16. Brodrick 1952:145.

17. According to many reports, St. Francis's body retained its flexibility and lifelike color until 1708 (Brodrick 1952:527–535). His body now lies in the Basilica of Bom Jesu in Goa, India.

18. Goss 1974:6.

19. Polzer 1982:39.

20. Bolton 1986:32–33, 62.

21. Polzer 1982:5–7.

22. Fontana, letter to author, Feb. 14, 1995; see also Sedelmayr.

23. Polzer 1982:25.

24. Goss 1974:66.

25. Polzer, telephone conversation with author, Feb. 23, 1995, concerning unpublished information on the 1966 excavation in Magdalena.

26. Roca 1967:64.

27. Polzer, telephone conversations with author, Sept. 21, 1993, and Nov. 22, 1994.

28. Pickens 1993:174.

29. The sepulchers of some Mohammedan saints are also sites of veneration and offering. Patches torn from the clothing of the sick are often hung on these tombs by faithful Moslems (Nilsson 1961:19–20).

30. Walsh 1987:181. Pelota is a game played on a walled court by throwing a ball using a wicker basket attached to a player's lower arm.

31. Turner and Turner 1978:143.

32. Didron 1896, 1:3.

33. *New Catholic Encyclopedia* 1981, 7:370.

34. Ibid.:372. The church defines three levels of worship. St. Thomas Aquinas defined two of them: *latria*, the adoration due to God alone, and *dulia*, the (lesser) honor or homage given to saints. The Virgin may also receive *hyperdulia*, which is greater than *dulia* but less than *latria*.

35. Freedberg 1989:32. Consecrated images are images that have been made or declared sacred by certain ceremonies or rites such as a blessing.

36. Ibid.:439–440.

37. Ibid.:429.

38. Ibid.:28.

39. Ibid.:30.

40. Ibid.:438.

41. A hábito is an inexpensive, plain, loose, long-sleeved cotton garment, usually with a cord at the waist, that replicates the habit of a holy figure. Its color denotes the saint in whose honor it is worn. People vow to wear hábitos daily for a period of time or until they fall apart from use. According to custom, a hábito can be washed but never repaired.

42. Polzer, telephone conversations, Sept. 21 and Dec. 1, 1993; Father Kieran McCarty, telephone conversation, Dec. 6, 1993.

43. Polzer, telephone conversation, Dec. 1, 1993.

44. The matter is even further confused because some people think the Xavier statue at Magdalena represents Padre Kino, and a few others have told me as recently as 1993 that it represents God!

45. *New Catholic Encyclopedia* 6:44; Griffith 1992:38.

46. Polzer, telephone conversation, Dec. 1, 1993. "This is a guess," Father Polzer said. "We can never know *exactly* why they wore brown."

47. A carved wood figure with an outer layer of plaster applied with a tool. After the plaster dried, it was chiseled and smoothed and then sealed with gesso—a liquid plaster of Paris—which was then painted (Ahlborn 1974:23–24).

48. Griffith (1992:54) relates an account of the statue being carved in Nogales, Mexico, by an itinerant sculptor known by the nickname "el Tiguas." There are often many different legends about popular religious statues.

49. Fontana 1981a:45.

50. Ahlborn 1974:8.

51. A *biretta* is a square hat with three projections and a tassel on top worn by Roman Catholic priests.

A *surplice* is a loose, white outer vestment, usually knee length, with large open sleeves, commonly worn by Roman Catholic and Anglican priests when performing religious rites.

52. Ahlborn 1974:78–79.

53. Ibid.:79.

54. Ibid.:78.

55. The San Xavier Reservation has six Feast Committees, each composed of six O'odham couples, and only one committee is active each year. Each committee's year of service begins and ends with a ceremony on December 4, the day after the Feast of St. Francis Xavier. The active committee is responsible for organizing the major feast day celebrations, which includes not only preparing the church and statues but also providing food for all the O'odham who come, as well as music for the religious ceremonies and for entertainment afterward.

56. The standing statue of Xavier above the main altar gets the same treatment before the December 3 celebration. About a week before the feast day, members of one of the feast committees take the statue down from its niche above the altar, bathe it, change its underwear, and redress it. If a feast committee has enough money—as the 1993 committee did—new clothes are made for the statue.

57. The *crossing* is the place in a cruciform church (one with the floor plan of a Latin cross) where the transept (or horizontal arm of the cross) crosses the nave (or vertical arm of the cross).

CHAPTER I: *Offerings and Answered Prayers*

1. Xavier's statue was kept in the church until the San Francisco chapel was built in 1977.

2. The Yaqui Indian pascola dancer wears a string of cocoon rattles wound around and, ideally, completely covering both of his lower legs. The cocoons, each about 1 ½ inches long and an inch wide, are emptied, dried, and filled with tiny pebbles. The rattles are said to represent a rattlesnake and, in fact, do sound somewhat like the snake's rattle (Painter 1986:245–246).

The Yaqui water drum is an undecorated half-gourd that floats upside down in a large, flat clay bowl filled with water. A light drumstick, wrapped in corn husks, is used to beat the gourd lightly, creating a low, hollow, thumping sound that carries several hundred feet (286–287).

3. One of the attendants told me that the candles are stored and later placed in the candle stands at times of the year when there are fewer pilgrims and the stands would otherwise be partly empty.

4. A crucifix with a very tall base, which allows it to be easily seen when carried in a religious procession.

5. In the Roman Catholic Church, a solemn ceremony by which the ceremonial appurtenances such as bells, candles, and statues are rendered sacred or venerable and dedicated to God.

6. Milagros placed on the statue earlier had been removed by members of the feast committee. Some milagros were placed in the sacristy; others were pinned to pillows in the bier where the statue normally rests in the west transept.

7. *Matachinis* are members of a male religious dance society who pledge themselves to the service of the Virgin Mary but consider themselves in the service of Jesus and San Francisco as well.

8. In the *University of Chicago Spanish Dictionary,* a *curandero* is defined as a "healer *(not a doctor),*" and also as "a medicine man *(among Indians).*" Although in some cultures they are believed to have an innate ability to heal people, curanderos are usually trained by apprenticeship. Their methods vary depending on their culture.

9. According to the Vatican Council, session 3, canon 3–4. "The teaching of the Church concerning miracles is to be found chiefly in the pronouncements of Vatican Council I. The Council declared: '... God willed that ... there be ... external proof of His revelation, i.e., divine deeds, and principally miracles and prophecies. Since these clearly show forth God's omnipotence and infinite knowledge, they are signs of revelation that are most certain and suited to the intelligence of all men'" (*New Catholic Encyclopedia* 9:891).

10. The Catholic Church teaches that because Mary was born without original sin, led a sinless life, and is the mother of Christ, she excels all other saints and is believed to be the most powerful intercessor in Heaven with God (*New Catholic Encyclopedia* 9:359, 386). Not surprisingly, shrines dedicated to the Virgin Mary, in Mexico and in other parts of the world, are among the most popular sites for people to leave milagros and other votive offerings.

11. *New Catholic Encyclopedia* 12:962 and Molinari 1965:16–17.

12. In the Catholic Church, the practice of devotions during nine consecutive days, usually for some special religious purpose.

13. At the 1982 fiesta in Magdalena, a fifty-year-old Yaqui man from Eloy, Arizona, told me he and his wife brought thirteen large votive candles—two for their daughter, three for his sister, two for his mother-in-law, three for his wife, and three for himself.

14. They planned to stay in the "Papago Campground," a few blocks from the church. They told me later that the man had slept on the ground, his wife

on the hood of the car, his sister on the back seat, and his daughter on the front seat. If it had rained, they all would have slept in the car.

15. A number of Mexicans and Mexican Americans, as well as folklorist James Griffith, have told me this.

16. In Spain, Portugal, and some other parts of the world, wax milagros are popular, and in some areas, such as northeastern Brazil, the offerings are often made of wood.

17. Señora Ochoa offered to save the milagros left by pilgrims each day from October 1 to October 7. She put each day's offerings in separate, labeled jars. The milagros were later counted by Señora Ochoa and Adelina Albaraba of Nogales, Arizona, who also volunteered to help with my research. Albaraba reported that 94 milagros were offered on Oct. 1, 83 on Oct. 2, 150 on Oct. 3, 741 on Oct. 4, 101 on Oct. 5, 73 on Oct. 6, and 68 on Oct. 7. Even though the feast day fell on a Sunday that year, when more people were free to travel, Señora Ochoa said that by far the most milagros are always offered on October 4. The vigil does not seem to be a major offering day.

18. A *sacristana* is a laywoman in charge of the sacristy of a church. In rural areas she usually has the keys to unlock the church for visitors.

19. The tendency to "punish" saints for failing to grant a request also occurs in other regions. Francis Toor described how people from villages adjoining Cuernavaca, Mexico, unsuccessfully offered prayers, candles, incense, and Masses to the saints to alleviate a drought. When rain failed to fall, the people undressed the statues of the saints and put them in the fields to bake in the hot sun "to see if suffering from it would make them listen to their prayers. When it rains too much, they put their saints in the streams so that they, also, may suffer from too much water and make the rains stop" (1947:28).

In Puerto Rico, when a saint does not answer prayers, some people respond by placing their household statue of the saint in the bottom of a trunk, by reprimanding it, or by turning it, like a naughty child, to face the wall (Vidal 1974:33).

20. "The Santo Niño de Atocha . . . is a purely Mexican devotion that originated in the town of Plateros, near Zacatecas, in Mexico's northern mining country. The Holy Child was originally part of a Mother-and-Child statue representing the Spanish Virgin of Atocha. At some point the statue of the child was removed from his mother's arms and became the object of a separate devotion. The Santo Niño is patron of miners and prisoners. His devotion is important all through the area that was once northern New Spain" (Griffith 1992:186).

21. The first person in line was an Indian woman who held out a large, heavy-

looking brown paper bag and asked Padre Santos to bless it. He quickly opened the bag and saw that it was full of large votive candles in glass holders. As the padre blessed the entire bagful, the woman said in Spanish, "They are for San Francisco." Nodding his head, Padre Santos took the bag from her and put it in a cabinet with dozens of similar bags. The woman watched him in disbelief. With a flourish of his hand, he told her, "It's all right, you don't have to carry these heavy candles any more and stand in a long line with them. You can just leave them here and San Francisco will know." Her expressionless face did not reveal whether she believed him and was satisfied or if she wished she could bring the candles to San Francisco's statue, and she turned and left without complaint.

22. Holy water is water that has been blessed by a priest for sacred use. The font is a bowl, usually of stone, which holds the water used in baptismal ceremonies.

23. Wood boats are offered in other regions as well. At the Iglesia de San Francisco in Tamulté de las Sabanas, Tabasco, Mexico, pilgrims from the east coast of Mexico (approximately 50 kilometers distant) still bring wood boats in gratitude for being saved at sea (Marion Oettinger, letter to author, Mar. 9, 1992).

24. At some Mexican shrines, statues of saints and the Virgin even receive mail! Many letters seeking help from El Santo Niño de Atocha are attached to the walls near his statue in a side chapel of the Cathedral of Tlaxcala, near Mexico City (Turner and Turner 1978:71).

25. Milagros are also worn in Puerto Rico and Cuba, and immigrants from both islands have brought the custom to Florida, New York, and other areas where they settled.

CHAPTER 2: *Offering Sites throughout the Sonoran Region*

1. To provide a description of all the milagros present at one time (as well as the images they were placed on) at thirty-two of the less-popular sites open to the public, I visited all of them between March 1 and April 4, 1993.

2. In St. Margaret's vision, which occurred in 1675, Jesus appeared to her, His heart exposed. A flame was rising from the top, and rays of light were radiating out from it. According to St. Margaret, Jesus pointed to his heart and said, "'Behold this heart that has so loved men. . . . I promise that My Heart will pour out abundantly the power of its love upon those who pay it . . . honor.'" (Schulzetenberg 1989:2). The pastor of St. Margaret's Church, Father Cyprian Killackey, says the Sacred Heart of Jesus has become one of the most popular devotions in the Catholic Church.

3. St. Jude was one of the Twelve Apostles and is a patron saint of people in desperate or hopeless situations.

St. Joseph was the husband of the Virgin Mary and is the patron saint of, among others, carpenters, doubters, and house hunters.

St. Anthony of Padua is a patron saint of the poor and those who have lost something.

St. Thérèse of Lisieux was a nineteenth-century French Carmelite nun. Known as "Little Flower of Jesus," she is the patron saint of florists, missions, and her native France.

The Infant of Prague is a representation of the Christ child. The original statue was brought from Spain to Czechoslovakia in the early sixteenth century and presented to the Descalced Carmelite priests in 1628. In 1631, when King Gustav of Sweden invaded and pillaged Prague, the statue was thrown on a rubbish heap and its hands were broken off. Several years later, after the statue was again displayed, a priest said he heard it say, "Have pity on me and I will have pity on you. Give me my hands and I will give you peace." The hands were replaced, and people who prayed to the Christ child began reporting miracles (Daughters of St. Paul 1980:4–6). The statue has remained in the Church of Our Lady of Victory ever since.

4. In his book *Beliefs and Holy Places,* Jim Griffith recounts the story of Our Lady of Guadalupe, "the most popular religious figure of the entire Mexican and Mexican-American world. She is the Protectress of the Mexicans, Queen of the Americas—the Virgin Mary as she appeared just outside Mexico City to an Indian named Juan Diego.

"It was 1531, little more than a decade after the bloody and traumatic Conquest of Mexico. Juan Diego was on his way into Mexico City, past the hill of Tepeyac, which in Aztec times had been sacred to the Goddess Tonantzin, "Our Mother." There by the hill he saw a beautiful woman who commanded him to go to Mexico City. There Juan was to see the bishop and ask him to build a church in honor of the Lady on the very spot where she had appeared. This Juan did, only to meet with a rebuff from the bishop. After a second request had also been denied, the Lady told Juan to gather the roses he found growing on the hill into his *tilma,* or cloak, and carry them to the bishop as proof of the truth of his story. He did as she commanded, spilling the roses at the bishop's feet. When he did so, he revealed on his tilma the image of the Lady with whom he had spoken" (239).

5. Of the 101 milagros of whole people, there were 34 kneeling men, 40 kneeling women, one standing man, 10 girls, 13 boys, and 3 infants.

6. Of the body-part milagros, there were 21 left legs, 16 right legs, 13 men's heads, 10 women's heads, and one infant's head.

7. St. Lucy was martyred in A.D. 304 and is the patron saint of people with eye problems and those suffering from hemorrhaging and throat infections.

8. Walsh 1987:291.

9. San Martín de Porres was the son of a Spanish knight and a "coloured freed-woman" from Panama. He was born in Lima, Peru, in 1579 and became a lay brother of the Dominican order who devoted his time to caring for the sick and the poor. He is the patron saint of those who seek social justice and of people of mixed race (Walsh 1987:304–306). According to Father Rafael Toner, who sometimes says Mass at the chapel, "He is very popular with the Yaquis because his mother was an Indian."

10. A common name for the medal of the Immaculate Conception of Mary. Catholics believe that because the Virgin Mary was conceived without original sin, her soul at conception was "immaculate." According to the church, the Virgin Mary appeared to Sister (now Saint) Catherine Labouré in a chapel in Paris in 1830 and asked her to have a medal struck depicting the Virgin standing on the Earth with her hands outstretched to all who ask her assistance. She told St. Catherine that all who wear the medal will receive great graces (Skelly 1961:11–12).

11. Religious processions on the nine nights before Christmas, symbolizing Mary and Joseph's search for a place to stay before she gave birth to Jesus.

12. See Griffith 1992:136 for other details.

13. See Griffith 1992:136–137 for a detailed description of the shrine.

14. When I asked permission to count them, Romo said she planned to write her own book about the shrine and therefore wanted me to report only what had already been written about it in newspaper stories.

15. Campbell said he chose St. Theresa "simply because my Uncle Bill, a Jesuit brother, introduced me to her. He had a lot of faith in her as an intercessor to God. So ever since I was small, she was my favorite saint." Although he is of Scotch and Irish descent, Campbell said he uses the Spanish version of her name "because my late wife was Mexican."

16. Two small pieces of cloth joined by strings, often with holy pictures attached to one side of each piece. Some Roman Catholics wear them on their chest and back, under their clothes, as a token of their religious devotion.

17. Madrid, letter to author, 1991.

18. A stepped-gable structure has a gable (or upper part of the end wall) built in the shape of two sets of stairs meeting at the peak.

19. Some of the O'odham practice both Catholicism and their native religion. As more than one have told me, they "get the benefits of both."

20. Infants' shoes are also found at another site where people leave milagros—the shrine of San Ramón in Nogales, Mexico.

21. According to Monsignor Oliver, the broom was placed there by the priests to symbolize the humble work St. Martin did in his lifetime: cleaning the Dominican monastery where he was a lay brother.

22. Since the Middle Ages, St. Raymund Nonnatus has been the patron saint of midwives, women in childbirth, and pregnant women. He was called *non natus,* or "not born," in Latin, because he was taken out of his mother's body after she died in labor (Walsh 1987:384).

23. Folklorist James Griffith relates a local legend that explains why the statue is black: A pious man used to pray to the statue and kiss its toes each day. When evil people tried to kill him by putting poison on the statue's toes, the statue turned black to warn him. Griffith heard this account from Josefina Gallegos, the sacristana at the church in San Ignacio, who had heard it from an old woman in Ímuris (telephone conversation, July 10, 1992).

Señora Carmen Corella, the sacristana at la Iglesia de San José, offered another explanation. On April 26, 1992, she told me that "the Black Christ was brought [from Spain] by Father Kino and buried during the [religious] persecution—that's why it's black." Anthropologist James Officer believes the statue was probably made in Mexico about 1810 or shortly after and that it was created as a black image because it was intended to replicate the Black Christ in Guatemala (telephone conversation, July 28, 1993).

In 1595, that Christ figure, carved from dark wood and blackened by candle smoke and incense, was brought to the town of Esquípulas in southeastern Guatemala. It was placed in a chapel built on the site of an old Indian shrine close to health-giving springs. Soon, miraculous cures were attributed to the statue. According to legend, Archbishop Pedro Pardo de Figueroa of Guatemala was cured of a contagious disease during a visit to the shrine in 1737. In gratitude, he began construction of the present Santuario de Esquípulas (Borhegyi 1956:3–4).

In a report written in 1843, Tucson's justice of the peace mentioned a likeness of that Black Christ in a convent room at El Pueblito (the Little Village), an old community of Tohono O'odham across the river from the Tucson presidio (Officer 1987:168). Mexican troops from the Tucson garrison took the statue to Ímuris in 1856, shortly after the Gadsden Purchase ceded the Tucson area to the United States (Officer 1987:370 n. 44).

24. Polzer, telephone conversation, Sept. 21, 1993.

25. Born in 1650, San José Oriol was a priest in Barcelona, Spain, known for his penance, almsgiving, and miraculous cures. Statues usually represent him in a priestly cassock and surplice (Ferrando Ruig 1950:153).

26. Polzer 1982:63–64; Griffith 1992:36–37.

27. Some people who confuse Padre Kino and San Francisco believe the bones belong to the saint.

28. See Griffith 1992:112–114 for other details.

29. Griffith (1992:113). Griffith also notes that although the literal translation is "John Soldier," a "more culturally accurate English equivalent" for "Juan Soldado" would be "G.I. Joe."

30. The statue's right hand rests on a painted white tree stump with a crucifix mounted on top of it. In Tijuana, James Griffith saw a photograph, purported to be of Juan Soldado, showing a young man in uniform with his right hand resting on a table with a crucifix on it. Griffith was told that this is "a standard pose for photographs of young men when they are about to join the army" (Griffith 1992:113).

31. Excluding about 120 offerings at the shrine of El Señor de los Milagros in Tucson (which the owner of the shrine did not want counted), there was a total of 968 milagros at the thirty-two sites that I visited between March 4 and April 1, 1993.

Among the milagros were 346 whole people, 602 body parts, six houses, one feather, and one automatic pistol. I could not identify twelve other milagros (at Santa Cruz Church) because they were jammed in a crucifix.

The most common type of milagro was eyes—a total of 260 in all, including 15 single eyes and 245 pairs. The second most common milagros were legs—61 right, 58 left, 119 in all. Next were kneeling men—111—and kneeling women—108, followed by 71 heads—40 men's, 30 women's, and one infant's.

The most offerings were made to St. Lucy; two statues had a total of 261 offerings, 259 of them eyes. Six images of Christ on the Cross had the second largest number—139. The folk saint Juan Soldado was third, with 72. The St. Francis "combination statue" in Sells was next, with 55. The Infant of Prague had 53 offerings, St. Martin de Porres, 36, and Jesus Scourged, 28.

St. Martin de Porres appears to be among the most popular saints; his images had received offerings at eight of the thirty-two sites, more than any other saint.

Images of Christ Crucified had milagros on them at six sites. Statues of the Infant of Prague and St. Jude had each received offerings at five sites. (These do not include the ones at St. Margaret's and Holy Family Churches in Tucson, where a total of 376 milagros are in displays instead of on the images. This probably does not change the order of popularity because at St. Margaret's, most people who offer milagros promise them to the Sacred Heart of Jesus, the Infant of Prague, or St. Jude, and the statues in Holy Family Church are St.

Martin de Porres, Christ Crucified, the Infant of Prague, St. Jude, St. Francis of Assisi, and Our Lady of Mt. Carmel.)

CHAPTER 3: *Buying a Milagro*

1. St. Peregrine Laziosi, born in 1260 in Italy, was miraculously cured of cancer of his foot the night before the foot was to be amputated. His is a popular patronage, not formally confirmed by the church.

2. All three women said that more people ask for right legs than left, and a clerk at Librería Méjico, the religious goods shop in Tucson that closed in 1993, told me the same thing. The saleswoman at Artemex also said she sells more right arms and hands than left.

3. All six shops had kneeling men and women, standing girls, men's and women's heads, right arms and legs, ears, lungs, and women's breasts. Five shops displayed standing boys, single and double eyes, left legs and feet, navels, and pierced hearts. Four had sitting infants, right hands and stomachs. Three stores were selling reclining infants, left arms and hands, right feet, double kidneys, and tongues. Two displayed lips, and hearts with crowns of thorns. One shop had standing women, another had flaming hearts, and a third had hearts with veins.

CHAPTER 4: *Stamping, Engraving, and Casting Milagros*

1. Blows are holes in the cast piece that are formed wherever gas or steam has been unable to escape from the poured metal. Scabs are disfigurations caused by gas eruptions during the pouring of the metal. Veins are uneven areas on the surface of a cast piece due to nonuniform crystallization of the cooling and hardening metal (Untracht 1968:326).

2. Ibid.:327.

3. Ibid.:323.

4. The color signified different qualities of the waxes, such as rigidity, flexibility, and the ability to capture detail. According to an employee of McGuires, a jeweler's supply house on East Tenth Street in Tucson, not even jewelers know what kind of wax it is. "The ingredients are unknown—secret formulas of the companies who make them," he said. "They could be 50 percent plastic and 50 percent wax or any other ratio of materials."

CHAPTER 5: *From Heads to Handcuffs: Many Kinds of Milagros*

1. In a variation of the customary use of milagros, someone may decide, in a case of acute illness, to pledge a whole-body milagro as a substitute for himself or herself and ask the saint or God to accept the image instead of taking his or her life.

2. Early in 1993, in an attempt to get information about the clothing depicted on these milagros, I sent photocopies of the photographs to the Museum of International Folk Art in Santa Fe, New Mexico; the Costume Institute at the Metropolitan Museum of Art in New York City; the Costume and Textile Department of the Los Angeles County Museum of Art; and the Fowler Museum of Cultural History in Los Angeles. None of the costume specialists could identify the clothing precisely. The consensus was that the modern clothing is mid-twentieth-century American, but that most of the other garments are merely generic. In the opinion of Jennifer Loveman of the Costume Institute of the Metropolitan Museum of Art, "the artisans were much more interested in conveying the idea of clothing than they were worried about the depiction of specific garments and details" (letter to author, Feb. 4, 1992).

When I showed the photographs to Agustin Calleros, a jeweler in Tucson, he told me, "It's probably like here. Some people like to be dressed up all the time, some people like to go around in Levis or shorts. If someone came in and asked me to make a man and they didn't give me any details—long-sleeve shirt, short-sleeve, etc.—then, sure, I'd make it, but I'd make it the way I wanted the man to look. So some silversmiths made a girl with a skirt with the pleats this way," he said, pointing to a girl milagro in one photograph, "and another one made a skirt like that," he added, pointing to another.

3. The desire for correct representation of left and right appendages seems universal. A Cuban jeweler in Miami, Florida, told me that he once had a hasty request for a cast-gold milagro of an arm. He said the customer left his store so quickly that he did not know whether the man needed a right or left arm. The jeweler said he had to make both and let the client choose the proper one when he arrived to pick it up.

4. There is a plaster statue of St. Lucy in a sculpture niche on the front facade of the mission, but the mission is not known as a shrine of St. Lucy, and most people do not even know the statue is there.

5. The portrayal of a cleft lip was confirmed by Dr. John T. Wolf, a plastic surgeon in Manchester, New Hampshire, after he examined a photograph of the milagro (letter to author, Feb. 10, 1993).

6. Bercht and Coelho Frota 1989:14.

7. Letter to author, July 13, 1993.

8. Teodoro Vidal (1974:69), an authority on Puerto Rican milagros, found a similar handcuffs milagro with a chain and key beside an image of Nuestra Señora de Merced (Our Lady of Mercy) in the Barrio Carrizao Chapel, Aguada, Puerto Rico.

9. Letter to author, Dec. 8, 1992.

10. At San Xavier, the whole-body milagros include 395 men, of which only

5 are standing and 390 are kneeling; 399 women, of which only 4 are standing and 395 are kneeling; 192 boys and 194 girls, all standing; and 52 infants, 1 of which is standing, 30 are sitting, 11 are reclining, and 10 are crawling.

The body-part milagros include 446 leg milagros, of which 201 are right legs, 243 are left and 2 are pairs; 340 heads, of which 188 are men's, 147 are women's and 5 are children's; 258 eyes, of which 121 are single and 137 are double; 189 arms, of which 100 are right and 89 are left; 143 feet, of which 34 are right and 109 are left; 137 hands, 71 of which are right and 66 are left; 61 ears, all right; 1 single breast; 1 bust of a girl; 1 throat; and 1 finger.

There are 224 internal organs, including 144 hearts, of which 118 are pierced by a sword, 17 have flames and 9 are plain; 76 single kidneys; 3 stomachs and 1 pair of lungs.

There were also 4 cars, 3 houses, 1 liquor bottle and 3 cows.

11. At Magdalena, the whole-body milagros include 6,434 men, of which only 31 are standing and 6,403 are kneeling; 6,742 women, of which only 23 are standing and 6,719 are kneeling; 3,364 standing boys; 3,354 girls, of which 202 are kneeling and 3,152 are standing; and 776 infants, of which 154 are reclining and 622 are sitting.

The body-part milagros include 8,989 leg milagros, of which 5,224 are right, 3,764 are left, and one is a pair; 3,524 heads, of which 1,836 are men's, 1,686 are women's, one is a boy's, and one is a girl's; 3,285 arms, of which 2,013 are right, 1,272 are left; 2,227 eyes, of which 636 are single and 1,591 are double; 1,182 feet, of which 372 are right and 810 are left; 1,069 hands, of which 453 are right and 616 are left; 331 ears, all right; 193 navels; 160 breasts, of which 4 are single and 156 are double; 26 lips; and 6 tongues.

There are also 1,572 internal organs, including 1,312 hearts, of which 967 are pierced by a sword, 172 are topped with a flame, 74 have a crown of thorns, 64 are plain, 34 have striations, and one has veins and arteries; 140 stomachs; 127 lungs, including one single and 126 pairs; and 93 kidneys, of which 60 are single and 33 are double.

The collection has 202 animal milagros, including 97 cows, 52 horses, 21 dogs, 18 pigs, 3 sheep, 3 goats, and a hen, a rooster, a cat, a burro, a donkey, a whale, a fish, and a shrimp.

There are 355 milagros of objects: 176 houses, 84 trucks, 83 cars, 7 keys, 2 books, a liquor bottle, a leaf, and a boat.

12. Dr. Valenzuela said that in that region, ulcers are often caused by spicy food, drinking alcohol, and smoking (conversation with author, Jan. 25, 1995).

13. Valley fever, or coccidioidomycosis, is an acute respiratory disease endemic to the southwestern United States, caused by inhaling the fungus coc-

cidioides immitis. It is most prevalent in California's San Joaquin Valley, thus it is called the San Joaquin or Valley Fever (Tapley et al. 1985:447).

CHAPTER 6: *What Becomes of Milagros?*

1. McCarty, letter to author, Dec. 8, 1982.

2. Some priests in other regions take drastic steps to safeguard the milagros they remove from the statues. Since milagros displayed in showcases in St. Lazarus Orthodox Catholic Church in the Cuban area of South Miami were stolen in 1980, Pastor Nelson Maiquez has been placing the new milagros left at the church in a bank safe-deposit box.

3. Some people think milagros offered in the Tucson area are similarly collected at San Xavier, but friars at the mission say this is not so.

4. One evening in early March 1993, Señora Gallego took me into the locked church and showed me a collection of milagros kept in a cookie tin in the sacristy. We took the collection to her house near the church, and a colleague and I spent the next hour and a half sipping coffee and counting the 1,102 milagros in the tin. Most of the offerings—902 double eyes and 97 single eyes—had been left by the statue of Santa Lucía. The remaining 103—other body parts, whole people, a car and a padlock—had also been left on Santa Lucía or on other statues in the church. Señora Gallego continues to add milagros to the collection when she periodically removes offerings from the statues in the church.

5. This is the only site in the region where only some milagros are removed from a statue.

6. Milagros are also buried at El Santuario de Chimayo north of Sante Fe, New Mexico. "They're removed once in awhile because it's such a tiny room," Father Miguel Mateo told me in August 1993. "They're stored and when they accumulate, sometimes we bury them."

If owners of household shrines in Puerto Rico think too many milagros have accumulated on the holy pictures or statues, they may bury the offerings near their houses, which is considered a very respectful way to dispose of the offerings (Vidal 1974:92).

7. In Chilapa, Mexico, the priests gather the metal milagros every few years and sell them by the kilo to local jewelers, who melt them down to reclaim the small amounts of silver (letter to author, Mar. 9, 1992, from Marion Oettinger, Curator of Folk Art and Latin American Art, San Antonio Museum of Art).

8. Letter to author, Dec. 8, 1982.

9. St. Gerard Majella is the popular patron saint of mothers. According to many Mexican Americans, he is prayed to especially by pregnant women.

10. Probably because virtually all milagros in the region are metal, to my knowledge they are never burned. In contrast, milagros in some parts of Mexico and in at least two places in Spain are routinely burned. According to Oettinger, priests in Chilapa, Mexico; Bogotá, Colombia; and northeastern Brazil "periodically clear out collections by burning them" (letter to author, Mar. 9, 1992). Wax milagros accumulated at Santuario de Nuestra Señora de Sonsoles (Sanctuary of Our Lady of Sonsoles) near Ávila, Spain, are burned every five or six years in the church yard, Padre Eugenio Martine told me in September 1990. At the world-famous monastery of Montserrat, near Barcelona, wax milagros left at the Basilica and at the Holy Grotto chapel are burned three or four times a year, according to Padre Jordi Castanyer.

CHAPTER 7: *The New Milagro Art*

1. Stamps depicting saints, the Virgin, and Christ are sold in Catholic religious-goods stores. According to Carrasco, "People buy stamps to give away. When somebody dies in the house, the family buys stamps and gives them to people who come to the funeral. Or when people are sick in the hospital, you buy a stamp and a priest blesses it and you bring it to the hospital instead of flowers. There are big ones—eight inches square—and little ones that the sick person can put in their wallet after they get better."

2. Amulets are charms usually worn to ward off evil spirits.

3. Milagro art has appeared in the Horchow catalog and the late fall 1994 catalog of La Colección J.T.C.

4. A series of fourteen images or pictures, as in a church or along a path leading to a shrine. The images represent the stages of Jesus' sufferings and are visited in succession by worshippers.

CHAPTER 8: *The Future of Milagros*

1. See Griffith 1992:139–142 for a detailed description of this site.

2. In contrast to Magdalena, it is impossible to correlate milagro sales and milagro use in the Tucson area for two reasons. During the last ten years, some stores that sold milagros closed and no one knows whether their customers switched to other stores in Tucson or began buying their offerings elsewhere. Also, in Tucson many milagros are bought for nonreligious purposes such as making art and crafts, and some shopkeepers do not know exactly, or do not want to reveal, how many are bought for which purpose.

3. Turner and Turner 1978:29–30.

4. Vidal 1974:89.

5. In Moyers 1993:105. Dr. Ornish is president of the Preventive Medicine

Research Institute at the School of Medicine at the University of California in San Francisco.

6. Kerényi 1959:50.

7. Pelauzy 1978:194.

8. Bercht and Coelho Frota 1989:20.

9. Toor 1947:68.

BIBLIOGRAPHY

Ackerman, James S. 1966. *Palladio.* Baltimore, Md.: Penguin Books.

Ahlborn, Richard E. 1974. *Saints of San Xavier.* Tucson, Ariz.: Southwestern Mission Research Center.

Allardyce, Isabel. 1912. *Historic Shrines of Spain.* New York: Franciscan Missionary Press.

Almagro Gorbea, Maria José. 1980. *Corpus de las terracotas de Ibiza.* Vol. 18 of *Bibliotheca Praehistorica Hispana.* Madrid: Consejo Superior de Investigaciones Cientificas, Instituto Español de Prehistoria.

Anderson, Lawrence. 1941. *The Art of the Silversmith in Mexico, 1516–1936.* Vols. 1 and 2. New York: Oxford University Press.

Aradi, Zsolt. 1956. *The Book of Miracles.* New York: Farrar, Straus, and Cudahy.

Benedictine Monks of St. Augustine's Abbey, Ramsgate (compilers). 1966. *The Book of Saints: A Dictionary of Persons Canonized or Beatified by the Catholic Church.* New York: Thomas Y. Crowell.

Bercht, Fatima, and Lélia Coelho Frota. 1989. *House of Miracles: Votive Sculpture from Northeastern Brazil.* New York: Americas Society.

Berrin, Kathleen. 1978. *Art of the Huichol Indians.* New York: Fine Arts Museum of San Francisco/Harry N. Abrams.

Boardman, John. 1964. *Greek Art.* New York: Frederick A. Praeger.

Bolton, Herbert Eugene. 1936. *Rim of Christendom: A Biography of Eusebio Francisco Kino, Pacific Coast Pioneer.* New York: Macmillan.

———. 1986. *The Padre on Horseback: A Sketch of Eusebio Francisco Kino, S. J., Apostle to the Pimas.* Chicago: Loyola University Press.

Borhegyi, Stephen F. de. 1956. *El Santuario de Chimayo.* Santa Fe, N.Mex.: Ancient City Press for the Spanish Colonial Arts Society.

Bray, Warwick. 1979. *Gold of El Dorado.* New York: Harry N. Abrams.

Brodrick, James, S.J. 1952. *Saint Francis Xavier (1506–1552).* New York: The Wicklow Press.

Canton, Katia. 1989. "House of Miracles." *Art in America* 77 (12): 73, 75.

Caro Baroja, Julio. 1957. *España primitiva y romana.* Barcelona: Editorial Seix Barral.

Cisneros, Florencio García. 1979. *Santos of Puerto Rico and the Americas.* Translated by Roberta West. Detroit, Mich.: Blaine Ethridge Books.

Coe, Michael D. 1962. *Mexico.* New York: Frederick A. Praeger.

Coggins, Clemency Chase, and Orrin C. Shane III (editors). 1984. *Cenote of Sacrifice.* Austin, Tex.: University of Texas Press.

Comstock, Mary, and Cornelius Vermeule. 1971. *Greek Etruscan and Roman Bronzes in the Museum of Fine Arts, Boston.* Boston: Museum of Fine Arts.

Crawford, Osbert Guy Stanhope. 1956. *The Eye Goddess.* New York: Macmillan.

Cuadrado Díaz, Emeterio. 1950. "Exvotos equinos del santuario ibérico del Gigarralejo (Murcia)." In *Protostoria Mediterranea.* Vol. 1:454–460. Firenze, Italy: Congresso Internazionale di Preistoria e Protostoria Mediterranea.

Daughters of St. Paul. 1980. *Infant of Prague Devotions.* Boston: St. Paul Books and Media.

Didron, Adolphe Napoléon. 1896. *Christian Iconography.* Vol. 1. Translated by E. J. Millington. London: George Bell and Sons.

Dorner, Gerd. 1962. *Folk Art of Mexico.* Translated by Gladys Wheelhouse. New York: A. S. Barnes and Co.

Eckhart, George B., and James S. Griffith. 1975. *Temples in the Wilderness: The Spanish Churches of Northern Sonora, Their Architecture, Their Past and Present Appearance, and How to Reach Them.* Tucson: Arizona Historical Society.

Egan, Martha. 1991. *Milagros: Votive Offerings from the Americas.* Santa Fe: Museum of New Mexico Press.

Euler, Robert C. 1984. "The Archaeology and Geology of Stanton's Cave." In *The Archaeology, Geology, and Paleobiology of Stanton's Cave,* edited by Robert C. Euler. Grand Canyon National Park, Arizona, Monograph No. 6. Grand Canyon, Ariz.: Grand Canyon Natural History Association.

Ferguson, George. 1954. *Signs and Symbols in Christian Art.* New York: Oxford University Press.

Ferrando Ruig, Juan. 1950. *Iconografía de los Santos.* Barcelona, Spain: Ediciones Omega.

Flannery, Austin, O. P. (general editor). 1975. *Vatican Council II: The Conciliar and Post Conciliar Documents.* Wilmington, Del.: Scholarly Resources.

Fontana, Bernard L. 1961. "Biography of a Desert Church: The Story of Mission San Xavier del Bac." *The Smoke Signal,* no. 3. Tucson, Ariz.: Tucson Corral of the Westerners.

————. 1981a. "Pilgrimage to Magdalena: The Feast of San Francisco Reflects Past and Present in Sonora." *American West* 18 (5): 40–45, 60.

————. 1981b. *Of Earth and Little Rain: The Papago Indians.* Photographs by John P. Schaefer. Flagstaff, Ariz.: Northland Press.

Freedberg, David. 1989. *The Power of Images: Studies in the History and Theory of Response.* Chicago: University of Chicago Press.

Furst, Jill Leslie, and Peter T. Furst. 1980. *Pre-Columbian Art of Mexico.* New York: Abbeville Press.

Gantner, Theo. 1980. *Geformtes Wachs.* Basel: Schweizerisches Museum für Volkskunde.

Garbini, Giovanni. 1966. *The Ancient World.* New York: McGraw-Hill.

García y Bellido, Antonio. 1947a. "Colonizaciónes Púnica y Griega." *Ars Hispaniae* 1: 137–198. Madrid: Editorial Plus-Ultra.

————. 1947b. "El arte Ibérico." *Ars Hispaniae* 1: 199–297.

————. 1947c. "El arte de las tribus Célticas." *Ars Hispaniae* 1: 301–338.

Giffords, Gloria Fraser. 1991. *The Art of Primitive Devotion: Retablo Painting of Mexico.* Fort Worth, Tex.: InterCultura, and Dallas: Meadows Museum, Southern Methodist University.

Goss, Robert C. 1974. *The San Xavier Altarpiece.* Tucson: University of Arizona Press.

Grant, Frederick Clifton (editor). 1953. *Hellenistic Religions: The Age of Syncretism.* New York: Liberal Arts Press.

Griffith, James S. 1992. *Beliefs and Holy Places: A Spiritual Geography of the Pimeria Alta.* Tucson: University of Arizona Press.

Grove, Richard. 1954. *Mexican Popular Arts Today.* Colorado Springs, Colo.: Taylor Museum of the Colorado Springs Fine Arts Center.

————. 1955. "Numbers of Things from the Profusion of Mexico's Crafts." *Craft Horizons* 15 (July): 28–37.

Hansen, H. J. (editor). 1968. *European Folk Art in Europe and the Americas.* Translated by Mary Whittall. London: Thames and Hudson.

Hawkes, Jacquetta. 1976. *The Atlas of Early Man.* New York: St. Martin's Press.

Haydon, A. Eustace. 1967. *Biography of the Gods.* New York: Frederick Ungar.

Henderson, John S. 1981. *The World of the Ancient Maya.* Ithaca, N.Y.: Cornell University Press.

Huot, Jean-Louis. 1965. *Persia I: From the Origins to the Achaemenids.* Translated by H.S.B. Harrison. New York: World Publishing.

Inturrisi, Louis. 1989. "Votive Figures for Collectors." *New York Times,* Feb. 19, sec. 5, p. 12:1.

Jansen, H. W. 1982. *History of Art.* New York: Harry N. Abrams.

Jarrett, Bede. 1912. "Votive Offerings." *Catholic Encyclopedia.* Vol. 15:509–510. New York: Robert Appleton.

Jones, Edward H., and Margaret S. Jones. 1971. *Arts and Crafts of the Mexican People.* Los Angeles: Ward Ritchie Press.

Kay, Elizabeth. 1987. *Chimayo Valley Traditions.* Santa Fe, N.Mex.: Ancient City Press.

Kerényi, C. 1959. *Asklepios: Archetypal Image of the Physician's Existence.* Translated from German by Ralph Manheim. New York: Pantheon.

Kino, Eusebio Francisco. 1919. *Kino's Historical Memoir of Pimería Alta: A Contemporary Account of the Beginnings of California, Sonora, and Arizona.* Translated by Herbert Eugene Bolton. Cleveland, Ohio: Arthur H. Clark.

Kjellberg, Ernst, and Gösta Säflund. 1968. *Greek and Roman Art, 3,000 B.C. to A.D. 550.* New York: Thomas Y. Crowell.

Kroeber, A. L. 1976. *Handbook of the Indians of California.* New York: Dover Publications.

LaFarge, Henry A. (editor). 1981. *Museums of the Andes.* Tokyo: Newsweek and Kodansha.

Lamb, Winifred. 1969. *Ancient Greek and Roman Bronzes.* Chicago: Argonaut.

Lloyd, Seton. 1961. *The Art of the Ancient Near East.* New York: Frederick A. Praeger.

Lullies, Reinhard, and Max Hirmer. 1960. *Greek Sculpture.* New York: Harry N. Abrams.

Lumholtz, Carl. 1898. "The Huichol Indians of Mexico." *Bulletin of the American Museum of Natural History* 10: 1–14.

———. 1902. *Unknown Mexico.* Vol. 2. New York: Charles Scribner's Sons.

———. 1990. *New Trails in Mexico.* Tucson: University of Arizona Press.

Madsen, William. 1964. *The Mexican-Americans of South Texas.* New York: Holt, Reinhart, and Winston.

Margueron, Jean-Claude. 1965. *Mesopotamia.* Translated by H.S.B. Harrison. New York: World Publishing.

Marinatos, Spyridon, and Max Hirmer. 1960. *Crete and Mycenae.* New York: Harry N. Abrams.

Maringer, Johannes. 1960. *The Gods of Prehistoric Man*. New York: Alfred A. Knopf.

Marsh, George P. 1969. *Mediaeval and Modern Saints and Miracles*. New York: Harper and Row.

Mazar, Benjamin (editor). 1960. *Views of the Biblical World*. Vol. 2. Jerusalem: International Publishing.

Meletzis, Spyros, and Helen Papadakis. 1964. *National Museum of Archaeology, Athens*. Munich: Schnell and Steiner.

————. 1967. *Akropolis and Museum*. Munich: Schnell and Steiner.

————. 1968. *Delphi*. Munich: Schnell and Steiner.

Mena, Ramón. 1926. "Votive Monument of Motecuhzoma Xocoyotzin." In *Mexican Folkways*. Vol. 2: 32–38. Mexico D.F.: Mexican Folkways.

Mitten, David Gordon, and Suzannah F. Doeringer. 1967. *Master Bronzes from the Classical World*. Mainz on Rhine, West Germany: Philipp von Zabern.

Molas y Rifà, Jordi. 1989. *The Official Guide to Montserrat*. Barcelona: Publicaciones de l'Abadia de Montserrat.

Molinari, Paul, S. J. 1965. *Saints: Their Place in the Church*. Translated by Dominic Maruca, S.J. New York: Sheed and Ward.

Moretti, Mario, and Guglielmo Maetzke. 1969. *The Art of the Etruscans*. New York: Harry N. Abrams.

Moyers, Bill. 1993. *Healing and the Mind*. New York: Doubleday.

Muller, Priscilla E. 1972. *Jewels in Spain, 1500–1800*. New York: Hispanic Society of America.

New Catholic Encyclopedia. 1981. Vols. 7, 9, 12, and 14. New York: McGraw-Hill.

Nilsson, Martin Persson. 1961. *Greek Folk Religion*. New York: Harper Torchbooks.

Officer, James E. 1987. *Hispanic Arizona, 1536–1856*. Tucson: University of Arizona Press.

Painter, Muriel Thayer. 1986. *With Good Heart: Yaqui Beliefs and Ceremonies in Pascua Village*. Tucson: University of Arizona Press.

Parent, Robert Alcide. 1977. "Two Aspects of French Canadian Art: *Ex Voto* Painting and *Portraits de Cadavres*." Unpublished manuscript.

Pasztory, Esther. 1983. *Aztec Art*. New York: Harry N. Abrams.

Patronato de Nuestra Señora de Sonsoles, eds. 1969. *Historia de Nuestra Señora de Sonsoles*. Ávila, Spain: Imprenta Porfirio Martín.

Pelauzy, Maria Antonia. 1978. *Spanish Folk Crafts*. Translated by Diorki. Barcelona, Spain: Editorial Blume.

Pickens, Buford. 1993. *The Missions of Northern Arizona: A 1935 Field Documentation*. Tucson: University of Arizona Press.

Polzer, Charles W., S. J. 1982. *Kino Guide II: A Life of Eusebio Francisco Kino, S. J.*,

Arizona's First Pioneer, and a Guide to His Missions and Monuments. Tucson, Ariz.: Southwestern Mission Research Center.

Prat, Joan. 1972. "El ex-voto: Un modelo de religiosidad popular en una comarca de Cataluña." *Ethnica Revista de Antropología,* no. 4, 137–168.

Redford, Robert. 1930. *Tepoztlan, a Mexican Village.* Chicago: University of Chicago Press.

Ricard, Robert. 1966. *The Spiritual Conquest of Mexico: An Essay on the Apostolate and the Evangelizing Methods of the Mendicant Orders in New Spain: 1523–1572.* Translated by Lesley Byrd Simpson. Berkeley: University of California Press.

Roca, Paul M. 1967. *Paths of the Padres Through Sonora.* Tucson: Arizona Pioneers' Historical Society.

Rouse, W.H.D. 1902. *Greek Votive Offerings: An Essay in the History of Greek Religion.* Cambridge: Cambridge University Press.

Sambon, Luigi. 1895. "Donaria of Medical Interest in the Oppenheimer Collection of Etruscan and Roman Antiquities." *British Medical Journal* 2: 146–150, 216–219.

Sandars, N. K. 1968. *Prehistoric Art in Europe.* Baltimore, Md.: Penguin Books.

Schlunk, Helmet. 1947. "Arte Visigodo." In *Ars Hispaniae.* Vol. 2:227–323. Madrid: Editorial Plus-Ultra.

Schulzetenberg, Mark. 1989. *The Sacred Heart Gives Life to the World.* St. Paul, Minn.: Leaflet Missal.

Sedelmayr, Jacobo. Forthcoming. *Before Rebellion: Letters and Reports.* Translated by Daniel S. Matson. Tucson: Arizona Historical Society.

Skelly, Rev. Joseph A., C. M. 1961. *The Perpetual Novena in Honor of Our Lady of the Miraculous Medal.* Philadelphia: Central Association of the Miraculous Medal.

Starr, Fred. 1904. "Notes upon the Ethnography of Southern Mexico: Expedition of 1901." In *Davenport Academy of Scientific Proceedings.* Vol. 9:63–171. Davenport, Iowa: Davenport Academy.

Tapley, Donald F., M.D.; Robert J. Weiss, M.D.; Thomas Q. Morris, M.D.; and Genell J. Suback-Sharpe, M. S., eds. 1985. *The Columbia University College of Physicians and Surgeons' Complete Home Medical Guide.* New York: Crown Publishers.

Thorndike, Joseph J., Jr., ed. 1979. *Discovery of Lost Worlds.* New York: American Heritage.

Thurston, Herbert, S.J., and Donald Attwater, eds. 1990. *Butler's Lives of the Saints.* Vol. 4. Originally compiled by Alban Butler. Edited, revised, and supplemented by Herbert Thurston and Donald Attwater. Westminster, Md.: Christian Classics.

Toor, Francis. 1947. *A Treasury of Mexican Folkways.* New York: Crown.

Toussaint, Manuel. 1967. *Colonial Art in Mexico.* Austin: University of Texas Press.

Turner, Victor, and Edith Turner. 1978. *Image and Pilgrimage in Christian Culture.* New York: Columbia University Press.

Underhill, Ruth. 1946. *Papago Indian Religion.* New York: Columbia University Press.

Untracht, Oppi. 1968. *Metal Techniques for Craftsmen.* Garden City, N.Y.: Doubleday.

Vessels, Jane. 1980. "Fátima: Beacon for Portugal's Faithful." *National Geographic* 158 (December): 832–839.

Vidal, Teodoro. 1974. *Los milagros en metal y en cera de Puerto Rico.* San Juan, Puerto Rico: Ediciones Alba.

Vogt, Evon A. 1976. *Tortillas for the Gods: A Symbolic Analysis of Zinacanteco Rituals.* Cambridge, Mass.: Harvard University Press.

Von Matt, Leonard, Stylianos Alexiou, Nikolaos Platon, and Hanni Guanella. 1968. *Ancient Crete.* New York: Frederick A. Praeger.

Walsh, Michael, ed. 1987. *Butler's Lives of the Saints.* San Francisco: Harper and Row, Publishers.

Wasley, William W. 1965. "A Preliminary Chronology for the Kino Mission of San Ignacio de Caburica and the Visitas of Santa Maria Magdalena and San Jose de Imuris." Tucson: Unpublished manuscript.

Wattenberg, Federico. 1963. *Las cerámicas indígenas de Numancia* (Native pottery of Numancia). Vol. 4 of *Bibliotheca Praehistorica Hispana.* Madrid: Consejo Superior de Investigaciones Científicas, Instituto Español de Prehistoria.

Woldering, Irmgard. 1967. *Gods, Men, and Pharoahs.* New York: Harry N. Abrams.

Espino, Edith Clark (St. Jude Shrine), 52, 54

Faith healer, 178
Fate of milagros: in archives, 161–62; buried, 159, 160, 215n. 6; burned, 165, 216n. 10; church position on, 155, 158; discarded, 162, 164; in displays, 44–46, 80, *81*, 156, 165; given away, 80, *81*; left indefinitely on images, *48*, 50, 56, 155, *156*, 157, 158, 176; melted for precious metal content, 162, 180; melted to make objects for church, 162, 215n. 7; in milagro art, 176; in museums, xvii, 160, 162; stolen, 44–45, 59, 64–66, 160, 164, 177; stored at site, xvii–xviii, 158–59; stored in safe deposit box, 215n. 2; taken home by offerer, 69, 164; unknown, 165
Feast committees (Mission San Xavier), 18–20, 204n. 55
Feast of St. Francis celebration (Mission San Xavier, October 4) 18–20, 26–28; Mass, 18, 26; and greatest number of milagro offerings, 21; procession, 26–28; compared to Magdalena fiesta, 17, 20, 27; religious pageantry of, 26–28; and Tohono O'odham in charge of Xavier's statue, 18–20, 26–27; vigil preceding, 26
Felix Lucero Park (offering site), 178. *See also* Garden of Gethsemane
Fiesta de San Francisco (Magdalena), xvii, 8, 15–16, *16*, 25–26; benefits of, 16–17, 187–89; camping at, 25–26, 205–6n. 14; milagros offered during, 21–25, 33; veneration of St. Francis at, 21–25, *23*, 190

Flores Nacional (shop), 82–83
Folk saint. *See* Soldado, Juan
Fontana, Bernard L.: on burning of San Francisco statue, 15; on miracles, xiii–xiv; on Mission San Xavier's milagros, xvii, 160; on number of milagros offered, 184; on earlier churches at San Xavier, 7
Francis, St., 14–15, 18; "combination statue" of, with milagros, 61, 157; as "the Old Man," 9–10. *See also* Feast of St. Francis celebration (Mission San Xavier); Fiesta de San Francisco (Magdalena)
Franciscans: replacing Jesuits, 7
Francis of Assisi, St.: introduced to Pimería Alta, 7; confusion of, with St. Francis Xavier, 14–15, 60–61, 132; feast day of, at Mission San Xavier, 18; in milagro art, 175; statue of, with milagros, 56. *See also* St. Francis, St. Francis Xavier
Francis Xavier, St.: belief in power of, 9, 12–13; confusion with God, 203n. 44; confusion with Padre Kino, 203n. 44; confusion with St. Francis of Assisi, 14, 15, 132; devotion to, spread by Padre Kino, 5–9; life of, 5–6, 202n. 17; miracles of, 6; as patron saint of Mission San Xavier and San Xavier Reservation, 6–7; as popular patron saint of Pimería Alta, 9; popularity of, 7; statues of, with milagros, 49, 62–64, *156*, 157, 165; statue burned, 15; statues receiving milagros, *ii*, 15, 17–18, *19*, *23*, 49, 61–64, *156*, *190*; veneration of statues of, 18, 21–28, *23*, 190. *See also* St. Francis

Freedberg, David: on power of images, 10–12, 203nn. 35–40

Fusion of St. Francis of Assisi and St. Francis Xavier, 14, 18, 61

Galaz, Betty (Santa Cruz Church): on theft of milagros, 164; on offering trends, 180–81

Gallardo, Alice: on future of custom, 185; repairing milagro display case, 165

Gallegos, Josefina (*sacristana*): on Black Christ, 210n. 23; and milagro storage, 215n. 4; and verse about saint's power, 37–38

Garcia, Matilda: and removal of milagros at Mission San Xavier, 161

Garden of Gethsemane (former offering site, Tucson), 178

God: power of, as evidenced by milagros, 190

Goldsmiths and silversmiths: Agustin Calleros, 84, 113–18; Carlos Diaz, 85–86, 96–98; Miguel Íniguez, 86–87; ; Rose Navarro, 86; Ruben Nubes, 90–91, 98–113, 102; Manuel Pulido, 78–79; Herman Romero, 88; Manuel Solís, 90

Griffith, James E.: on Black Christ, 210n. 23; on Juan Soldado, 211nn. 29, 30; on Our Lady of Guadalupe, 208n. 4; on Padre Kino, 68; on San Francisco statue, 203n. 48; on Santo Niño, 206n. 20.

Grijalva, Yolanda: on fate of milagros, 164; on future of custom, 184

Gerard Majella, St., 215n. 9; statue of, with milagros, 164–65

Gulf War: and increase of offerings, 180–81, 184

Hábitos, 14, 203n. 41; milagros depicting, 122; offered to saints, 54; rubbed on St. Francis, 13, 23; wearing of, 23, 29

Hair: offerings of, 26, 34, 54, 59, 182

Hernandez, Sister Augustina, 158; on fate of offerings, 158

Hickiwan (Sells Papago Indian Reservation), 61–62

Holy Cross Hospital (Nogales, Arizona), 62–63, 158

Holy Family Church (Tucson), 46, 157, 164, 165, 185

Hospital identification wristbands offered at shrines, ii, 26, 56

Iglesia de la Sagrada Familia (Nogales, Son.), 65–66, 157

Iglesia de San Ignacio de Cabúrica (San Ignacio, Son.), 67–68, 158, 159, 215n. 4

Iglesia de San José (Ímuris, Son.), 67, 210n. 23

Iglesia de San Martín de Porres (Magdalena), 68

Iglesia de Santa María Magdalena, xvi, xxi, 7, 8

Ignatius of Loyola, St., 5; statues of, with milagros, 67–68

I'itoi (Tohono O'odham creator): offerings to, 60

Imagenes (images), 77

Images (statues, pictures, and other depictions of Christ or saints): attitude of hospital staff toward, 50, 157, 185–86; attitude of nuns toward, 50, 158, 179; belief in power

lagros, 120–21, 124; on uncompleted manda, 35; on vandalism, 178

López, Delfina Suarez de (Juan Soldado shrine), 69–71, 160

Lopez, Donna Scott (Trinity Bookstore), 75–76

López, Francisco Campa de (wife of Jesús López), 179

López, José (husband of Delfina), 69–70

López, Lucía (daughter-in-law of Jesús López del Cid), 179–80

López, Socorro V. de, 88. *See also* Sagrado Corazón de Jesús

López del Cid, Jesús (Santo Niño shrine), 179–80

Louisa (O'odham woman), pilgrimage to Magdalena, 31

Lucy, St. (Santa Lucía), *159*; devotion to, 49; life of, 9, 47, 209 n. 7; shrines to, 47, *48*, 49, 67–68; statues of, with milagros, 47, *48*, 49, 67–68, 155, *159*, 211 n. 31, 215 n. 4

MacBain, Ron (milagro art), 167–69

Madrid, Arnold (late brother of Edward Madrid), 58

Madrid, Edward: and manda to build shrine of the Virgin Mary, Bisbee, *57*, 57–59

Magdalena de Kino (Sonora), xxi. *See also* Iglesia de Santa María Magdalena

Mail addressed to images, 51, 207 n. 24

Making milagros: cutting and engraving, 96–98; cutting from coins and watch lids, 98, *99*; die stamping, 93–96; lost-wax casting, 113–18;

metals used in, xx, 32–33, 94–96; sand casting, 98–113, *102, 105, 107, 108, 110, 111*

Mama Chatman (faith healer), 178

Mandas, 28–38; all, as equally efficaceous, 31–32; for animals, 34; completion of, help in, 35, 36; discussed with jeweler, 90; discussed with owners of shrines, 56, 57; explicit, 32, 90–91, 129, 213 n. 3; fulfilling of, by building shrine, 56–59, *57*, 66; —, by crawling to shrine, 25, 29; —, on feast day, 33, 206 n. 17; —, by offering milagros, 24–25, 28, 38, 77, 78–79, 90–91; —, by making a pilgrimage, 29–32; —, when a request is granted, 33–34; —, when a request is partly granted, 36; —, when a request is not granted, 38; for inanimate objects, 34; making several, at once, 34; for other people, 24, 34; other types of, 29, 50; uncompleted, 35. *See also* candles

Mardon, Allan (milagro art), 175

Mares de Pérez, María de Jesús: fulfilling manda, 38

Margaret Mary Alocoque, St.: vision of, 207 n. 2

Martin de Porres, St. (San Martín), 209 n. 9, 210 n. 21; household shrine to, 178; statues of, with milagros, 5, 49, 50–51, 56, 60, 62–63, 65, 68, 158, 178, 211 n. 31

Martinez, Alice: and repainting of Virgin Mary statue in Bisbee, 59

Martinez, Edith (wife of Herbie Martinez): on milagros, 42

Martinez, Herbie: with cuerpecito, 13; and guitar milagro, 146–47; wearing heart milagro, *41*, 42

Mary (Virgin). *See* Virgin Mary

McCarty, Father Kieran: on church position regarding milagros, 155, 184; and acceptance of custom, 184; and horse-blanket offering, 149; and milagros donated to museum, 160; on date change of San Francisco feast, 14, 203n. 42; on smelting milagros, 162

Mementos: of pilgrimage, 16, *16*, 22

Mendivil, Martha: on milagro art, 171; selling milagros, 80; shrine of, *81*

Mendivil, Ricardo (husband of Martha), 171

Mercado, Arturo: and milagro art, 173–75; selling milagros, 82

Milagro art. *See* artistic uses of milagros

Milagro displays, 44–46, 80, *81*, 157, 184–85, 208nn. 5, 6

Milagros: appropriate, desire for, 129, 212n. 2 (chap. 3), 213n. 3; attached together, 34, 123, 130, 136, 150–51; attaching of, to images, 39; belief in efficacy of, 82, 186–87; blessing of, 38–39; 182; composite, 121, *121*, 125, 125–26; definitions of, xiii, xiv, xv–xvi, xvii; emotions evoked by, 165, 189–90; failure to help offerer of, 37; gold, for household shrines, 74, 80; history of, 3–4; gold, preference for, 33, 75, 77, 83, 86–87, 90; identifying donors of, 40–42; keeping of, near image, 39–40; large, *40*, 40–41, 132, *133*, *134*, *135*, *142*, *143*, *143*, *144*, 144–45, *146*, 149–50, *150*; mailing of, to shrine, 51; obtaining, help in, 35–36; as proof of an image's power, 184–85; as proof of a saint's power, 166; offered by royalty, 4, 202n. 9; wearing of, *41*, *42*, 207n. 25. *See also* attitudes toward milagros; benefits of offering milagros; buying milagros; collections of milagros; fate of milagros; making milagros; milagro displays; nonmetallic milagros; offering milagros; offering sites; offering trends; removal of milagros from images; theft of milagros; types of milagros

Miracles, xiv, xv, 7–8, 210n. 23; church doctrine on, 28, 205n. 9; people's belief in, 24, 37, 51–52, 55

Miraculous Medals, 160, 209n. 10

Mission San Xavier del Bac, xv, *5*; dedicated to St. Francis Xavier, 6–7, 9; history of, 6–7; and origin of name, 201n. 1 (preface)

Molina, Connie: on fate of milagros, 165

Money (as offering), 24, 25, 29, 30

Mortuary Chapel, Mission San Xavier, 5

Murrieta Inclan, Ubaldo: manda of, to build San Ramón shrine, 66

Nambé Outlet (shop, Tucson), 80

Names engraved on milagros, 40–41

Narcho, Mary: and dressing of St. Francis statue, 18–19

Navarro, Rose (goldsmith), 82, 86

Nonmetallic milagros, 33; bone, *32*; plastic, 63; shell, *76*, 131; wax, 85, 206n. 16; wood, *40*, 40–41, 132, *133*, 207n. 23

Notes: mailed to Santo Niño (Tlaxcala, Mexico), 207n. 24; presented

to Christ and God, 50; identifying
milagro donors, 40–42
Novena, 29
Nubes Duarte, Ruben (goldsmith),
102; casting milagros, 98–113; and
making of bell, 162; on selling mi-
lagros, 90–91
Nuestra Señora de Guadalupe
(Our Lady of Guadalupe), 208n.
4; shrine of, in Carmen, Arizona,
59–60; statues, lithographs, and
other images of, with milagros, 5,
46–47, 59–60, 64–65, 67, 180
Nuestra Señora de San Juan de Los
Lagos (Our Lady of San Juan of
the Lakes; the Virgin Mary): in mi-
lagro art, 167, 169–71, *172,;* statues
of, with milagros, 60, 157

Ochoa, Celia H. de (jeweler): selling
milagros, 87. *See also* Joyería No-
gales (Sonora)
Ochoa Cantua, Consuelo: and count-
ing of milagros on San Francisco
statue, 33, 206n. 17; on offering
trends, 183
Oettinger, Marion: on melting mi-
lagros, 215n. 7; on wood boat mi-
lagros, 207n. 23
Offering milagros: for other people,
22; as specified in *manda,* 29, 32,
90–91; in supplication, xv, xvii, 36–
37, 51, 146–47, 186–87; in thanks-
giving, xv, xvii, 37
Offerings (other than milagros). *See*
candles; *cuerpecitos;* hair; jewelry;
money; photographs; pillows
Offering sites (other than Magdalena
and Mission San Xavier): chapels,
47, 49–50, 67; churches, 43–47,

60–68; hospitals, 50–51, 62–63,
180; household (indoor), 51–52,
53; images at, 211–12n. 31; im-
portance of, 71; in Arizona,
43–64; in Sonora, 62, 64–71; mi-
lagros at, summary of, 211n. 31; no
longer used, 177–80; roadside, *57,*
57–60, 66–67, 69–71; yard shrines,
52, 54–57; tomb of Padre Kino,
68–69
Offering trends: declining, 180–82;
decline reversed, 43, 185–86; in-
creasing, 184–86; no change,
182–84; ceased, 177–80
Officer, James E.: on history of Black
Christ (San Ignacio), 210n. 23
Oliver, Monsignor John: on Infant of
Prague's popularity, 64; on pur-
pose of images, 10; on St. Martin's
broom, 210n. 21
O'odham, xx. *See also* Tohono
O'odham
Ornish, Dr. Dean: on benefits of
offering milagros, 187–88
Orosco, Victoria: on fate of mi-
lagros, 165
Our Lady of Guadalupe. *See* Nuestra
Señora de Guadalupe
Our Lady of Mt. Carmel (the Virgin
Mary): statue of, with milagros,
46
Our Lady of the Sacred Heart
Church (Sells, Arizona), 60–61,
157
Our Lady of San Juan of the Lakes.
See Nuestra Señora de San Juan de
Los Lagos

Papago Indian Reservation: de-
scribed, xxi

EMMAUS PUBLIC LIBRARY
11 EAST MAIN STREET
EMMAUS, PA 18049

ABOUT THE AUTHOR

EILEEN OKTAVEC has been studying milagros since she moved to Tucson in 1973 to begin her graduate studies in anthropology at the University of Arizona. Born in New York City in 1942, Oktavec became an accomplished artist and photographer after studying at the Cooper Union School of Art and Architecture in the early 1960s, and she took many of the photographs that appear in this book.

Oktavec received her B.A. in anthropology from the State University of New York at Stony Brook in 1973, and an M.A. in cultural anthropology from the University of Arizona in 1974. In addition to her study of the custom of offering milagros, Oktavec's research includes studies of the Shinnecock Indians and Puerto Rican migrant workers in New York State; a Yaqui Indian health clinic in Tucson; and the disease *otitis media* among Indians of Arizona. Oktavec has lived with the Hopi, Navajo, and Tohono O'odham.

Now residing in New Hampshire, Oktavec returns to Arizona annually to continue her study of Tohono O'odham religious ceremonies as well as her study of the milagro-offering culture.